Edible Selby

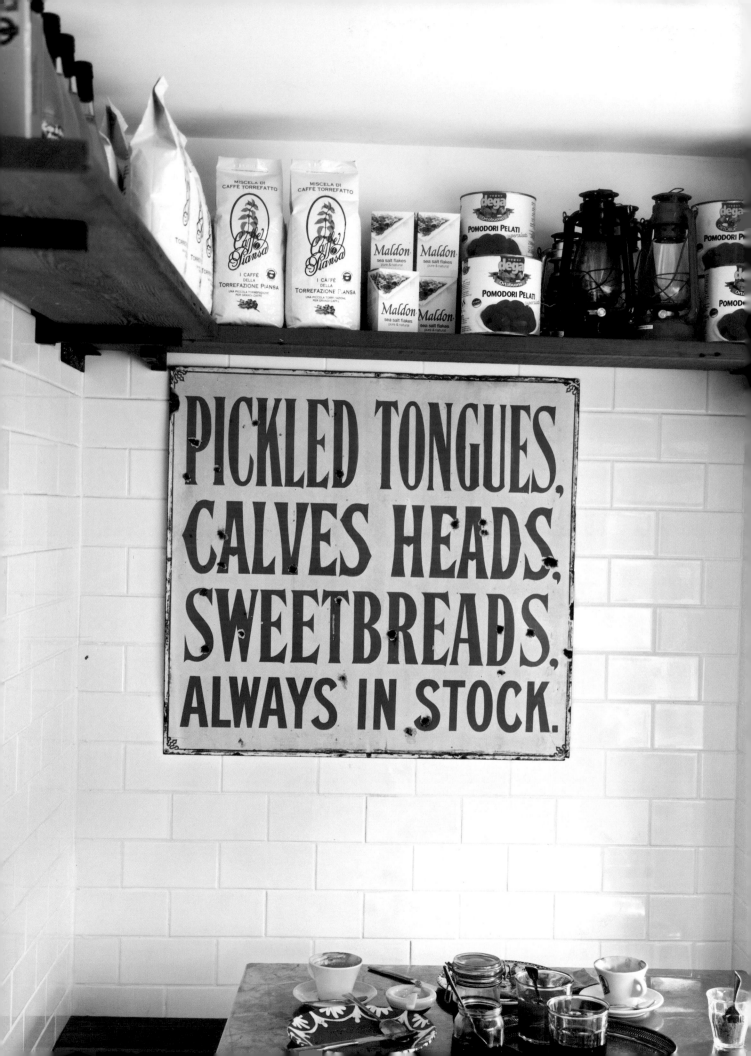

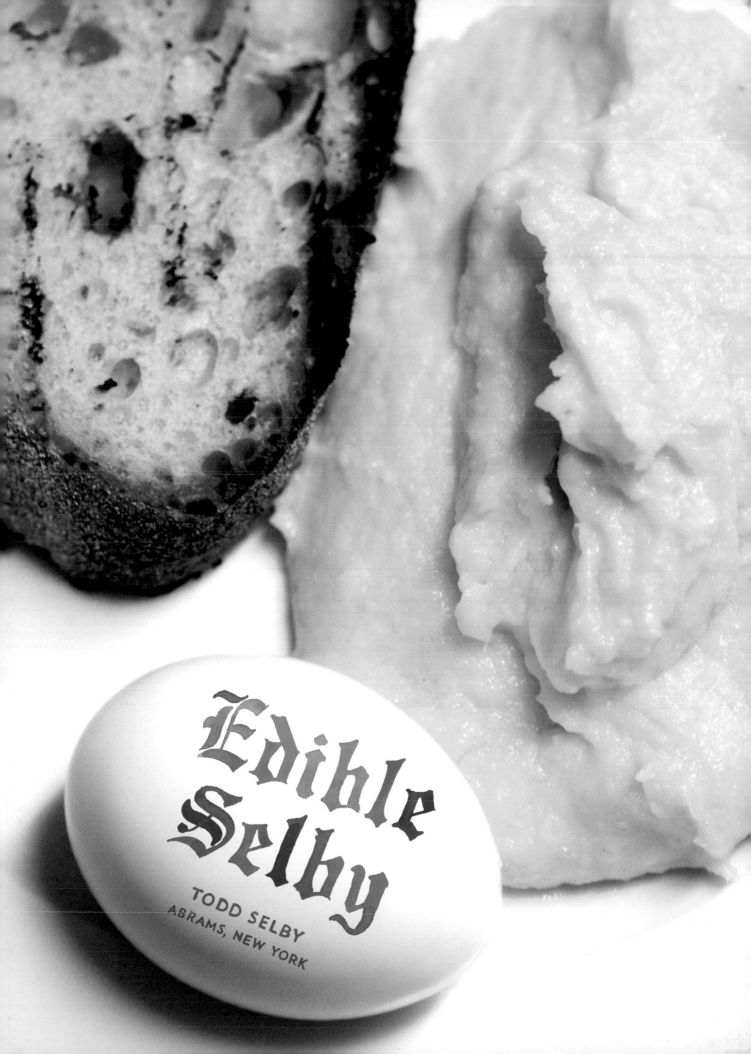

Edible Selby

TODD SELBY
ABRAMS, NEW YORK

TABLE OF CONTENTS

Mission Chinese Food

14

D.O.M.

20

Azienda Agricola

26

Blue Bottle Coffee

34

Eagle Street Rooftop Farm

40

Geranium

44

Renaissance Forge

52

Rosendals Trädgård

60

Tatemichiya

66

St. JOHN and Rochelle Canteen

72

Cake Man Raven

80

Hansen & Lydersen

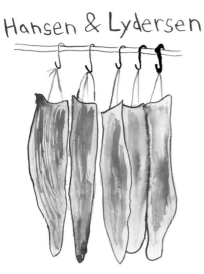

84

Le Chateaubriand

92

M. Wells

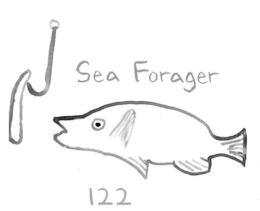

100

Cookbook

116

Noma

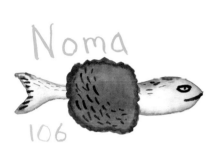

106

Sea Forager

122

Seirinkan

130

Hartwood

134

Violet Cakes

140

Rockaway Taco

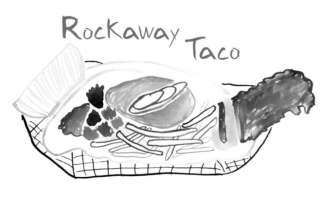

146

Whangaripo Buffalo Cheese Co.

154

Mistral 160

Captains of Industry 166

Tartine Bakery 172

L'Osteria Senz'Oste 176

Towpath 186

Next 190

Ishimiya 197

Camino 202

Yoshida Farm 208

Relæ 216

Four & Twenty Blackbirds 222

La Tête dans les Olives

228

Far i Hatten

234

The Phoenix Collection

238

ISA

246

Nordic Food Lab

254

Peko-Peko

260

Bethells Beach Café

THE BETHELLS STORE

268

Du Pain et des Idées

272

Mast Brothers Chocolate

278

Sa Foradada

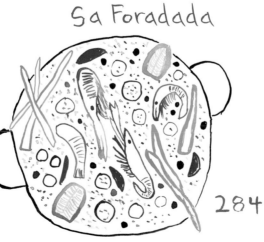

284

Edible Selby's Home-style Recipes

290

FOREWORD
SALLY SINGER

Todd Selby once asked me if I had ever seen the monkey-faced eel. I had not. He then whipped out his phone and showed me pictures of the creature, which looks exactly as it sounds and, in Todd's eyes, somewhat like a young Stalin. He was off to hunt for it with an urban fisherman he had met, a northern Californian with a passion for consuming slimy creatures with despotic visages. I wished him well. Bon appétit.

Could I have anticipated such culinary intrepidness when we began collaborating on the Edible Selby column in late 2010? Todd had come to me with the notion that local and sustainable food culture was simultaneously uniting and

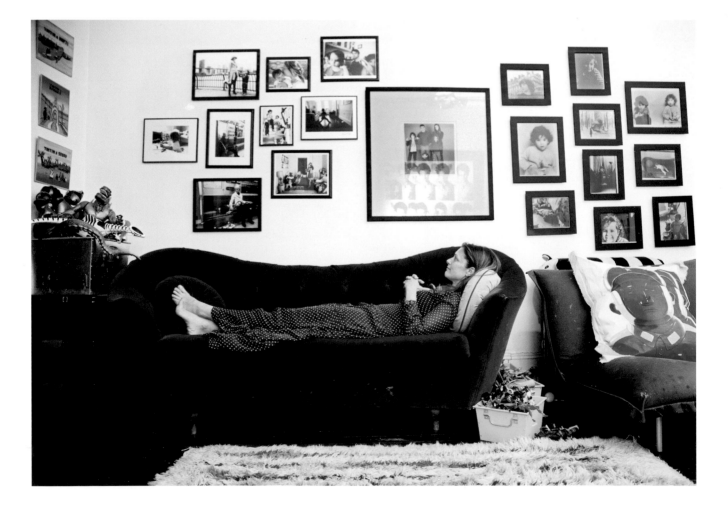

remapping the world of design, travel, and style. He was going to tour the globe to meet agriculturalists and artisans, butchers and briners, cleavers and cookie monsters. He had heard of cheese makers in Japan and of a bento box guru in Oakland. I thought it a brilliant evolution of his interest in decorative arts and, for lack of a better term, the sociology of lifestyle. On his website, TheSelby.com, he has revealed for years the curated and curio-filled living quarters of his generation. He has documented the obsessions and passions and just plain old stuff through which people build their identities. Todd's pictures of homes are fascinating because they joyfully raise questions about what makes us happy, what makes us human, what makes us us. Why do so many people over the age of 10 have a Hello Kitty toaster on their kitchen counter? What is it about Eames chairs and troll dolls? And why do people line up the products in their bathroom cupboards with such care, while their refrigerators wallow in neglect—some old Kombucha, a few deceased greens?

Refrigerators are just one of the reasons Todd turned his eye to kitchens and their inhabitants. The other is pure Selby: a chance to meet total obsessives in the very places in which they realize their crazy and yummy aspirations. So in the pages that follow, you'll meet a salmon smoker who has dedicated his life to smoking only that one fish; Scandinavian foragers; and an Italian innkeeper who sends a German lionkeeper to his premises to set out Prosecco and nibbles in the morning before anyone turns up to feed themselves and leave a small contribution—it is an inn with no innkeeper (says Todd, "How much more could a place be about philosophy?"). There are recipes and tricks of the trade, specialized gear and gorgeous surroundings.

It is not the world Todd was born into, because he hails from Orange County, California, and came of age at a time in which the local food culture consisted of drive-thrus and tacos. It is the world he grew into, in part because he was educated at Berkeley, right down the street from Chez Panisse, the "big hub" (his words) of all this deliciousness; in part because it rewards his impeccable taste in nearly every area of endeavor. But mostly, I think, Todd Selby has an affinity for these local gurus of grub because they share a common objective, which is to make daily life and that which is inevitable and unchanging—we have to eat, we have to cook or be cooked for, we have to nourish ourselves and our families—utterly delightful, with minimal expense, dollops of love, and perhaps a monkey-faced eel.

INTRODUCTION
CHAD ROBERTSON

Todd had taken the red-eye from New York to meet me at Tartine early one morning before we opened. I'd heard good things about a Selby shoot, though I imagined the typical scenario: another photographer in the way all day. My staff and I were game, but it wasn't something we were looking forward to.

I made coffee, and Todd began to shoot without anyone really noticing. He worked alone mostly, and moved through the room with unusual grace for a tall guy with a big camera and no professional kitchen training. Professional kitchens are notoriously hot, smelly, loud, and intensely stressful environments. Walking into one is like landing in the jungle to shoot wild animals. Yet here was Todd,

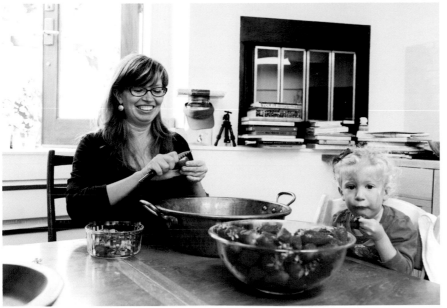

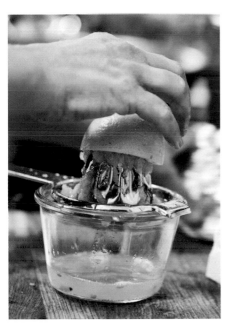

Liz how do I make jam?

HERE'S MY BASIC THUMBNAIL SKETCH
FOR PERFECT QUICK JAM:

4 PARTS BERRIES OR CUT-UP FRUIT

3 PARTS SUGAR

JUICE OF 3 LEMONS

PUT ALL IN A DEEP, WIDE POT, COOK TO 221F.

SKIM THE FROTH THAT COLLECTS ON TOP.

MEASURE IN POUNDS OR GRAMS.
EX: 4 POUNDS FRUIT:
3 POUNDS SUGAR:
3 TBSP LEM JUICE.

calmly walking in with a smile and pulling behind him his Louis Vuitton camera case. Early on in a Selby session, the line blurs between creative intensity and workmanlike setups, between serious artistic exploration and just fucking around. You get pulled into his reality and start having fun—and it shows in the images.

We broke for lunch and headed to my and Elisabeth's tiny house in Glen Park for a family photo session. Todd wanted to meet our notoriously shy 3-year-old daughter, Archer. Most of the chefs I know who appear in this book have little kids, and they all love Todd. It may have something to do with the cool stickers he hands out, or the goofy T-shirts he wears. Todd's kind of like a kid himself— and kids get this. I left Todd to get acquainted with Archer while I waxed a couple of surfboards to prep for the season. Within 15 minutes, Archer had invited Todd into her Muppet tent to meet her dolls. She still talks about him to this day.

This marked the start of a friendship that would evolve in unexpected ways over the next year. At one point, Todd and I overlapped while traveling in Europe. I was researching ancient and native grains, while Todd was deep into his Edible Selby project, capturing a creative shift under way in kitchens around the world. In Copenhagen he shot a portrait of me at the bakery where I had just begun to work with Nordic wheats; it was across from Relæ, my favorite restaurant there. That day he also shot photos of Kødbyens Fiskebar, and I joined him for a meal after the shoot. Among other things, we talked bread. I was thrilled with the leads he passed along: a biodynamic bakery in Stockholm, a place in Sicily to get its ancient black wheat, a bakery in Brazil that is known for using native ingredients from the Amazon.

How does this guy know so much about food? Most food photo shoots are the same: food stylists, prop stylists, lighting equipment, assistants. More often than not, the photos end up looking like stale catalog work. But food must be captured in the moment. Just like people, food has a good side and a bad side—and Todd knows this. When creative people are making food with skill and passion, there's a dynamic story there.

Improbably, he made a civilized affair of our day together at Tartine. We all had fun, and our famously talented photographer, with his rare and delightful way of sharing his good humor, made it look effortless, like he wasn't quite working. Yet the depth of observation found in a Selby session is extraordinary—he captures the narrative of the day.

MISSION CHINESE FOOD

In 2010, Danny Bowien and Anthony Myint were looking for a way to start a Chinese restaurant but didn't have the capital to set up their own place. The genius solution they came up with was to start Mission Chinese Food inside of another Chinese restaurant, Lung Shan, on Mission Street. Danny grew up in Oklahoma City, where he loved to eat "buffet-style Americanized Chinese" and barbecue. Danny and Anthony had never cooked Chinese food before opening their restaurant and "never had true ties to tackling authenticity." To them "it's all about honoring the original idea or concept and then making it our own." With that in mind they have developed their own style of unique dishes that meld American Chinese food with California cuisine and touches of Oklahoma barbecue, like white bread and Coca-Cola sauce.

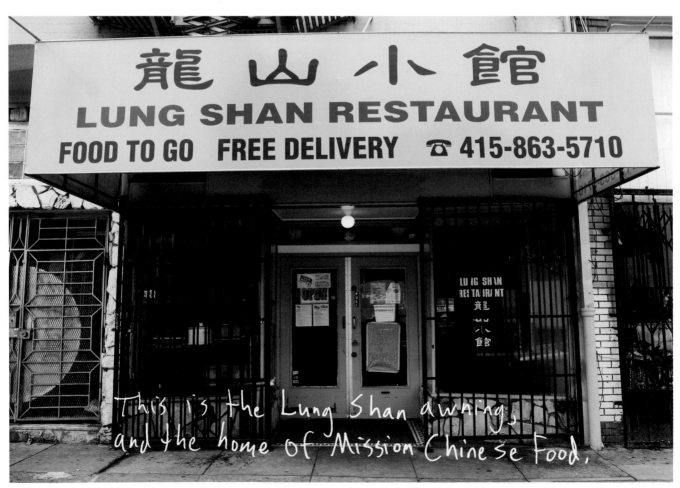

This is the Lung Shan awning, and the home of Mission Chinese Food.

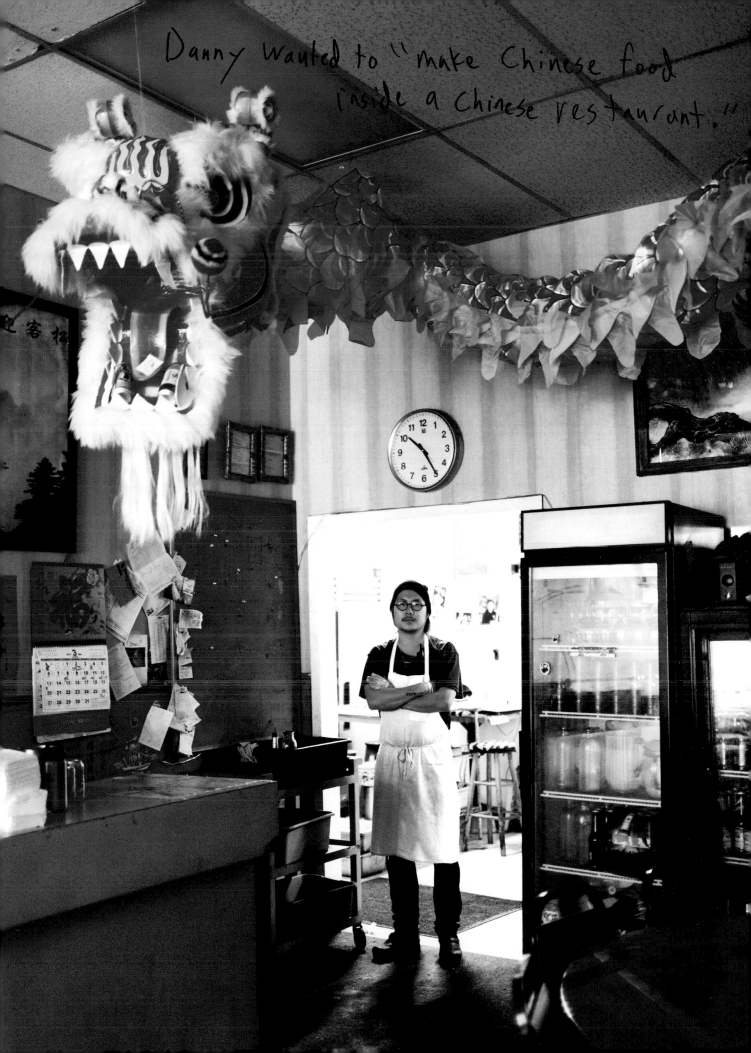

Danny wanted to "make Chinese food inside a Chinese restaurant."

the BBQ station in the front window.

"I'm from Oklahoma, so I grew up eating a lot of BBQ... This is a really ghetto smoker. We cut a hole in the wall, shoved the metal in the wall with dryer ducts taped on top."

OKLAHOMA BARBECUE

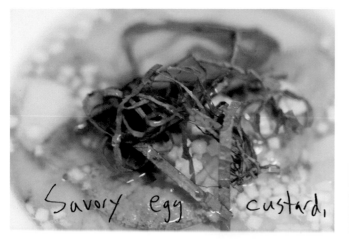

Savory egg custard,

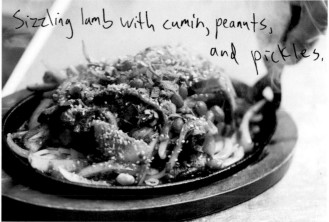

Sizzling lamb with cumin, peanuts, and pickles,

The ingredients for XO sauce - country ham, fried scallops, anise, garlic, and chopped ginger.

"Szechuan pickled vegetables. They're fermented and left sitting out for several days... Todd wanted to stick my knife in the food... I saved up for eight years to get that knife."

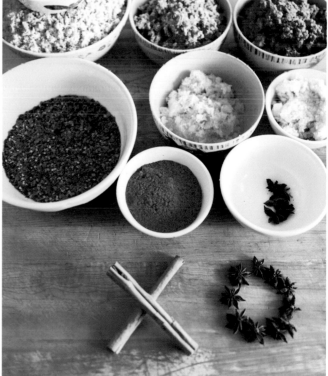

DANNY'S CHINESE FOOD

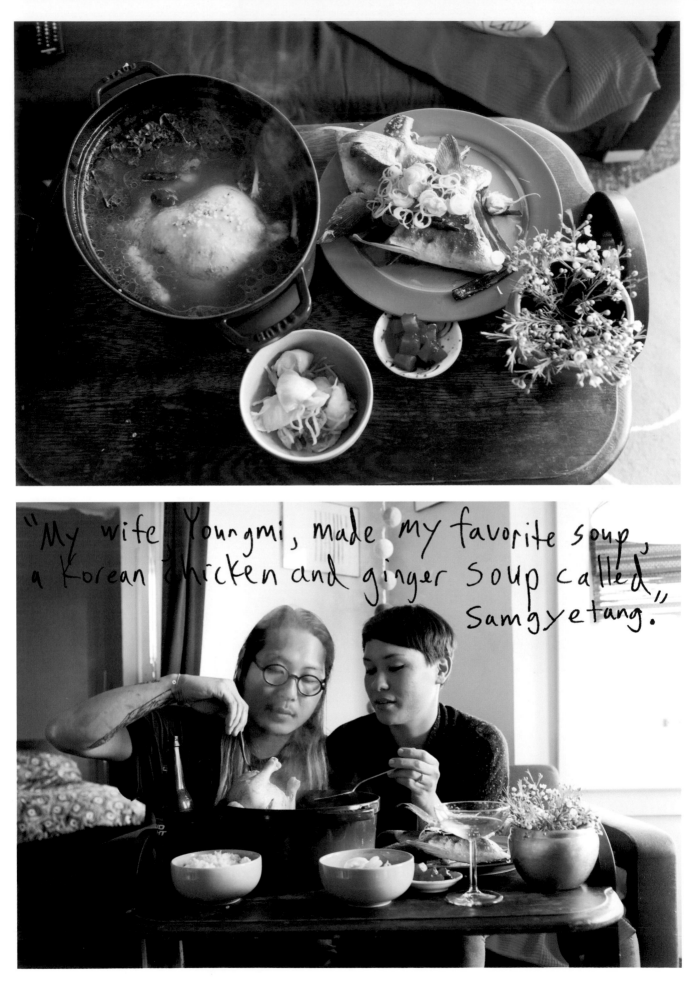

"My wife, Youngmi, made my favorite soup, a Korean chicken and ginger soup called Samgyetang."

LUNCH AT HOME

Hi Danny + Youngmi, Danny how do I make Ma Po Tofu?
START with equal parts pork belly and shoulder. salt them overnight (like 1 pound each.) Grind.
in a large pot or dutch oven, saute onions, chilis, 1 stick cinnamon + 1 bay leaf until vegetables are
translucent, add chili flakes or fresh ground chilis along with a few teaspoons of szechuan peppercorns.
once you smell the peppercorns, start adding pork, in batches until browned. once browned, add
shaoxing wine, white wine, fermented black beans, and a little fish sauce. braise, covered,
stirring occasionally for about 3½ hours or until the meat is super tender. season with
freed szechuan peppercorns and chili oil. warm tofu in a little boiling H2o, then toss gently in
sauce like a pasta until it thickens.

Youngmi could you draw and label the Kitchen of Mission Chinese ⟲

Danny how do I make XO sauce?
soak dried scallops + shrimp in cold H2o
overnight. drain. chop very fine with a
knife. finely chop country ham or
chinese sausage, ginger - garlic
(about 1 tbsp each,) + shallot. in a heavy
bottomed pan, sweat ginger shallots +
garlic, then add seafood + meat.
next add crushed chili, (we use awesome
ones from the sichuan province) salt,
rock sugar + soy sauce. cover with
oil + gently poach for about 45
minutes. at the very end, season w/ a little
cinnamon + anise.

Danny what is the best over the
counter BarBQ sauce?
HEAD N COUNTRY FROM OKLAHOMA CITY.

Youngmi could you tell me how to make Samgetang? I just use weird
ingredients from rainbow since it's hard to get korean ingredients. I stuff a raw
chicken with ginseng (dry) garlic and quinoa and put it in cold water. I bring the
water to a boil and simmer for 1 hour. Then I take the chicken out and put it in
the oven for another hour — pretty low like 300-400° Then I add kale, tofu, more
quinoa and other herbs (whatever you have) along with ginseng extract (aprox 4
into the remaining broth. It's pretty bland but it's supposed to be. You add salt before eating to taste. vials)

Youngmi could you draw your salad cook T-Bone

Danny could you draw + label Kung Pao Pastrami ⟲

XXX
chili paste fumes!!!

potato

We smoke corned beef
for 12 hours, over fruit
woods. we
call it pastrami.

SICHUAN
chili pods

flaming
chili
oil!!!

peanuts

celery

i am a terrible artist. :(

T-Bone
salad
cook

D.O.M.

Alex Atala started D.O.M. in 1999 to highlight and reinterpret Brazilian cuisine and ingredients in a very modern way. At D.O.M., Alex has worked to "domesticate" the "really wild character" and flavors of Brazilian food and give the diner the "ultimate Brazilian experience." He uses all sorts of progressive techniques and combinations but always stays true to his local ingredients. Even Brazilians are surprised by the variety of produce that Alex cooks with, which includes rare and exotic fruits; vegetables; and spices found deep in the rain forest, such as priprioca root, Baru nuts, and giant wild filhote fish.

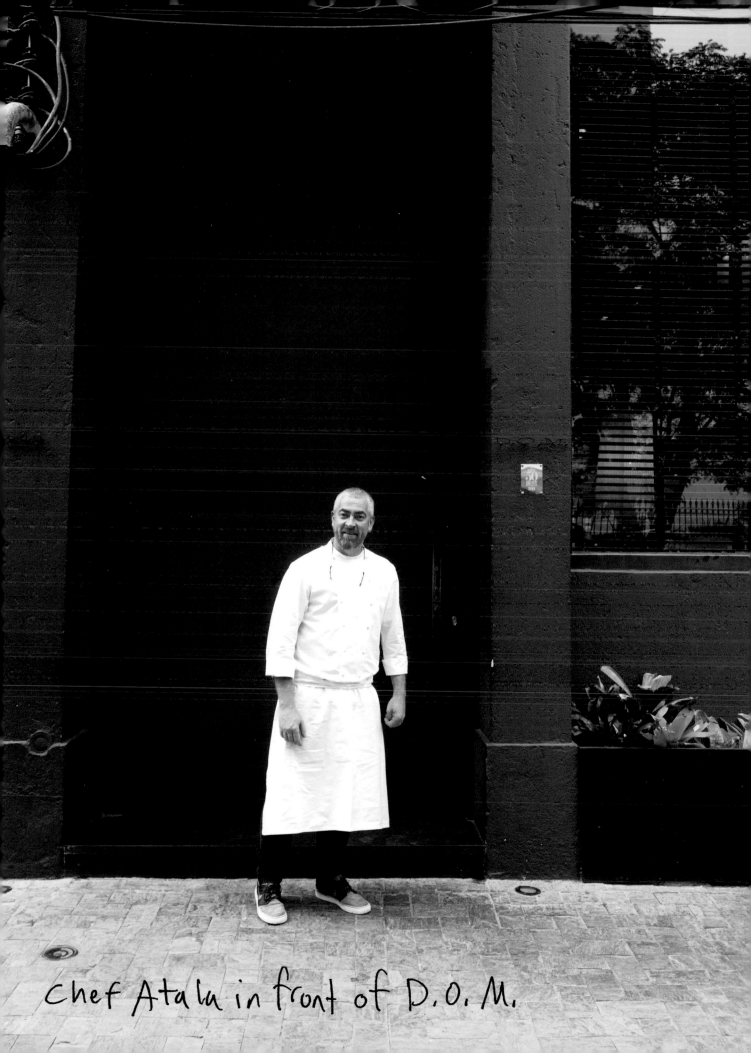

Chef Atala in front of D.O.M.

chef Atala plating a dish of sweet potato with Brazilian mate tea béarnaise.

THE D.O.M. KITCHEN

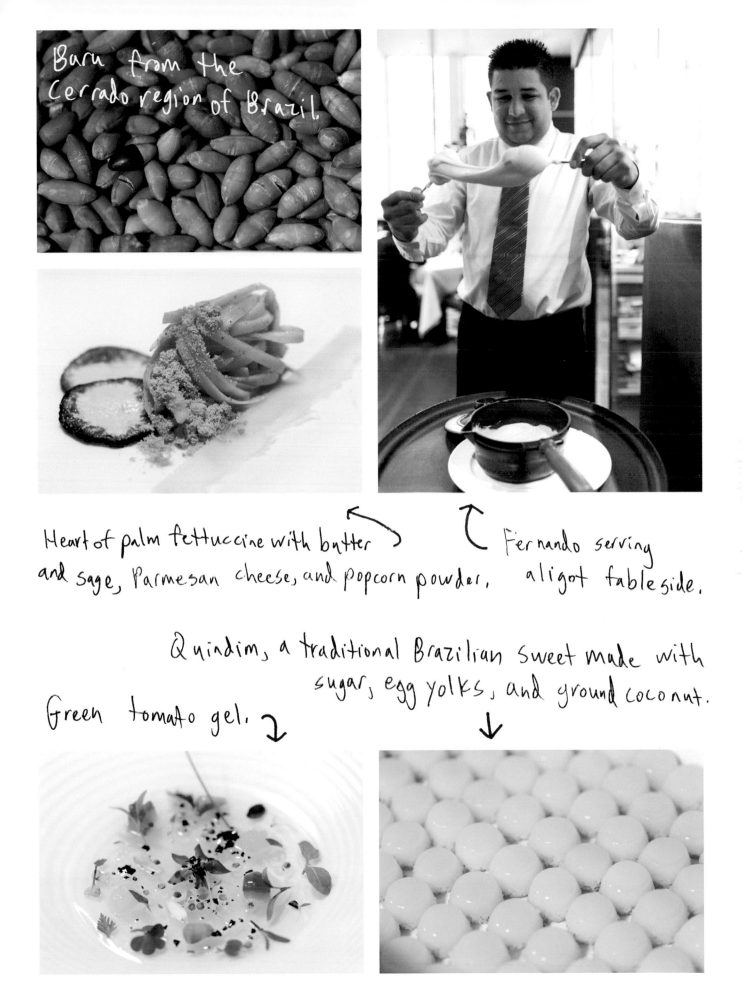

Baru from the Cerrado region of Brazil.

Heart of palm fettuccine with butter and sage, Parmesan cheese, and popcorn powder.

Fernando serving aligot tableside.

Quindim, a traditional Brazilian sweet made with sugar, egg yolks, and ground coconut.

Green tomato gel.

INGREDIENTS FROM THE JUNGLE

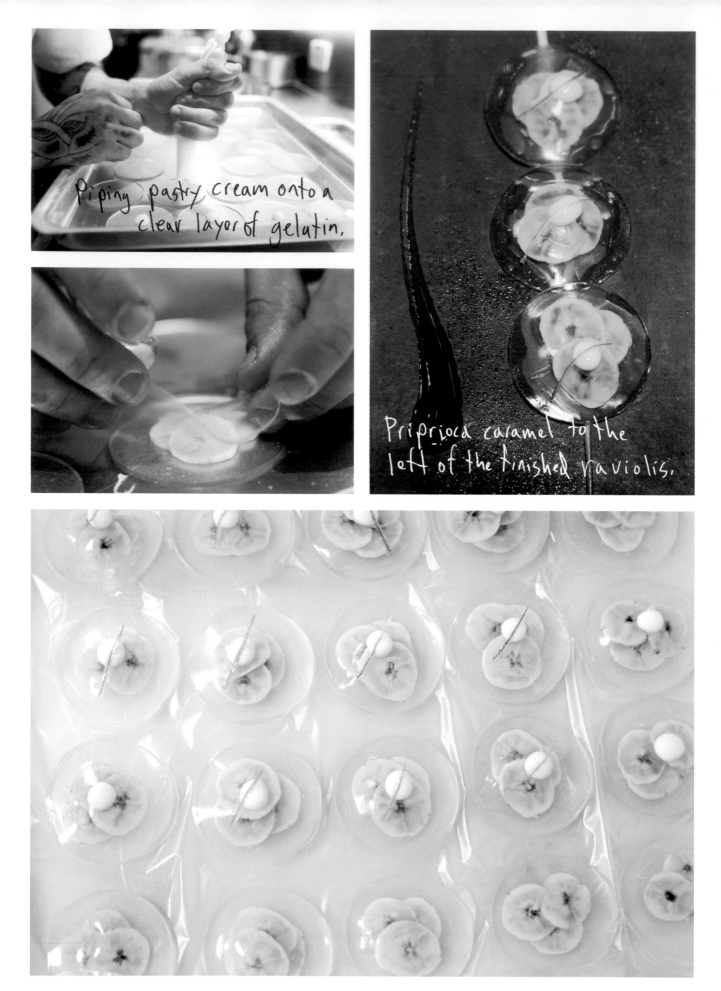

Piping pastry cream onto a clear layer of gelatin.

Pri priocd caramel to the left of the finished raviolis.

BANANA LIME RAVIOLI

Hi Alex. Can you draw + label your favorite fruits + vegetables from Brazil ↘

Jaboticaba
Baccuri
Mandioca
Priprioca
Jambu

How do I make Mandarain / thai basil water?
sparkling ↔ "Very cold"!

1/4 Fresh mandarin

Basil Flowers

Could you draw your totems from the kitchen in D.O.M. ↘

What are the secrets of Brazilian cooking?

What are the the jungle?

1 WATER

2 Soil

4 most beautiful things you ever saw in

3 FIRE

4 WIND

Could I get the recipe for ~~green tomato~~ & oysters + tapioca?

4 oysters + 1 egg
50g o/ ~~~~ pre-cooked tapioca
100g Greated Brioche bread
30g Salmon Eggs
50ml Lime Juice
Olive oil, soya sauce, chives

1) make a crest with 1: egg 2: Brioche
2) Pan Frie in olive oil
3) Marinaded The Tapioca with Oyster water
 Lime juice + Salt
4) Served with Salmon eggs &
 chopped chives

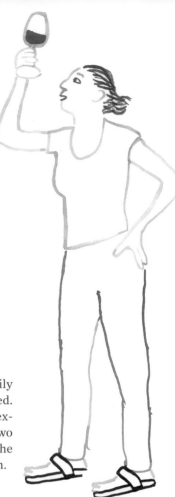

AZIENDA AGRICOLA

Arianna Occhipinti started her winery in 2004 in an ancient building in Sicily that was used for making wine until the 1960s, at which point it was abandoned. Arianna fixed it up and dedicated her winery to making natural wines that express the island's unique terroir. She uses Nero d'Avola and Frappato grapes, two red varietals that are native to the region. Sicily has many different climates, so the grape harvest is done over a four-month period depending on the exact region.

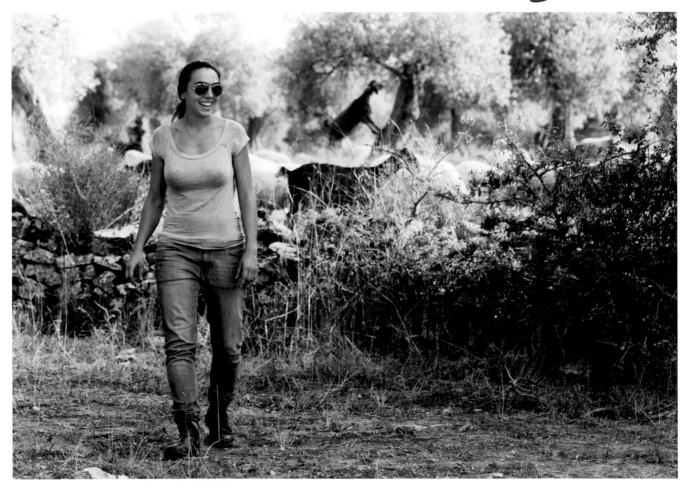

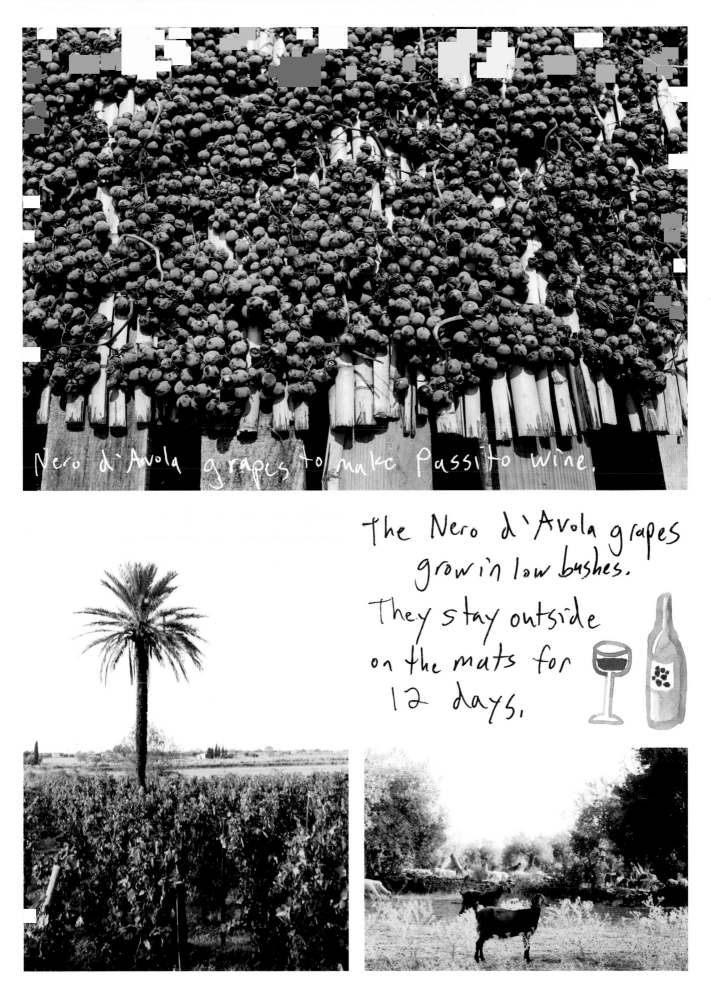

Nero d'Avola grapes to make passito wine.

The Nero d'Avola grapes grow in low bushes.
They stay outside on the mats for 12 days.

THE LAND

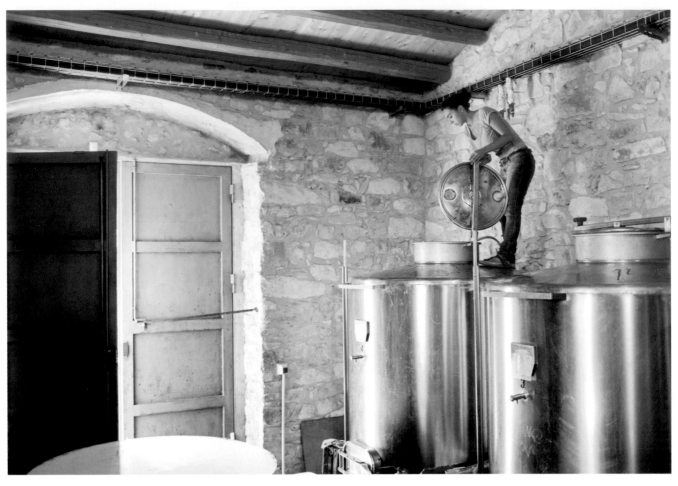

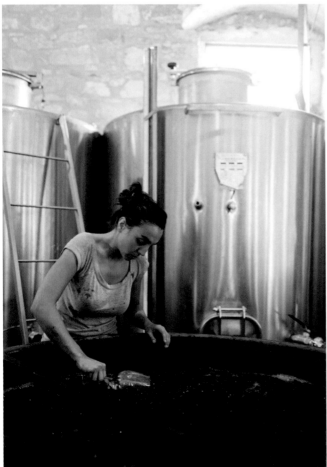

Arianna is "punching down," in order to mix the skin of the grapes with the juice during the fermentation.

Checking the consistency and smell of the fermenting grape skins.

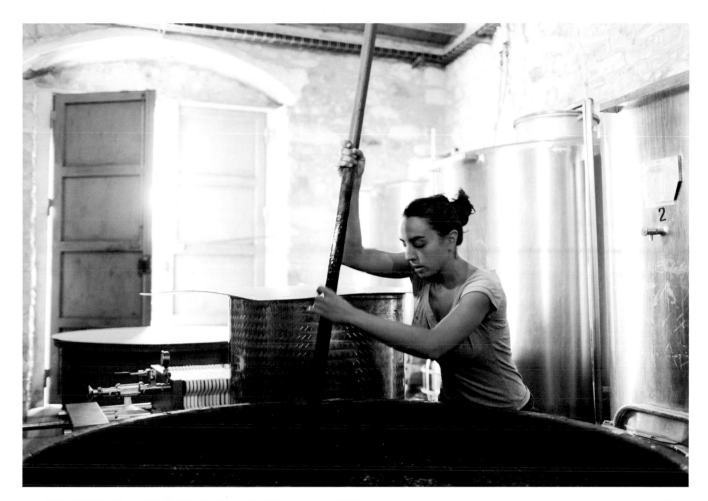

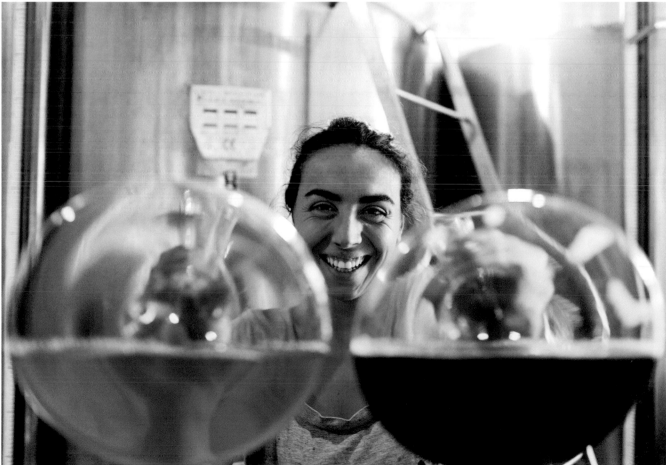

WINE MAKING

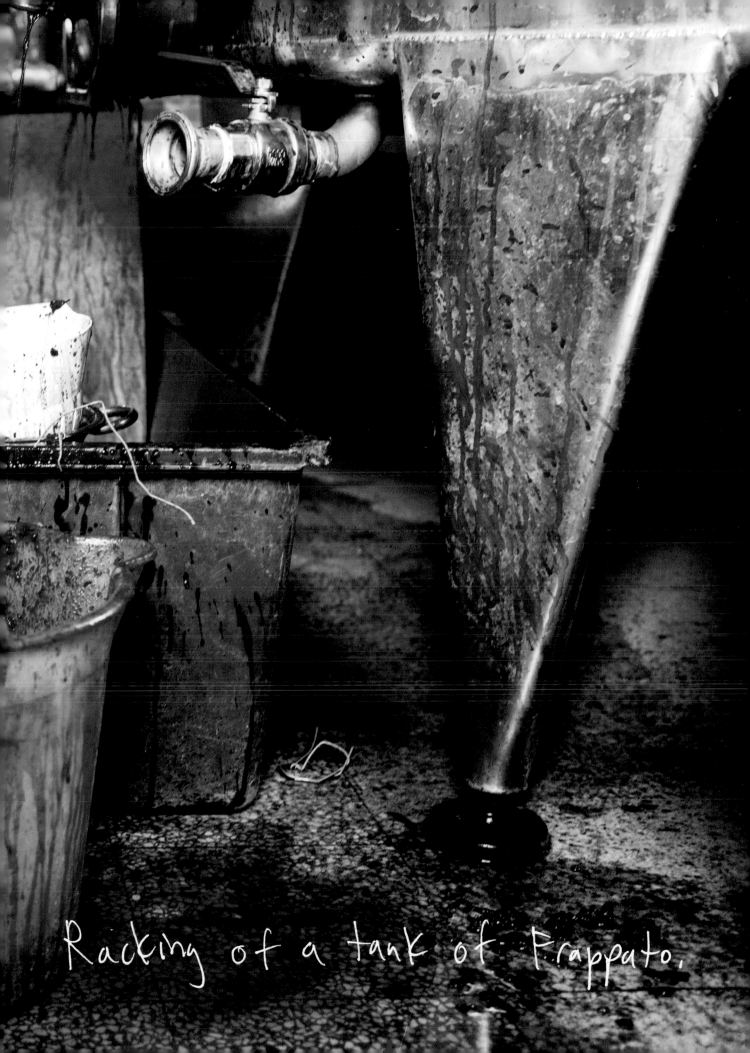

Racking of a tank of Frappato,

Hi Arianna. Could you draw+label your living room back when it was a place to make wine ⇗

SP68 Red FRAPPATO NERO D'AVOLA SP68 WHITE

How do I make grape marmalade?

1 Kg GRATE MOSCATO
0,3 Kg sugar

Remove the seeds from the grape and destem it.
After put the grape in a pot with the sugar and mix by a wood spoon until the fruit changes thanks to the caramelization of the sugar. When it is dense put everything in a glass jar when it is hot. Close and cold. It is ready.

Could you draw a map of Sicily with the different grape varietals that grow there ⇗

■ PALERMO (nero d'Avola)
■ MESSINA-FARO (Noera, Norello cappuccio's)
■ VITTORIA - Frappato (Nero d'Avola)
■ MARSALA (grillo-catarratto)
■ ETNA (Nerello mascalese)
■ SIRACUSA (MOSCATO E NERO d'Avola)

what do you love about making wine?

I love the natural aspect of the wine. Thanks to it I feel in contact with the land and with Nature. I love to stay she work in the vineyards, but also to touch the grape and wine in the cellar.
the wine makes me feel free.

Could I get your recipe for pasta with broccoli?
1 broccolo
500g di paccheri
oil ex - toasted bread
Raisins - pine nuts - almonds -

Cut the broccoli in add it in a pan after frying the garlic. Add sausage cut into small pieces and splash some with wine. After add pine nuts and raisins. When it is ready add to the paccheri and put up some toasted bread. oil.

How do you make Frappato?

Frappato is a native grape of Vittoria. I cultivate an old vineyards in organic. Frappato has a tick skin so I like to make long skin contact for about 30/40 days. Daily punch down and pumping over. After pressing the wine ages for 1 years and on half in barrel of 25 hl. it's not filtered.

BLUE BOTTLE COFFEE

James Freeman spent many years playing the clarinet in a lot of musical groups and traveling all around the United States. While on the road, he ate a lot of bad food, but one thing he couldn't stand was all the bad coffee, so he came up with his own system. He roasted coffee beans at home on a baking sheet and then ground them up (wherever he might be) using a Zassenhaus hand grinder. Then he would brew the coffee in a Bodum French press. Even when he was on a plane! He is serious about his coffee. He left the music business and in 2002 started Blue Bottle Coffee in a 186-square-foot potting shed. In 2009, SFMOMA asked James to open a café on its rooftop sculpture garden. James's wife, Caitlin, came up with the idea to make art-inspired desserts. She has made pastel cakes inspired by Thiebaud, a gilded hot chocolate inspired by Koons, and a color-blocked cake inspired by Mondrian.

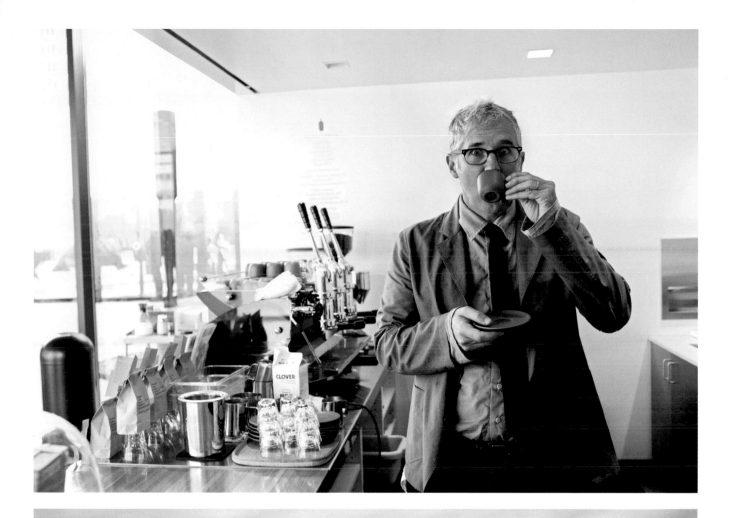

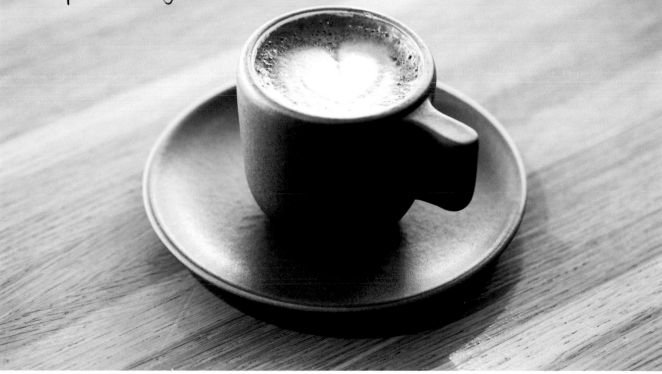

Macchiato, served in the Heath demitasse that James helped design.

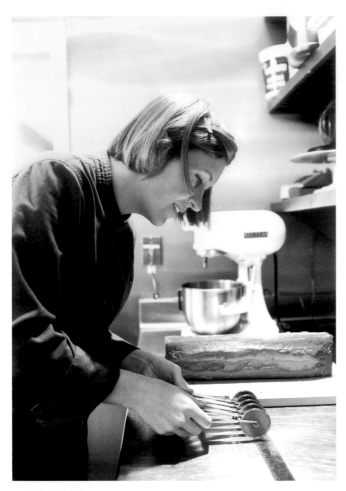

"We bake, chill, and cut up four different cakes (white, yellow, red, and blue) and then reassemble them as one. They're all a vanilla velvet cake made with just egg whites (for the whitest possible color)." — Caitlin

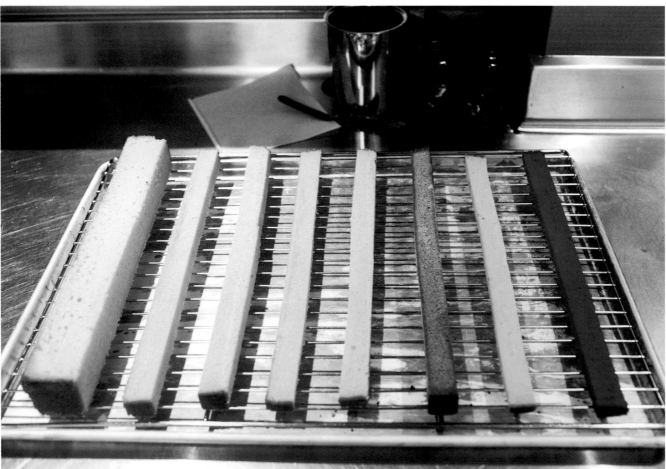

THE MONDRIAN CAKE

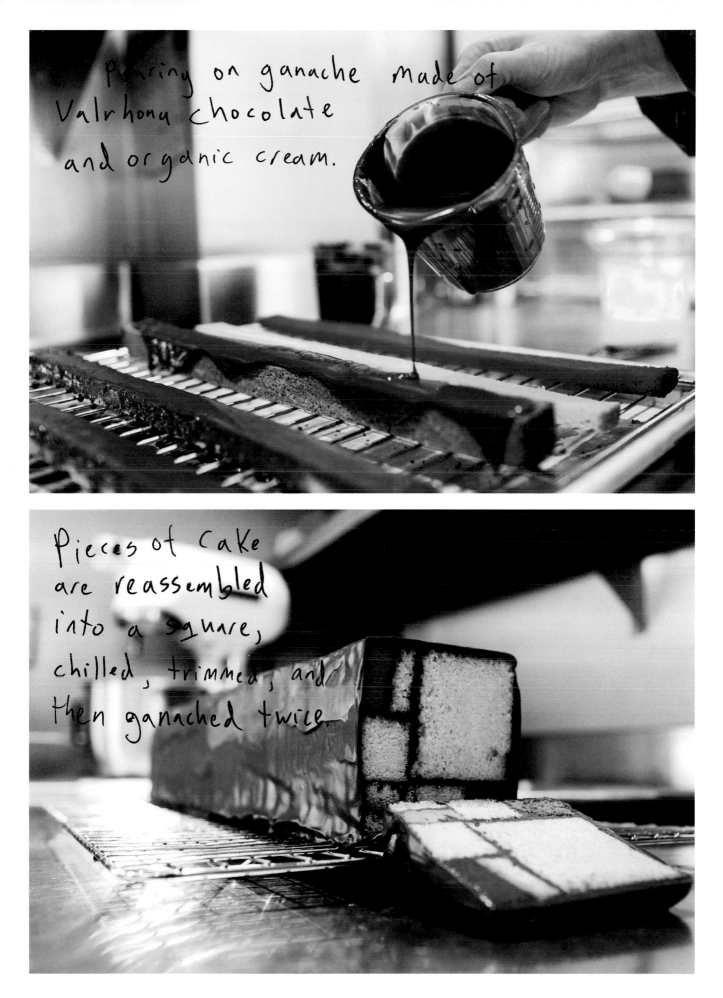

Pouring on ganache made of Valrhona chocolate and organic cream.

Pieces of cake are reassembled into a square, chilled, trimmed, and then ganached twice.

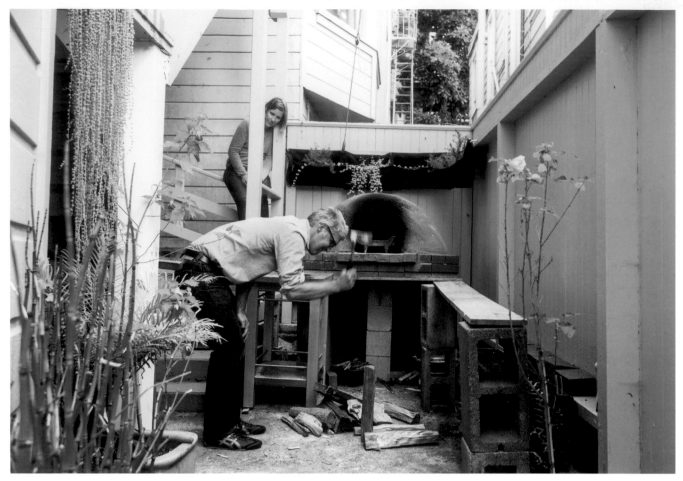

James's old Atomic
coffeemaker from
Australia.

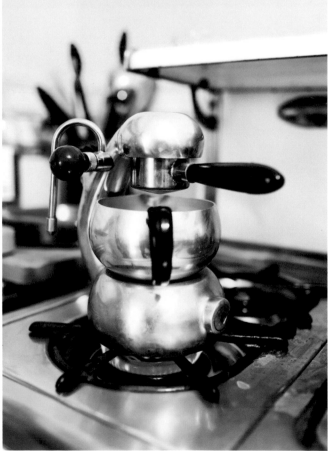

Roasting
coffee in a cast-iron
skillet in the wood oven.

MAKING COFFEE AT HOME

Hi Caitlin + James! James how can I build a wood burning oven?

Building things is easy if you are not afraid of making a mess of getting dirty. 1. stack brick, cement, sand etc into a thermal mass, approx 3.5 feet high 2. sand mold the dimensions of your oven. 3 2" of clay/water/sand /3" of clay/water/sand/hay 2" of clay/water/sand. When oven is dry-ish - (48 hours) scoop sand out and light fire! If fire department arrives, appologize.

Caitlin could you draw + label a desert inspired by Dali?

James how can I roast coffee at home?

It's easy! oven at 500°, green beans one level deep on perforated baking sheet. 1st crack (endothermic) should arrive at 6:30 - 8:30 minutes. pull before 2nd crack (exothermic). cool w/ 2 strainers on back porch so chaff wafts to neighbors' yards. enjoy after 24 hours but before 7 days

An interactive environment wherein customer enters "hot room" and watches clock shaped popsicle melt

James could you draw + label the most beautiful espresso machine you have ever seen

The 1953 faema urania, painstakingly restored in almost a condition that would qualify it for the Maltoni collection of museum-quality espresso machines. It's in austria, but will be steaming towards brooklyn soon. It's ours. I got it through a fairly well-known bass clarinetist who is friends of these french boiler engineers I know.

Caitlin could you draw + label your 4 favorite candies?

Pink grapefruit mentos

Kococo Pink peppercorn Chocolate

HARIBO roulette

Leone violet hard candies

James what's fun about coffee?

everything! coffee is tangible. It is not made of ones and zeros. It makes us smarter, funnier, healthier, and is delicious

Caitlin what was the most artistic meal you ever had?

at a tiny slip of a restaurant called Kappo Sakamoto in Kyoto. My mind was blown at the many types of citrus he used and the very special handmade dishes + vessels he served in. All was secondary, however, to the perfect kaiseki meal.

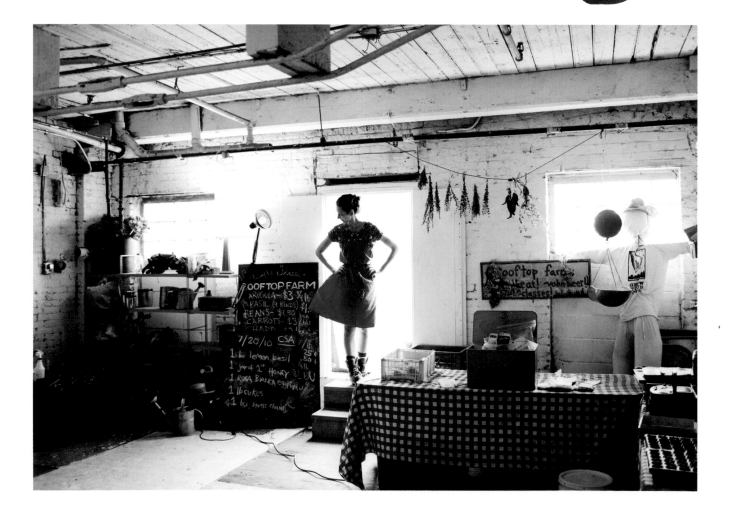

EAGLE STREET ROOFTOP FARM

The Eagle Street Rooftop Farm in Brooklyn was the first commercially run, fully landscaped green roof in the United States. In the three years it has been around, it has grown tons of food and been a home to 80,000 honeybees, some rabbits, and a flock of chickens. Annie Novak started the farm primarily as a way to promote green roofs and rooftop farms, and to show that they can be commercially viable and helpful to owners of buildings as well as the greater community. Annie has dedicated her life to connecting people to their food, so the Farm is truly a labor of love. By planting on roofs we insulate buildings to keep them warm in the winter and cool in the summer. Plus it's a lot more fun than a bunch of gravel or tar.

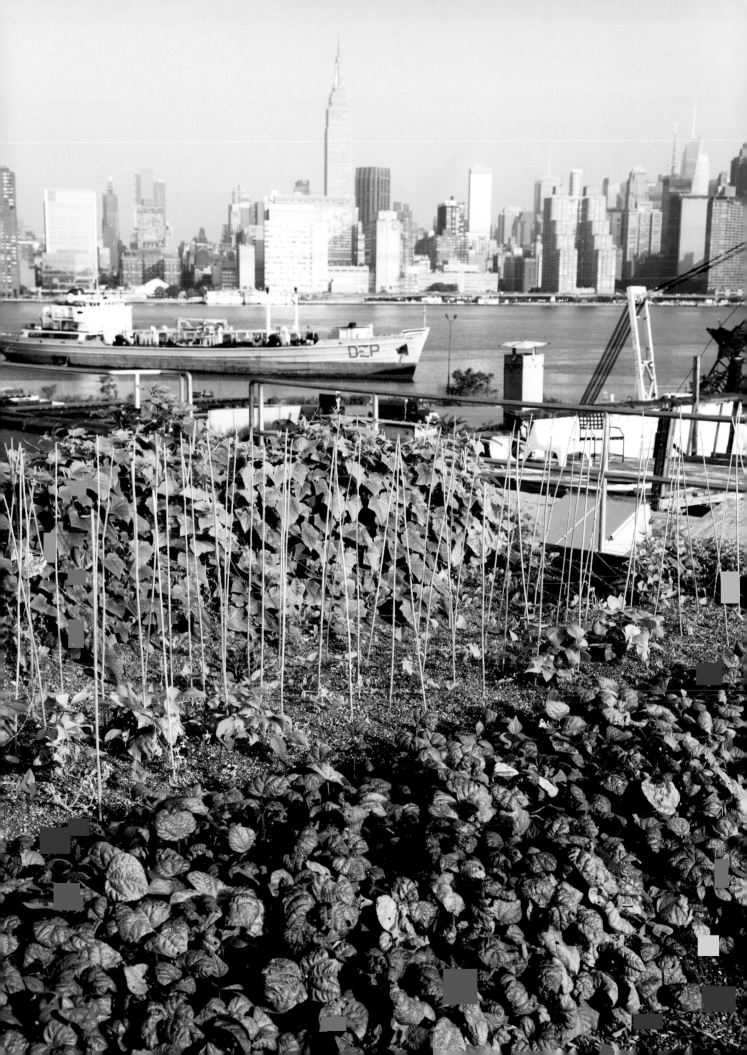

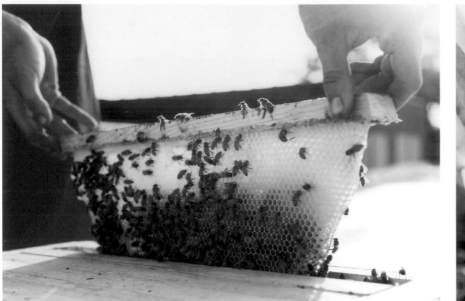

Baby carrots for the rooftop rabbits.

Classic Kirby pickling cucumbers,

Annie's mom wore this Same red dress when she was pregnant with her in Mexico,

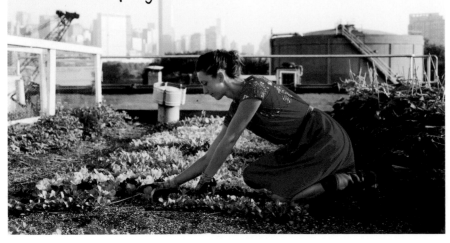

ON THE ROOFTOP

Hi Annie! Could you draw (label) a map of Eagle Street rooftop farm ⤵

What have (4 crops) grown the best on the farm?

① BASIL 🌱 ② CUCUMBERS

③ NIGHTSHADES → eggplants peppers tomatoes ④ BEES! 🐝

If you could run a rooftop farm on top of any building in the world which would you pick? Eagle Street is actually pretty spectacular: it's the perfect marraige of need (an city w/an antiquated sewage system in need of green roofs to help w/storm water runoff), a generous + green-minded building owner, an amazing community of foodies + green thumbs, and a rockin' view of the best city on the PLANET.

CHICKENS!

BEAUTIFUL NYC

COMPOST!

30 VARIETIES OF FRUITS + VEGGIES AND ALL ON TOP OF A 6000 SQ GREENROOF

BEES!

BROADWAY STAGES

could you draw (+ label) the ultimate window box farm ⤵

What has the farm taught you? New Yorkers actually love food plants as much as eating!

CUCUMBERS MINT BASIL MORE CUKES MINT

What needs to happen for there to be more rooftop farms in NYC?

① GREEN ROOFING BUILDINGS IN NYC should be a logical + integrated part of new architecture. Every flat roofed condo that can structurally support a greenroof ought to have one.

② Training + supporting the YOUNG FARMERS and redirecting the FOOD SYSTEM around LOCAL, ECOLOGICALLY VIABLE FARMS.

③ Bravery, curiosity, innovation + hard work = the new 9-5!

GERANIUM

Chef Rasmus Kofoed has competed and won gold, silver, and bronze in the world's largest and most prestigious gastronomic competition, the Bocuse d'Or, where he has developed and refined techniques and flavors (such as his sauce of pickled elderflower and browned butter) that end up in dishes that he makes at his restaurant, Geranium. The chefs at Geranium use many of the techniques of molecular gastronomy, such as sous-vide cooking and blending herbs in liquid nitrogen. Rasmus calls these techniques the "salt and pepper" of his dishes because they help bring out the inherent flavor of a dish in a totally invisible way. For instance, the Jerusalem artichoke dish is continuously cooked for two weeks before it is served. But you would never know this when you eat it, as that information is not on the menu. (This is in direct contrast to a lot of chefs, who use the same scientific equipment and make these techniques the center of attention.) All you would notice is that the artichoke is the lightest and most refined you have ever had.

A dish of fresh tomato water,
gelée of ham, and lemon thyme oil.

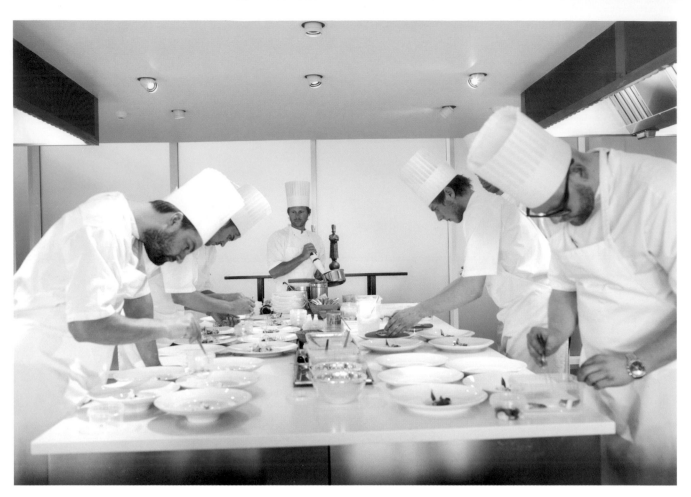

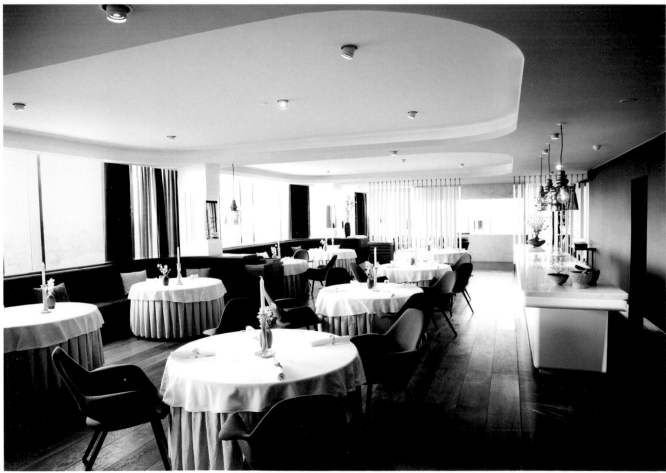

DINING ROOM

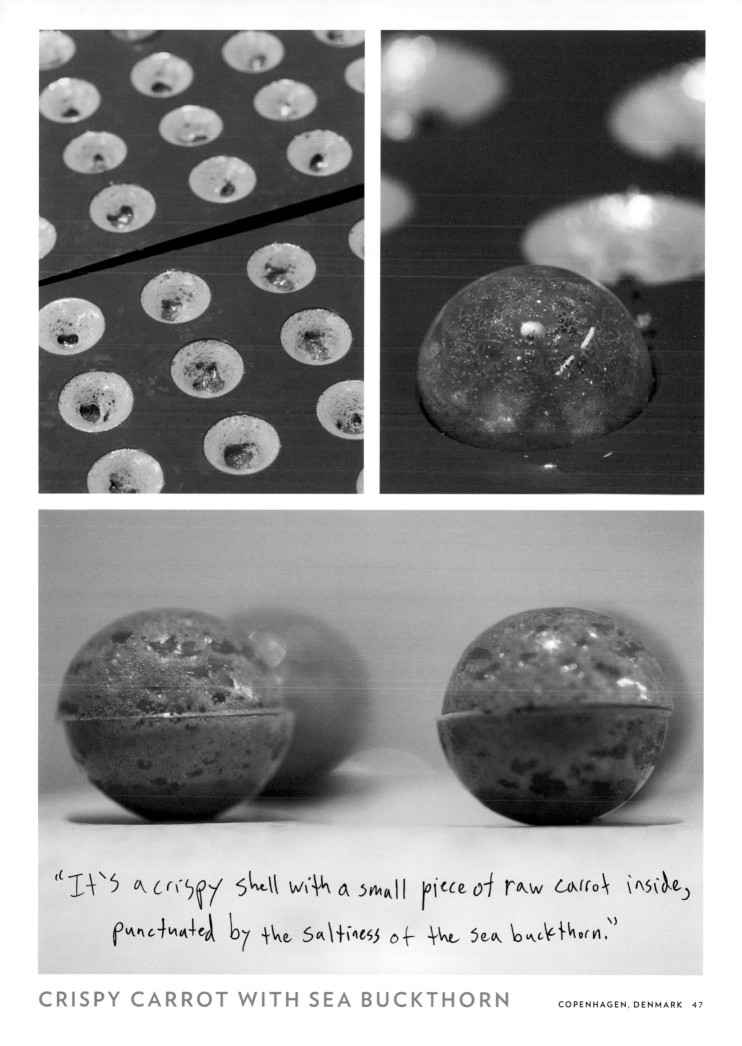

"It's a crispy shell with a small piece of raw carrot inside, punctuated by the saltiness of the sea buckthorn."

CRISPY CARROT WITH SEA BUCKTHORN

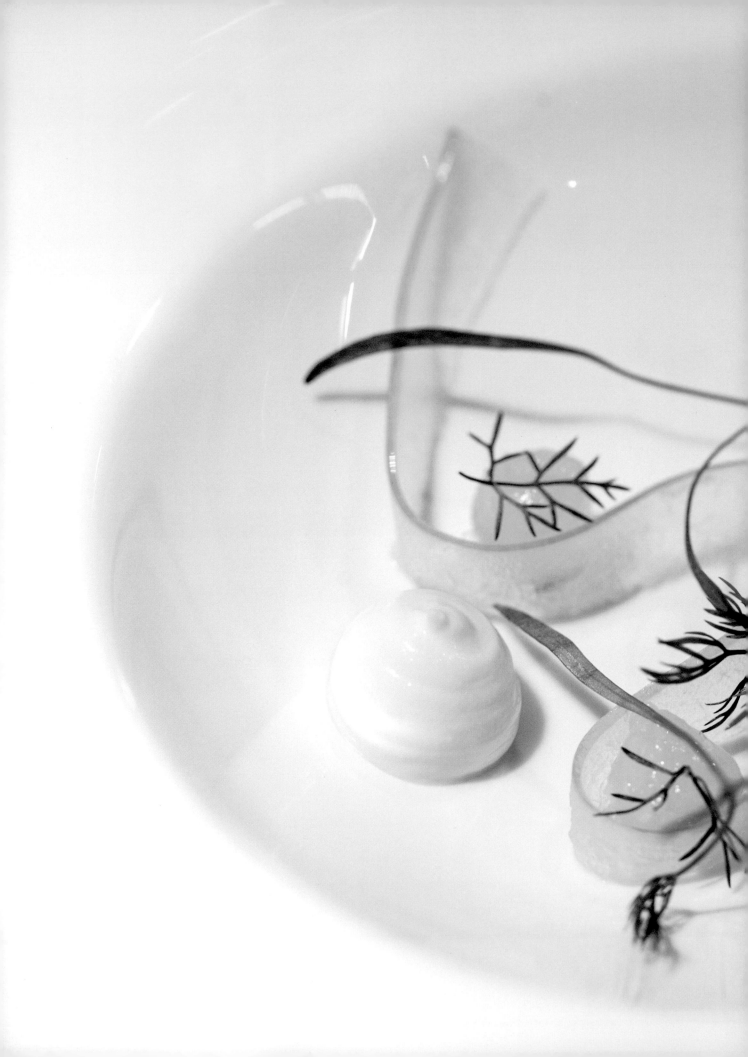

A starter of fresh fennel juice,
fennel, and celeriac.

What is your philosophy about the food at Geranium?

♡ + 🌱 + ☁ + ✋
Heart Nature Brain Hand

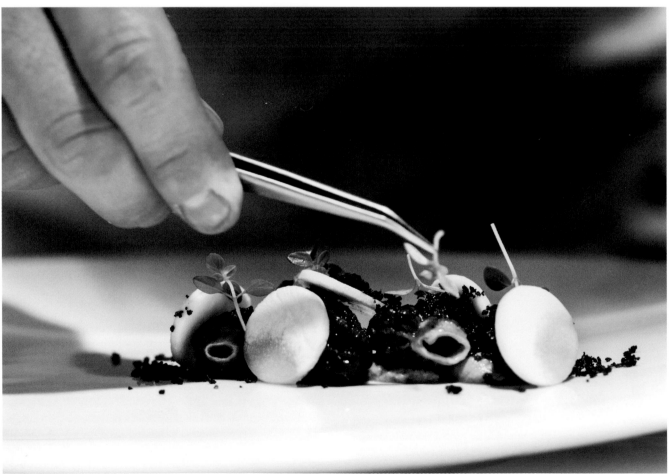

THE FOOD

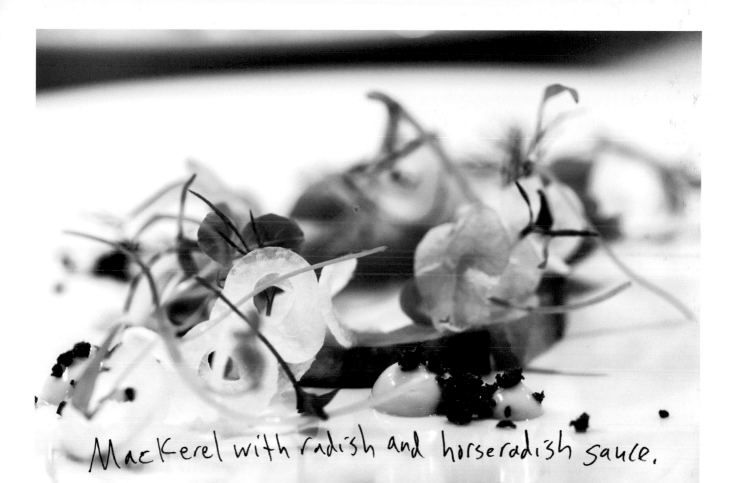

Mackerel with radish and horseradish sauce.

A snack of sour apples with celery confit.

White asparagus, salty cheese, and green strawberries.

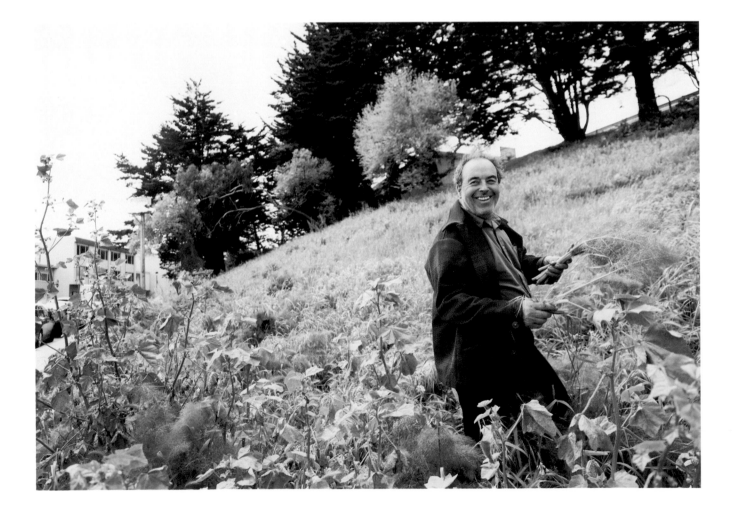

RENAISSANCE FORGE

Angelo Garro's house has the most incredible kitchen I have ever seen. It is a large sprawling space that includes his metal forge, his stainless-steel-drum barbecue pit, and an open space with a large fig tree growing out of it. He makes his own pasta and wine, cures olives, and makes prosciutto from the boars that he hunts in his friend's grape fields. Under the name Renaissance Forge he makes custom hand-forged architectural details as well as beautiful fireplace tools. He is so enthusiastic about making food, it really gets you going, and he makes everything sound so simple and easy to do. His dinner parties are famous in the SF Bay Area; he cooks up whatever he and his friends gather, and everybody comes over and eats at a giant table in the garage area.

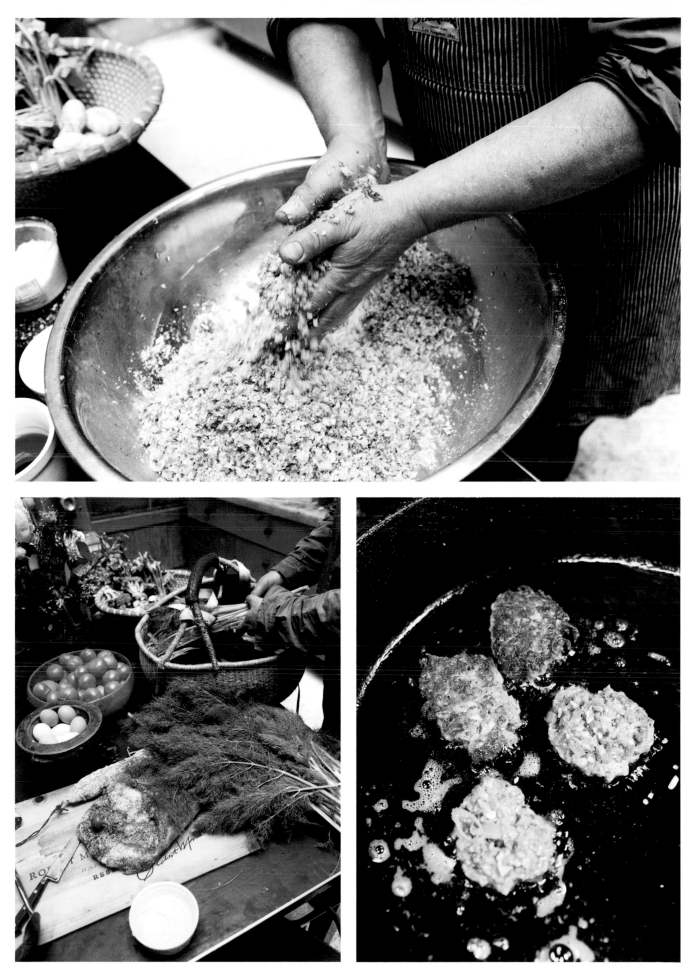

FENNEL FRITTERS

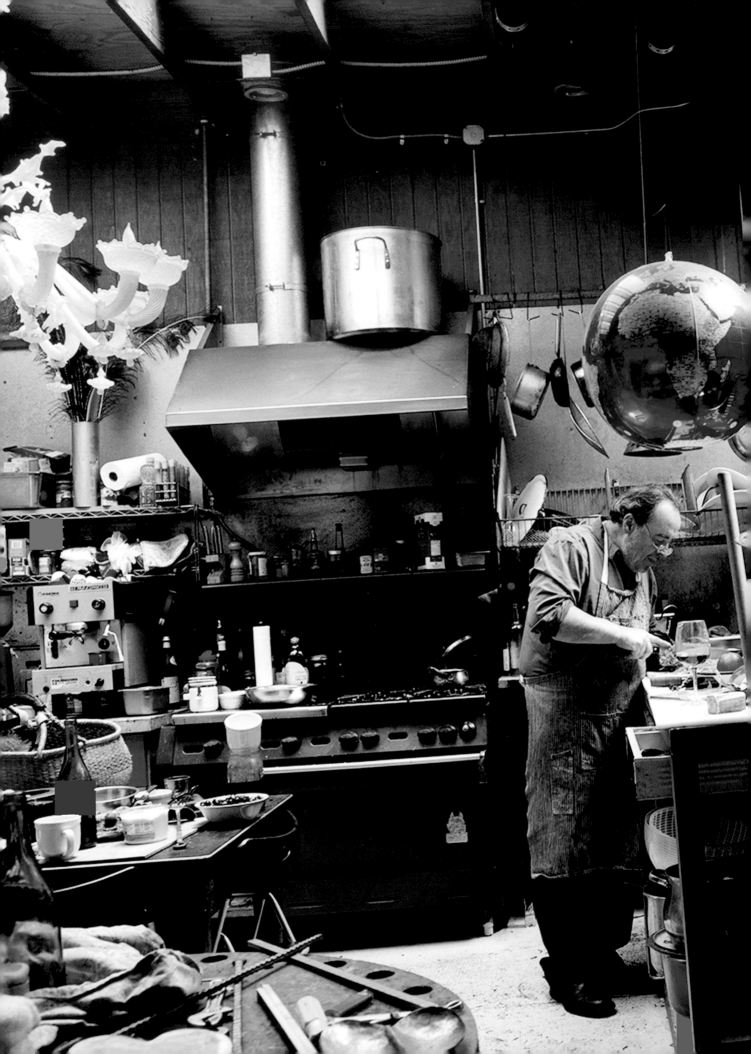

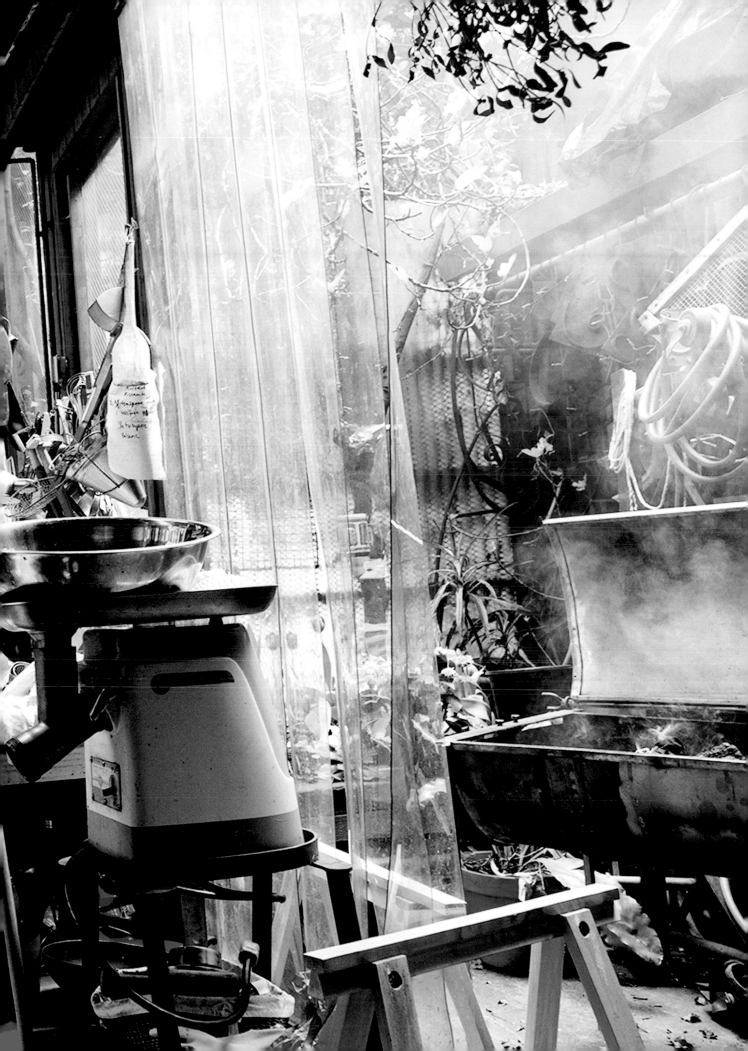

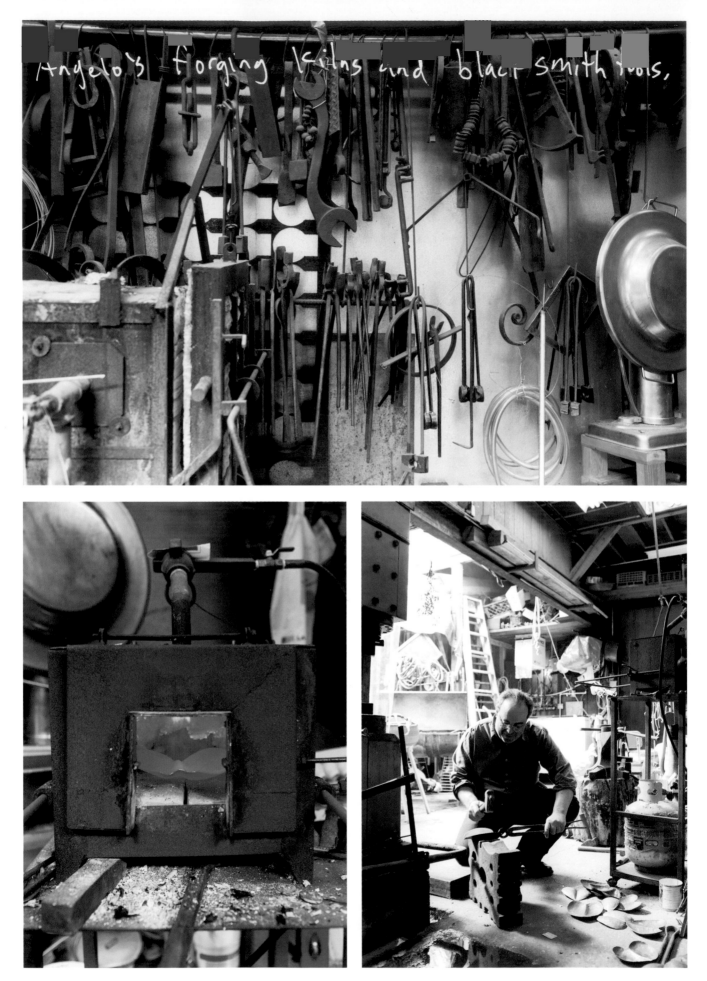

Angelo's forging kilns and black smith tools,

THE FORGE

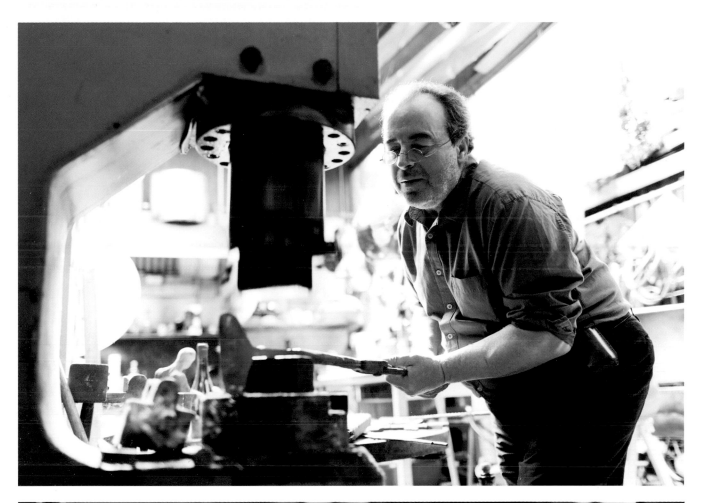

Angelo hand-forges a heart-shaped piece of steel into a mussel-shell shape for the bowls of his egg spoon.

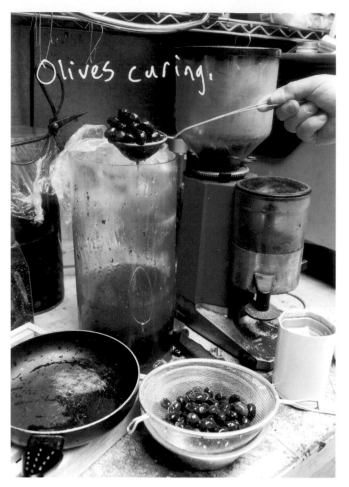

Olives curing.

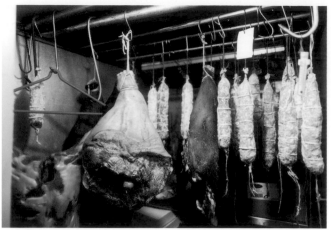

Angelo ages wild boar and pasture-raised pig prosciutto and salami in his home walk-in.

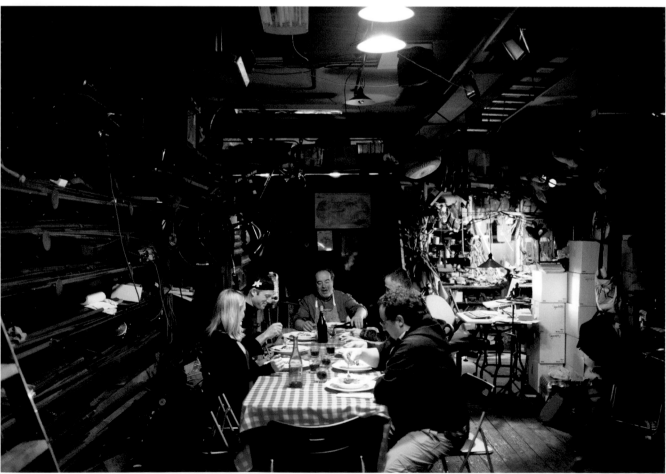

DINNER WITH ANGELO

Hi Angelo! What is the meaning of life?

When you are born, you are irrelevant!
than you spend all your life
to become relevant.
than you Die.

What is the recipe for your fennel cake?

1 Lb fennel wild. Shop it up very fine. Cook for 10 minute in salt water. let it Drain put it in Mixing boll. ad garlic 1 cup parmiggians 1cup Bread crumbs 2 Eggs salt pepper to taste, Mix all up. Make little cake. and Fry in olive oil. they are very good.

Could you draw + label your favorite things to forage for in the Bay Area?

What is the recipe for making olives?

Buy 1 LB Black olive, put it in fresh water for 2 to 3 hours. than Dry well, put it in Fry pan ad orange feel wild fennel seeds ted Dry hot peperoncino Fry to 6 minute than serve

Black olive

Could you draw + label your Kitchen/Forge room?

Counter Stove Counter Window
Sink
Dining table
Fig Tree
Egg Spoon
Wall Forge Kiln
Power Hammer

Boar
Fennel
porcini morels
Ducks Fishing olives

What are 4 ideas you had while hunting?
① New Form for candle stick
② Food recipe
③ meaning of life
④ mesmerized by the Beauty of Nature and off them thinks How Beautiful

What is the best thing you ever ate in Sicily?
Pasta with Sardine

What is the tastiest thing you ever cooked?
Wild Boar
Todd thank you for your visit pleasure to meet you! My friend ate.

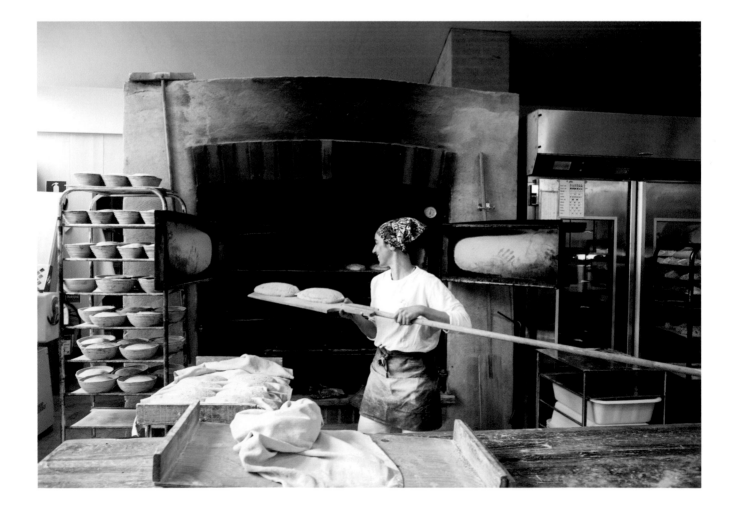

ROSENDALS TRÄDGÅRD

Linnéa Thomsen is one of the bakers at Stockholm's only bakery that uses a wood-fired oven. The wood is burned in the oven in the afternoon, and then everything is baked the next morning in the residual heat. Everything is made from scratch at the bakery at Rosendals Trädgård (Garden), using the highest quality biodynamic and organic ingredients. The bakery is located within a large park, next to a beautiful series of greenhouses that houses a café as well as a plant shop. The garden is open to the public, and all of the profits from the bakery and the greenhouses go toward the running of the garden. Rosendals Trädgård has a special place in my heart, as that's where I first had cardamom rolls, which are even better than the cinnamon buns I grew up eating.

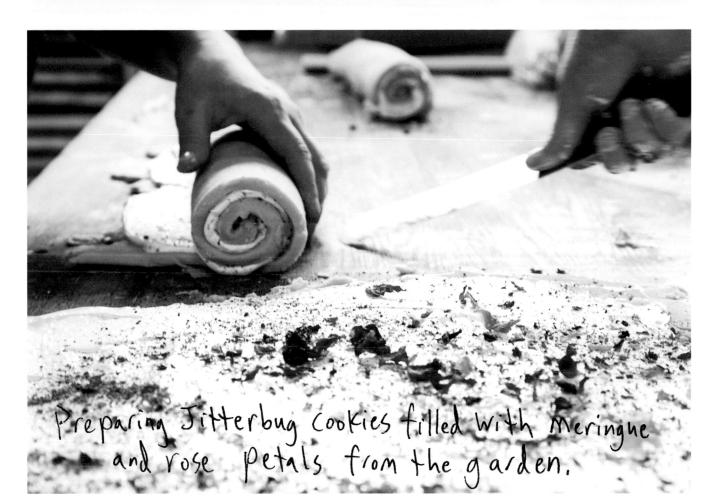

Preparing Jitterbug cookies filled with meringue and rose petals from the garden.

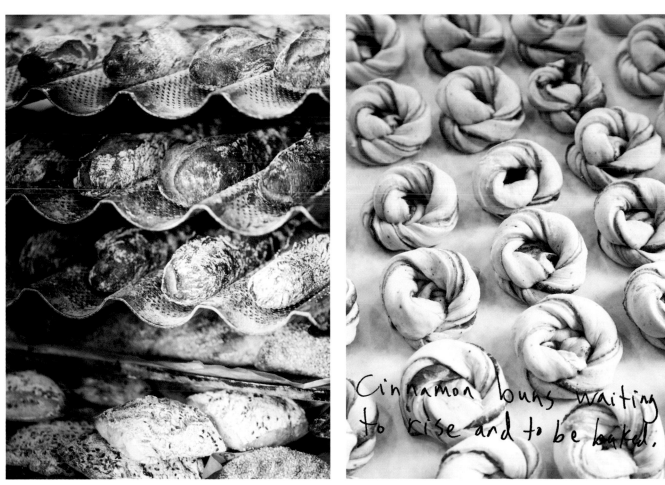

Cinnamon buns waiting to rise and to be baked.

IN THE BAKERY

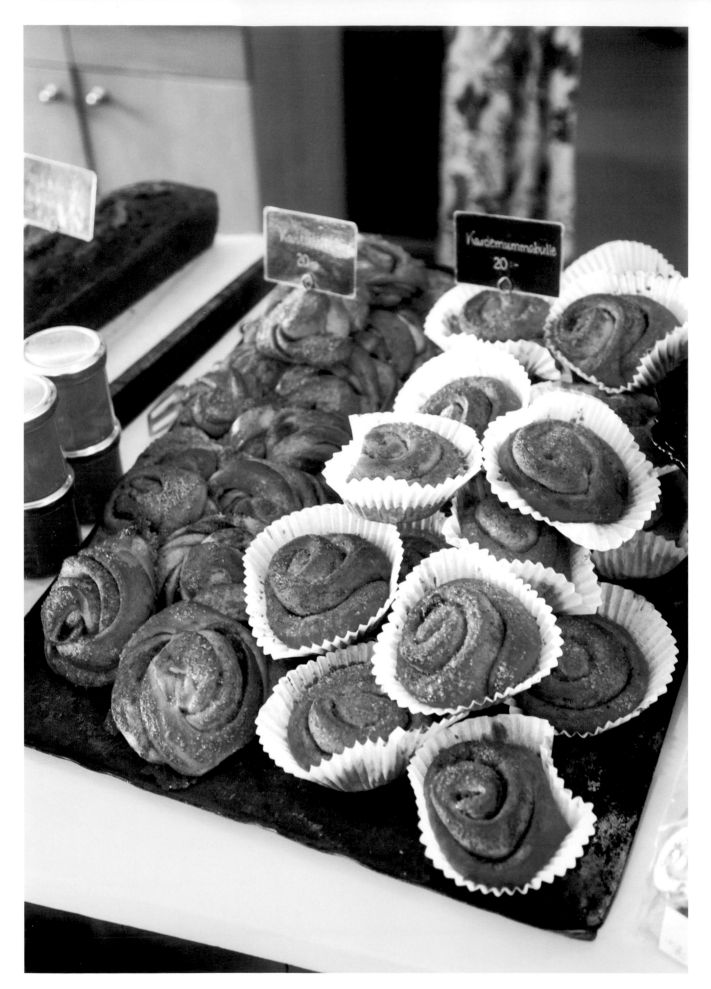

CARDAMOM ROLLS

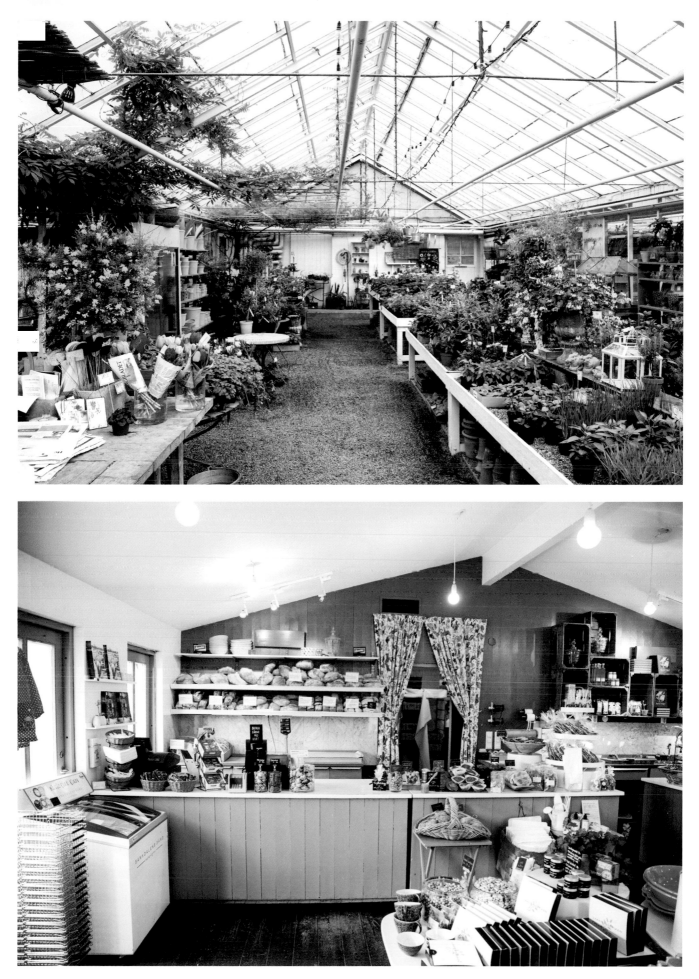

THE GREENHOUSE AND SHOP

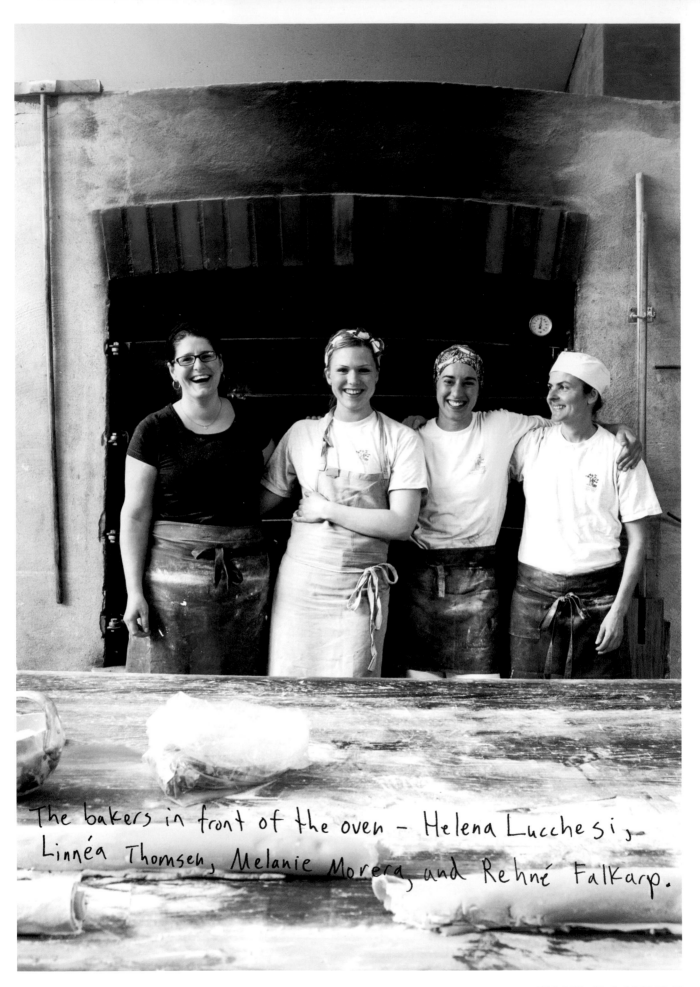

The bakers in front of the oven — Helena Lucchesi, Linnéa Thomsen, Melanie Morera, and Rehné Falkarp.

THE BAKERS

Hi Linnéa! Could I get a recipe for cardamom buns?

Part one:

4 dl milk, 38°C
40 g yeast
415 g wheat flour
→ let it rest for 1 hour

Part two:

415 g wheat flour
160 g sugar
160 g butter
10 g cardamom
5 g salt

temp. oven: 220°C

→ Add following ingredients and mix everything until everything's smooth.
→ Create any shape you'll like and fill it with butter/sugar.

Could you draw + label your favorite things you bake →

Could you draw a map of the area around Rosendals Bageri →

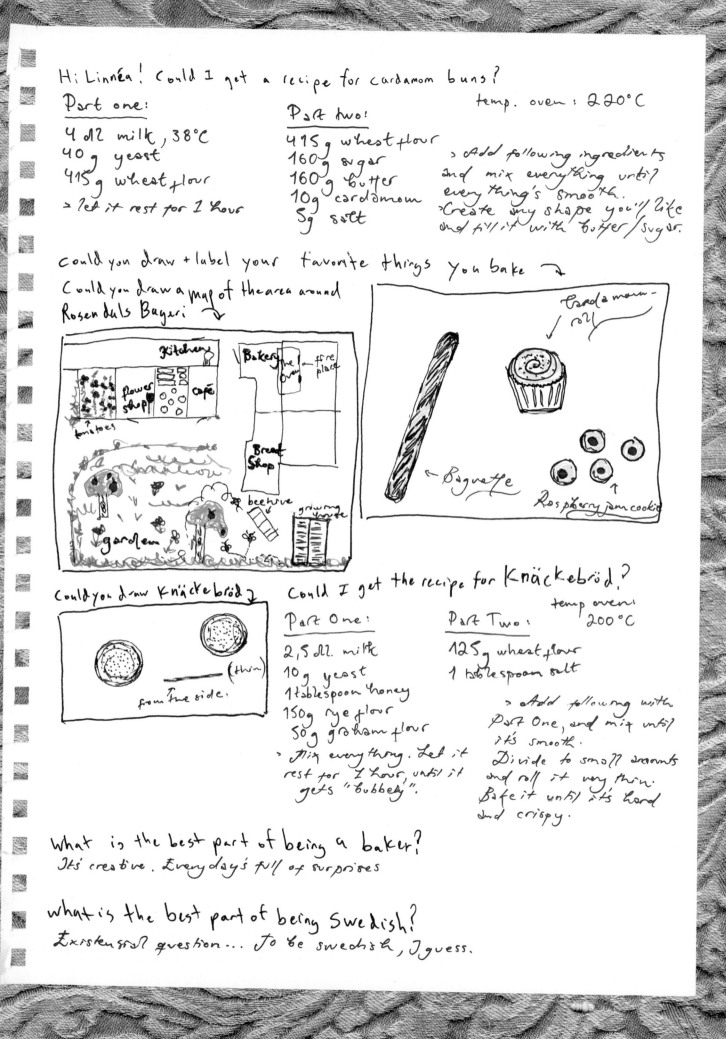

Could you draw Knäckebröd ↓

from the side.
(thin)

Could I get the recipe for Knäckebröd?

Part One:

2,5 dl. milk
10 g yeast
1 tablespoon honey
150 g rye flour
50 g graham flour
→ Mix everything. Let it rest for 1 hour, until it gets "bubbely".

Part Two:

125 g wheat flour
1 tablespoon salt

temp oven: 200°C

→ Add following with Part One, and mix until it's smooth.
Divide to small amounts and roll it very thin. Bake it until it's hard and crispy.

What is the best part of being a baker?
It's creative. Everyday's full of surprises

What is the best part of being Swedish?
Existensiel question... To be swedish, I guess.

TATEMICHIYA

Yoshiyuki Okada-san used to manage someone else's izakaya (a Japanese bar with food) until he got sick of it and decided to start up a punk rock izakaya to call his own. Okada-san takes equal pride in the simple but delicious food he serves and in his collection of vintage punk rock posters and flyers that decorate the walls. The sake bottles that line the bar and the cabinets in the wall all belong to Tatemichiya's patrons.

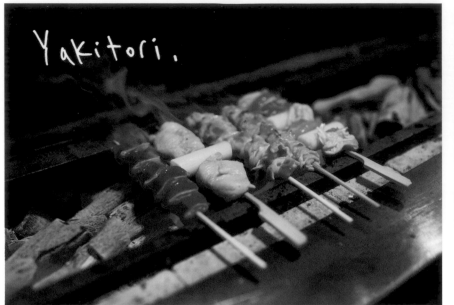

Yakitori.

what are the 4 most fun things to do in Tokyo?

① 日帰り温泉. Day trip to hot spring spa.　③ 酒. Sake.

② レコードショップめぐり Record shop tour.　④ パチンコ. Pachinko.

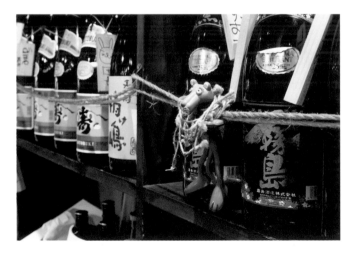

Customers' bottles with their names on wooden tags.

Five kinds of dried seafood ready for customers to grill. They are very chewy, so be careful if you have any false teeth. ⟶

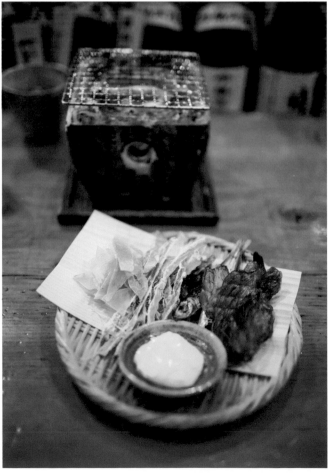

THE FOOD

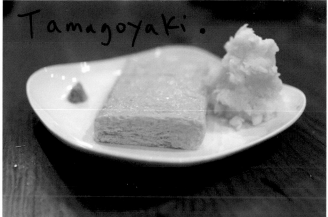

Tamagoyaki.

what does punk mean to you?

生き様. A way of life.

Deep-fried octopus balls.

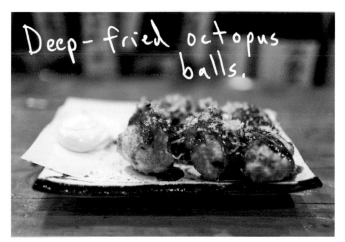

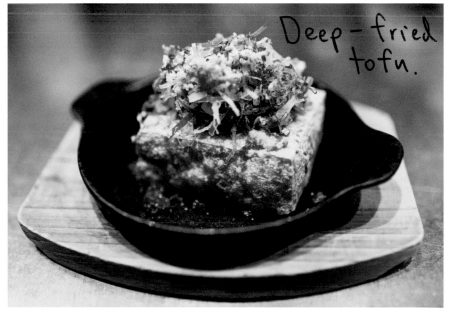

Deep-fried tofu.

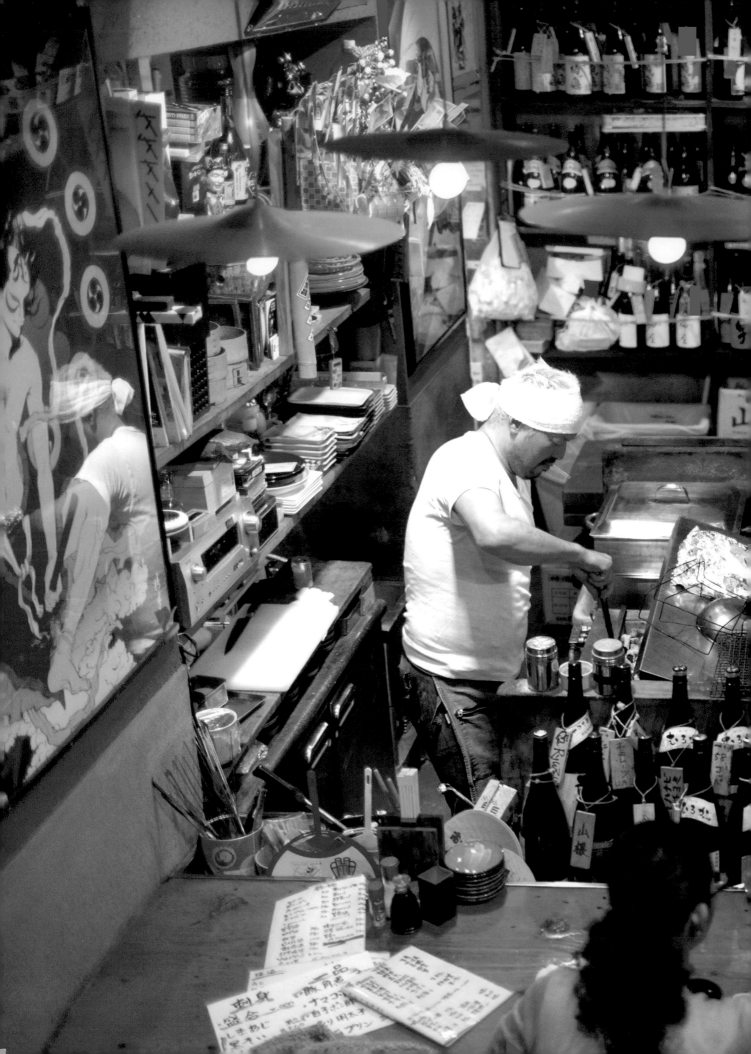

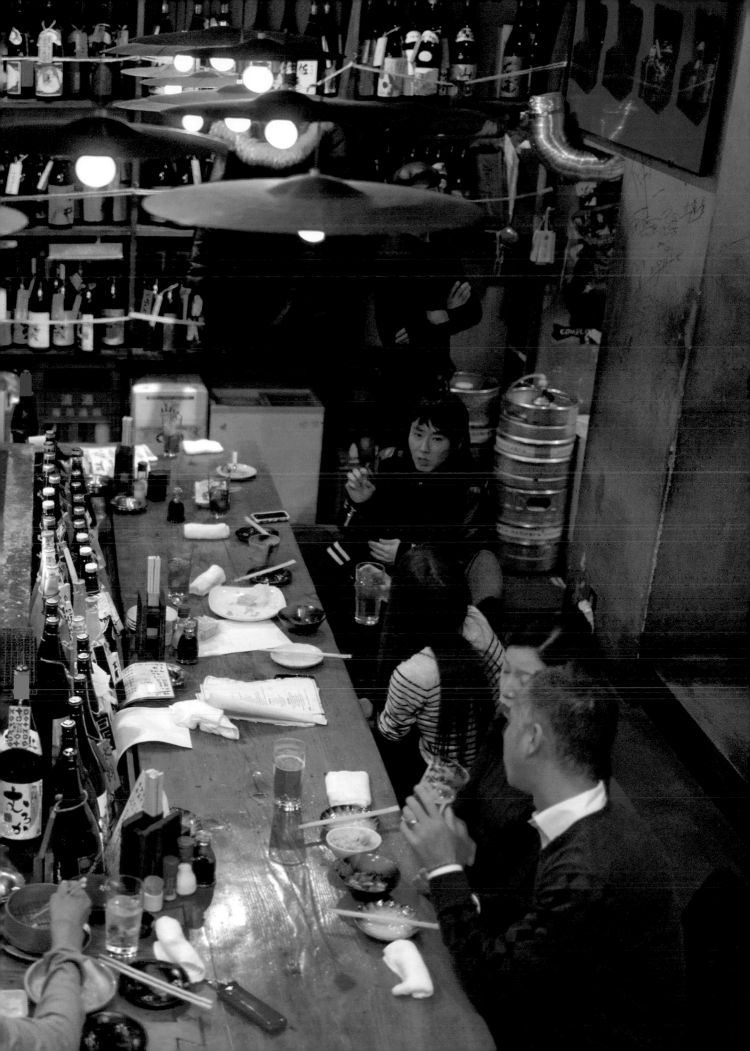

ST. JOHN AND ROCHELLE CANTEEN

Fergus and Margot Henderson are famous for being champions of nose to tail eating, but to me they are best known for teaching me about lunch. Fergus told me about "elevenses," which is like afternoon tea but you eat it at 11 in the morning. If you stop by St. JOHN at 11 a.m., you can join Fergus for a seedcake and a glass of Madeira. He also pointed out that if you get tipsy and pig out at dinner, you are for sure going to pass out. But if you do that at lunchtime, who knows where the rest of your day is going to go. Margot has her own unique style of simple, flavorful food that she prepares at her lunch-only restaurant, Rochelle Canteen. I love the matter-of-fact way she cooks and plates her dishes.

"Salt Cod and Potato Bake, the first dish I cooked for Fergus. We had just met and love was in the air. It's a Portuguese dish made of salt cod, potato, garlic, onions, bay leaves, and olive oil." —Margot

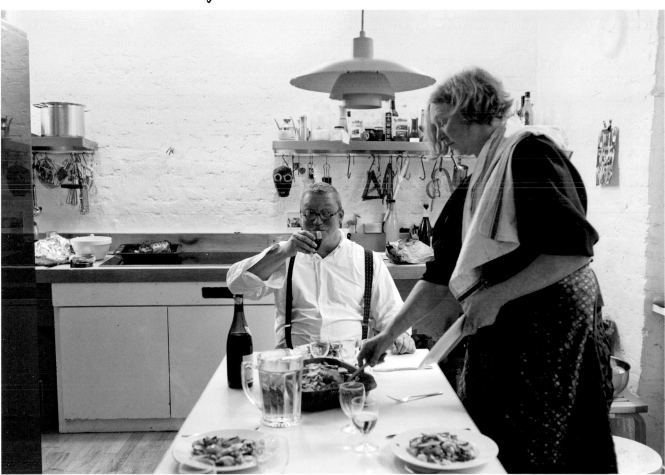

LUNCH AT HOME

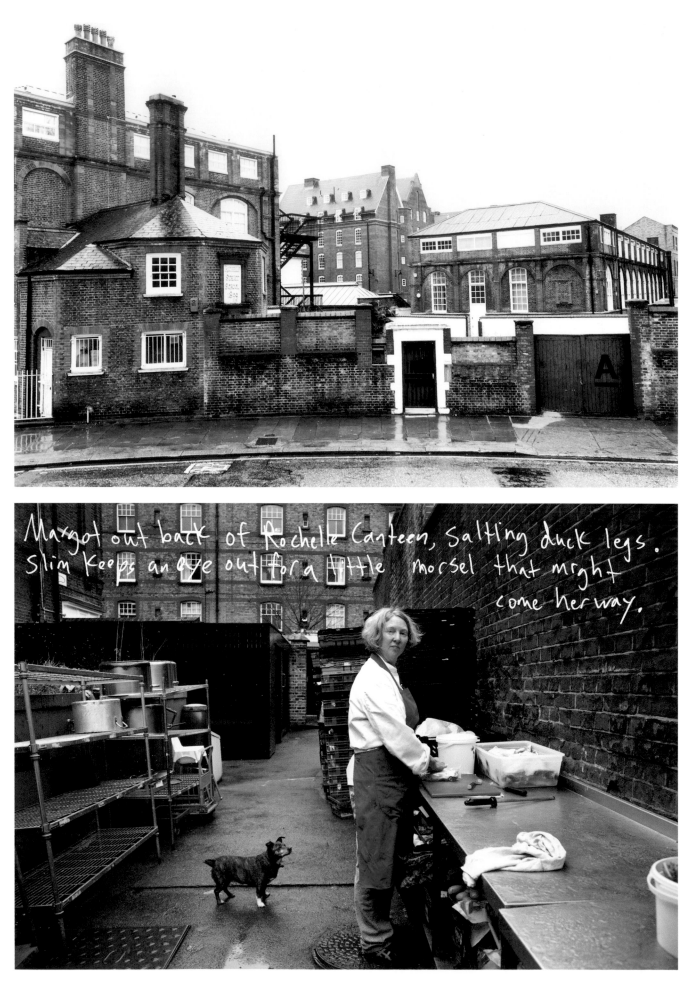

Margot out back of Rochelle Canteen, salting duck legs. Slim keeps an eye out for a little morsel that might come her way.

ROCHELLE CANTEEN

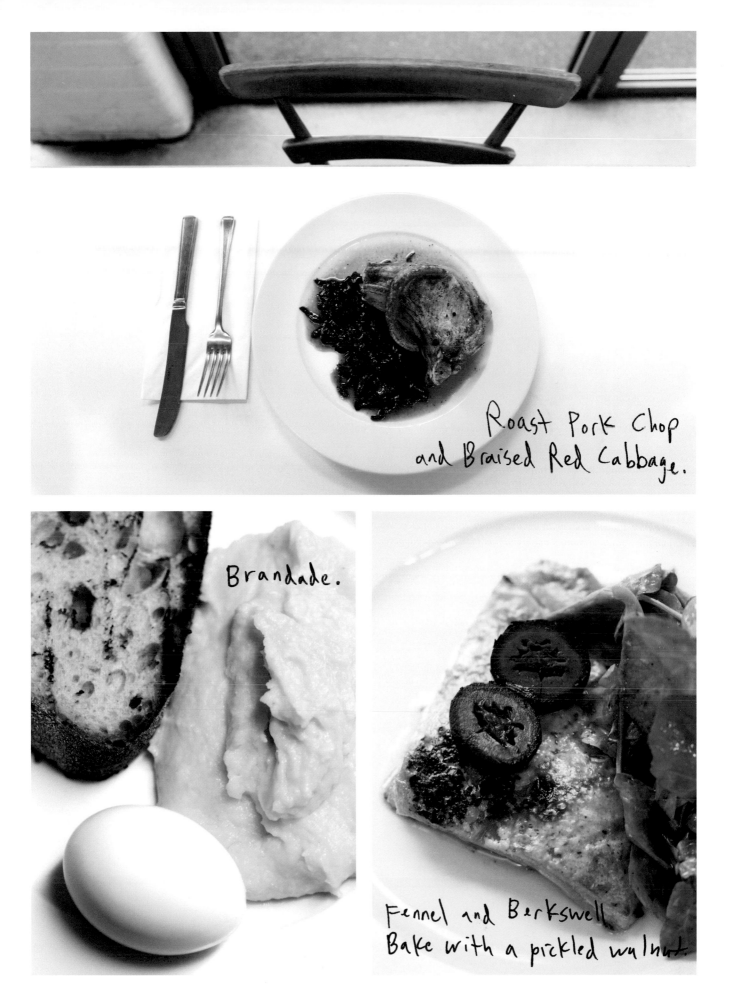

Roast Pork Chop
and Braised Red Cabbage.

Brandade.

Fennel and Berkswell
Bake with a pickled walnut.

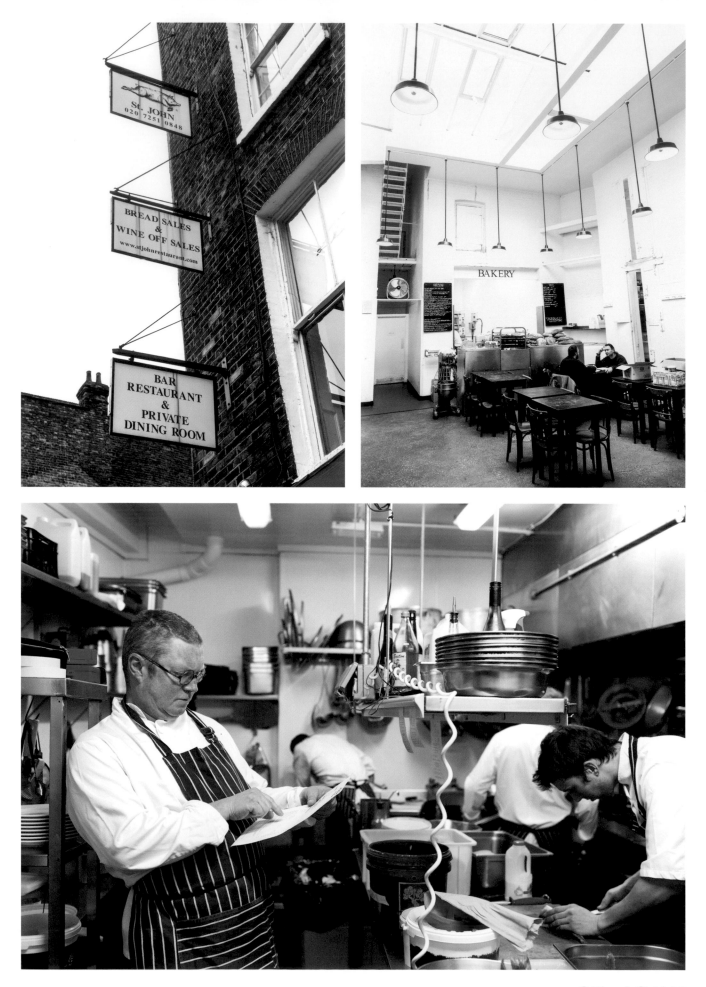

ST. JOHN

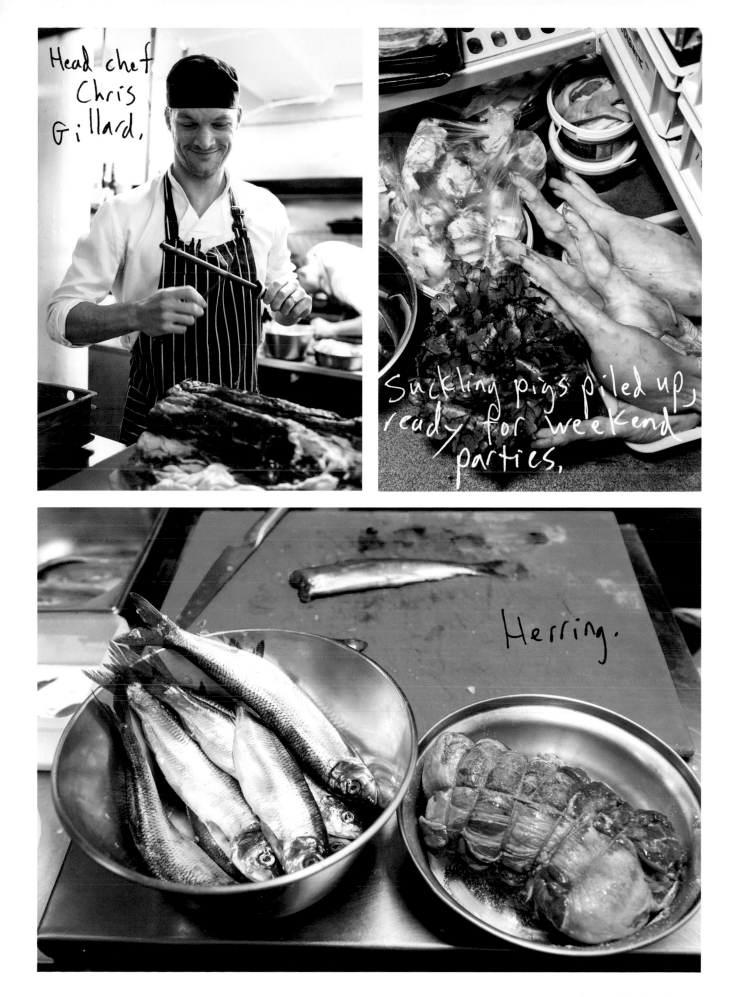

Head chef Chris Gillard.

Suckling pigs piled up, ready for weekend parties.

Herring.

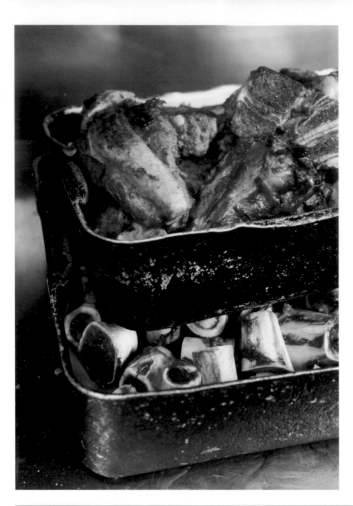

Fergus's 4 favorite ingredients

KIDNEY

BURGUNDY

PARSLEY

DUCK FAT

Seedcake and Madeira for elevenses. ⟶

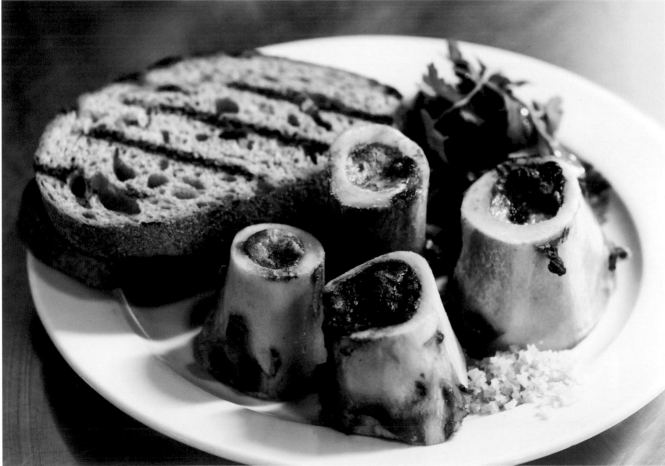

ROAST BONE MARROW

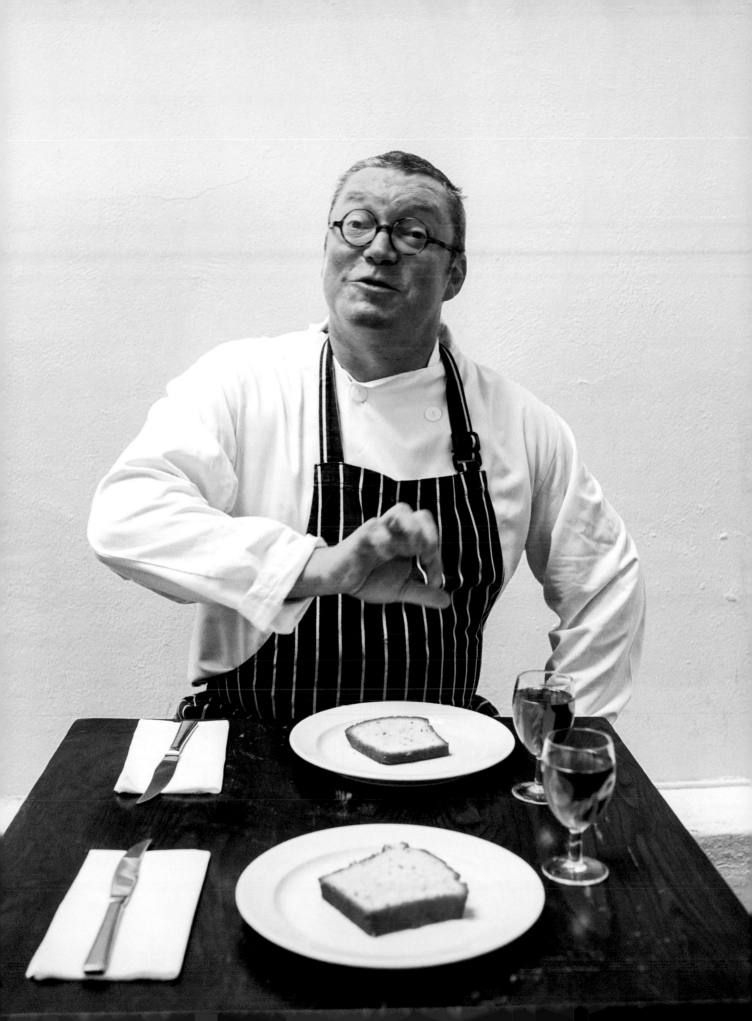

CAKE MAN RAVEN

Cake Man Raven (Patrick De'Sean Dennis III) is the third Raven in his family, after his dad and grandpa. Cake Man has been baking since he was a little kid. Back then he was known as Cake Boy and won his first baking competition at age 13. Cake Man is known for his cream cheese and crushed-pecan frosted red velvet cake and for making cakes in very unique shapes. He has made them in the shape of the Brooklyn Bridge, the Bible (for Al Sharpton), and an Adidas shoe in tribute to Jam Master Jay.

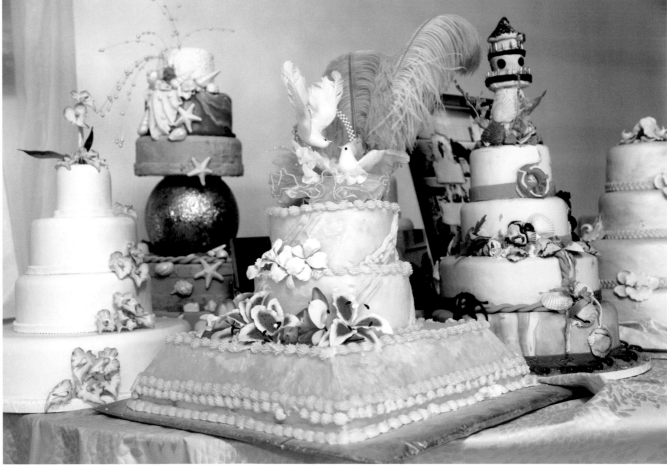

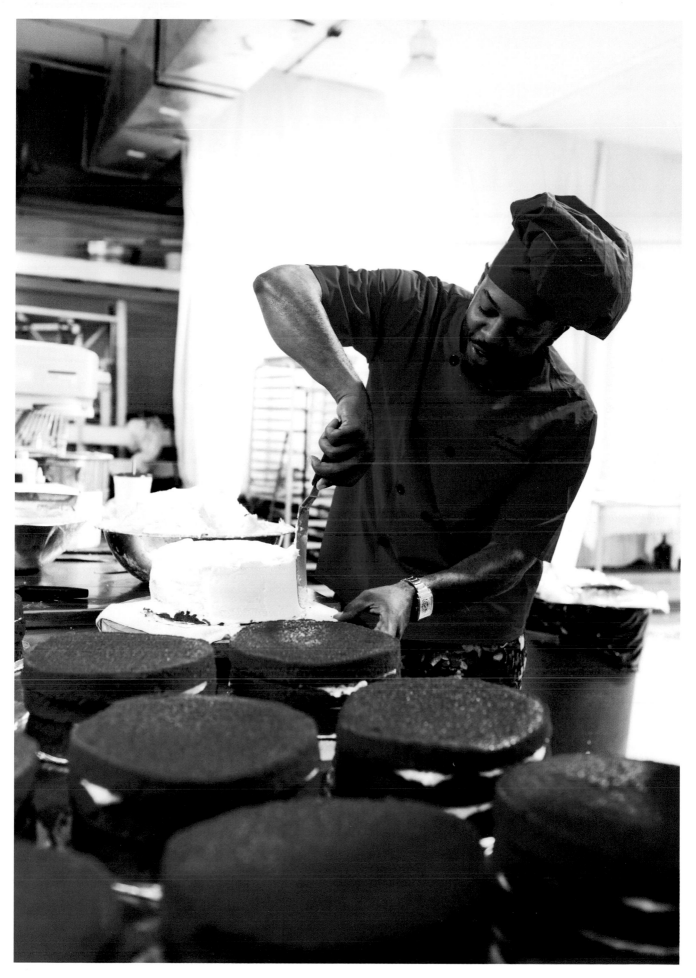

RED VELVET CAKE

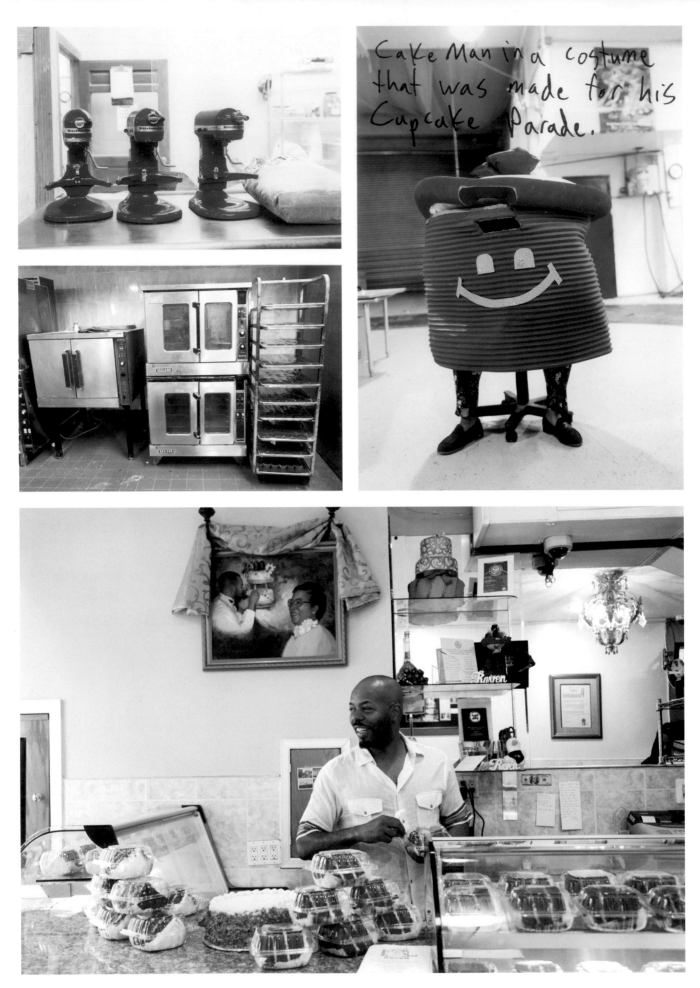

Cake Man in a costume that was made for his Cupcake Parade.

CAKEVILLE, USA

Cake Man could I get your recipe for a basic scratch cake?

1½ sticks of butter
1 cup sugar
3 eggs
¾ cup of milk
1¾ of Flour self rising
1 teaspoon of Vanilla

Cream the ingredients
add 1 egg @ a time, the flour
slowly & the extract.
(main method)

1 teaspoon of Lemon

(2 layers yield)
25 min.
Baking time

HANSEN & LYDERSEN

Hansen & Lydersen was started in 1923 in Kirkenes, Norway, by Ole Hansen's great-grandfather Lyder-Nilsen Lydersen. The original smoked salmon recipe was lost over time, but Ole has attempted to re-create Lyder-Nilsen's method and teach himself salmon smoking through a long process of trial and error. Ole has no formal training; before he started smoking salmon he was a sound artist. He views his work as an "exercise in endurance, keeping true to an artisan's very narrow field." Everything in Ole's production process has been stripped back to its simplest and purest components: fish and smoke. He uses two kinds of wood for the fire and a fan to gently move the fish as they are smoked, and finishes them off with a simple twine-and-waxed-paper packaging.

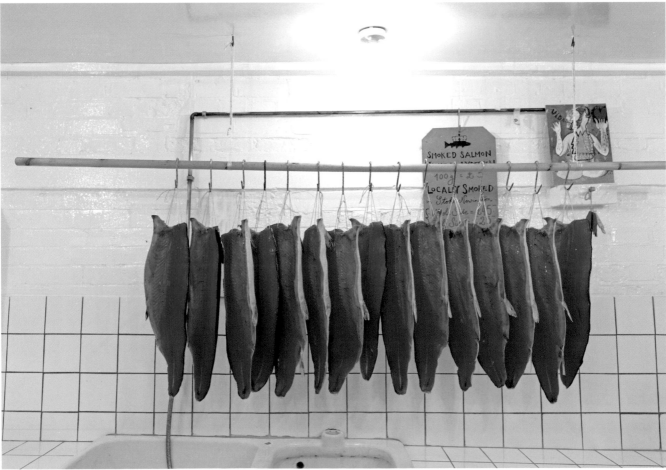

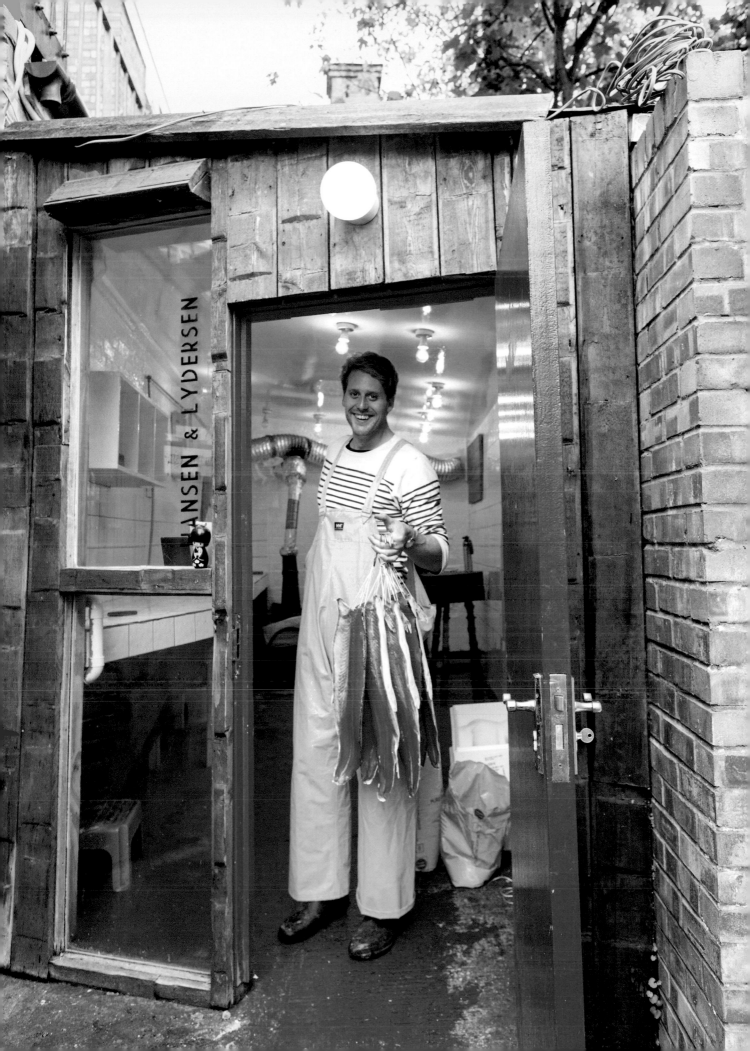

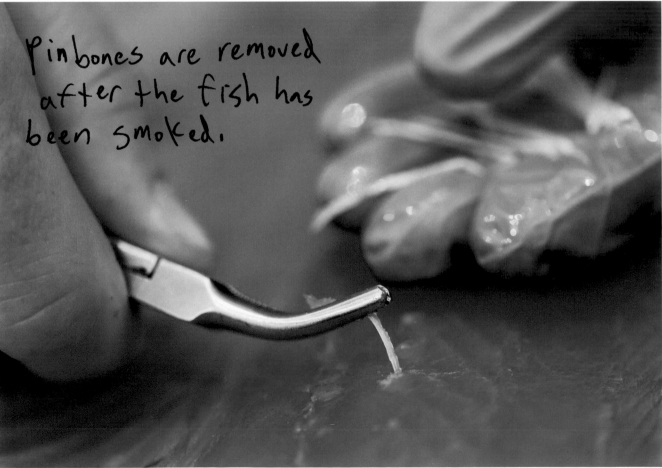

Pinbones are removed after the fish has been smoked.

SMOKING SALMON

HANSEN & LYDERSEN
FOUNDED 1923 ✚ KIRKENES NORWAY

Beech

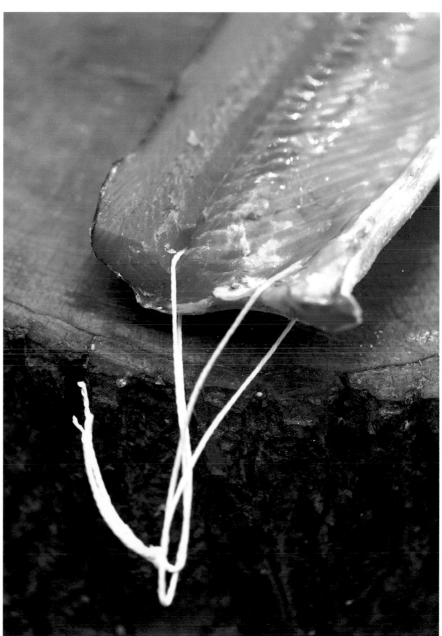

Ole smokes the fish for 12 hours, using a mix of 70 percent beech wood and 30 percent juniper wood.

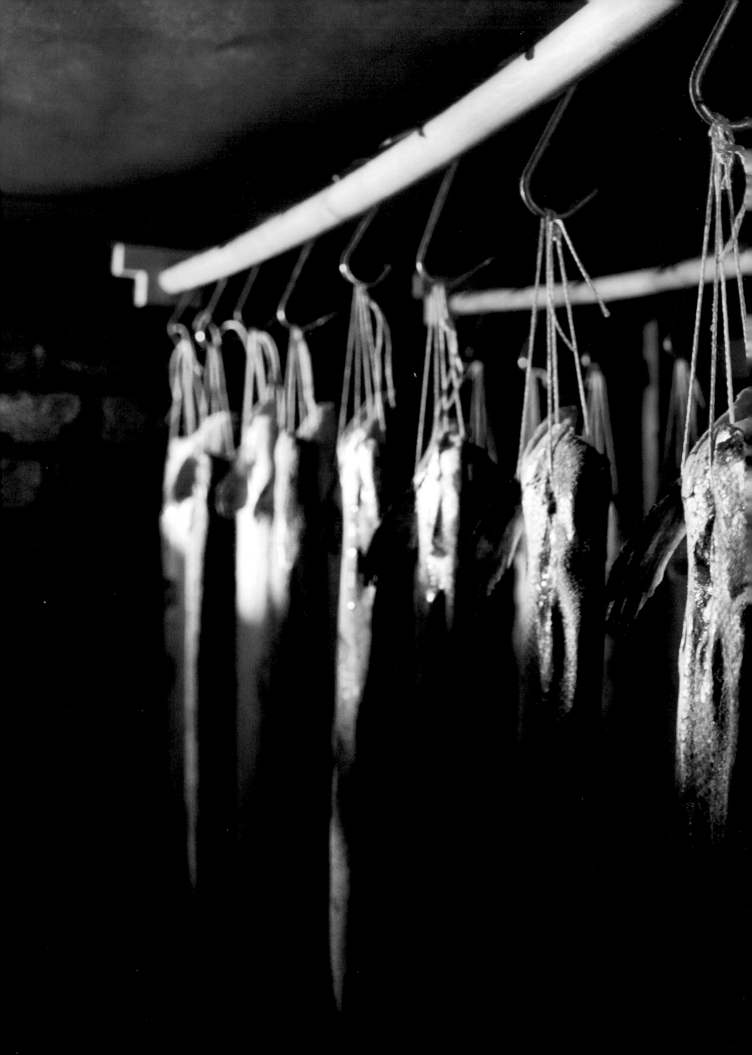

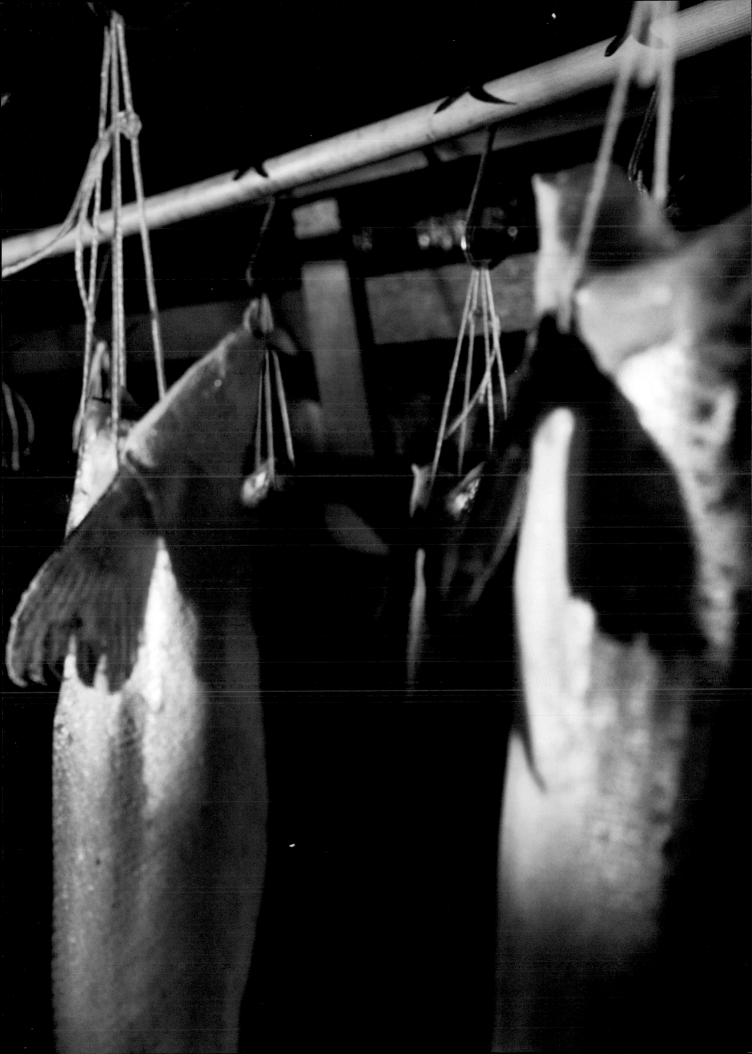

Tapas with smoked salmon, crème frâiche, and a branch of dill on sourdough.

£1·50
Per Piece

BROADWAY MARKET

Hi Ole! What did you learn from your grandfather about smoking salmon?

INTEGRITY & HONESTY — in sourcing the best raw materials, never compromising and focus on one PRODUCT

could you draw + label a map of your smokery

Could I get the recipe for salmon tartare?

200 grams of belly (fatty)

+ HANDFULL OF GOOSE BERRIES CUT IN 4.

+ SPOON OF CITY HONEY

+ Peels of LIME (GRATED) + A SQUEEZE

= MIX ALL TOGETHER AND SERVE IN a small glass

FLOOR PLAN — PIES — filleting area — sink — 10m — packing — SMOKE INLET — smoking chamber — STORAGE

SMOKING KILN — HANGING SALMON — FAN — SMOKE FLOW LOOPE — FRESH AIR IN / EXHUST OUT

what do you use for fuel to smoke your salmon?

70% & 30% JUNIPER + BEECHWOOD
↘ POETRY OF FOREST

→ sweet and mild
→ VERY SIMPEL SKANDINAVIAN

How does your work now relate to when you were a sound artist?

I get to imerse myself in sounds of the city delivering salmon on my scooter, sounds of the fans, the propane burners, birds in the morning. Since I am just doing one thing I get to explore deep into one process which to me is what I would do as an artist

Could I get some recipes for good things to do with your salmon?

— Belly of smoked salmon, one spoon honey! Red Currants or Black currants

— good 300g whole piece seared for 15 sec. on high heat — serve with a little dash of cream fresh

— simple on rye bread — w/ crem fraish — leave with pickeld lemons overnight to soke in flavours.

what is special about salmon?

It's an amazing fish — travels far to make love to other salmon in the artic, comes back to the same river, struggles up the stream, a real fighter.

[+++ it taste AMAZING]

LE CHATEAUBRIAND

Le Chateaubriand is a small, classic, understated-looking bistro that has become super influential under the guidance of its chef, Inaki Aizpitarte. Everything about the place and the food is restrained, stripped back, and "simplified." Accordingly, there is no à la carte dining at the restaurant; the only choice is what to drink with your reasonably priced five-course set menu. This simplification frees up the tiny kitchen to prepare creative, challenging, surprising, and delicious food.

"I always try to hitchhike from my balcony but it never works."

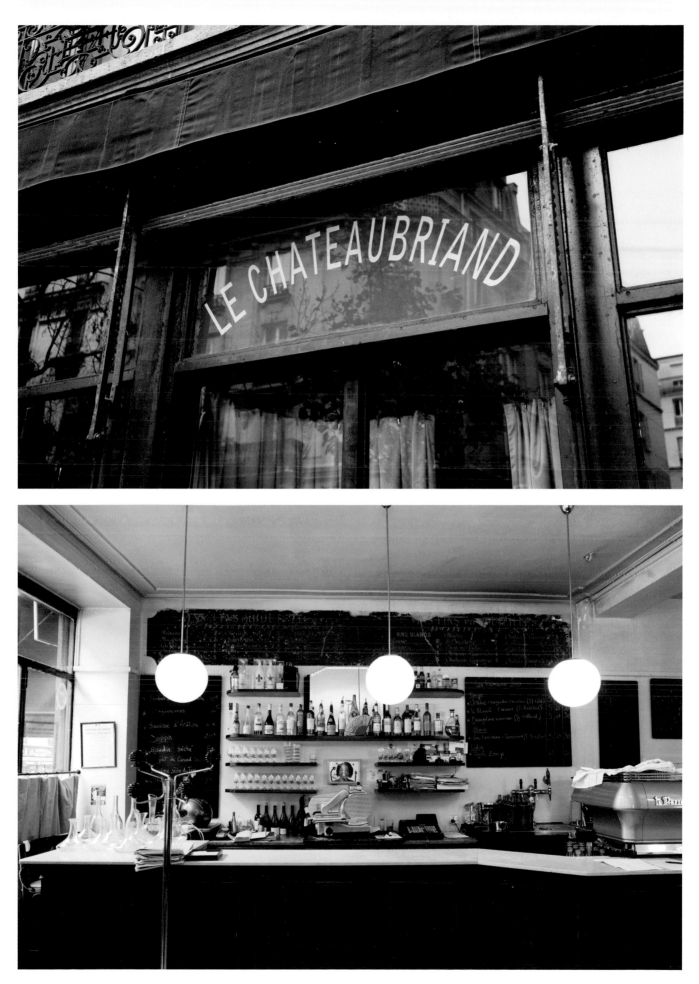

THE BISTRO

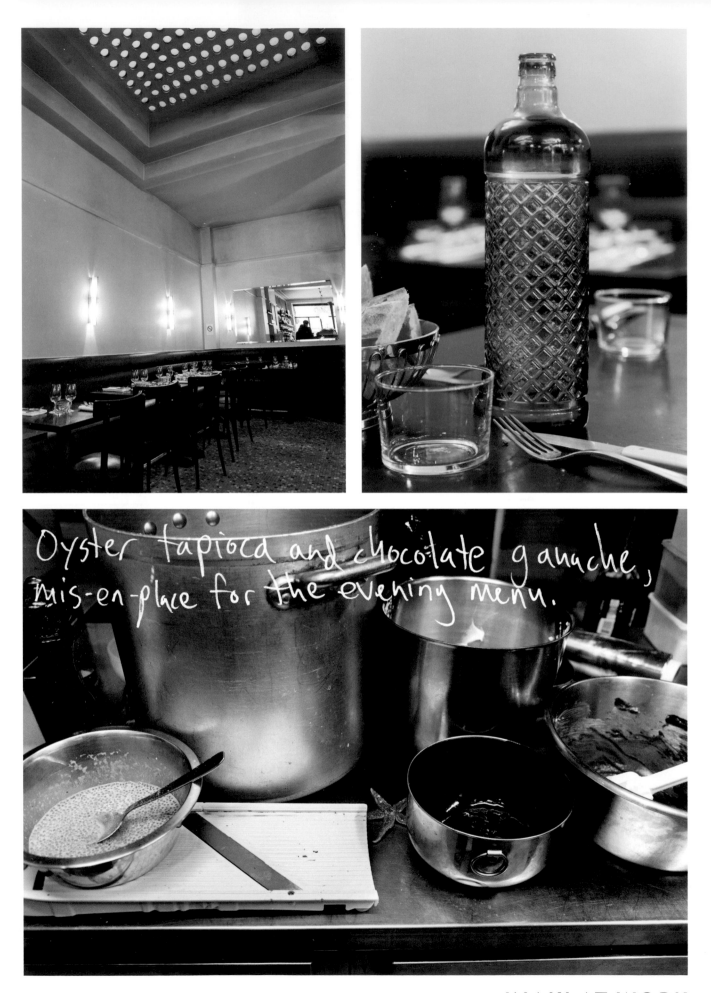

Oyster, tapioca and chocolate ganache, mis-en-place for the evening menu.

INAKI AT WORK

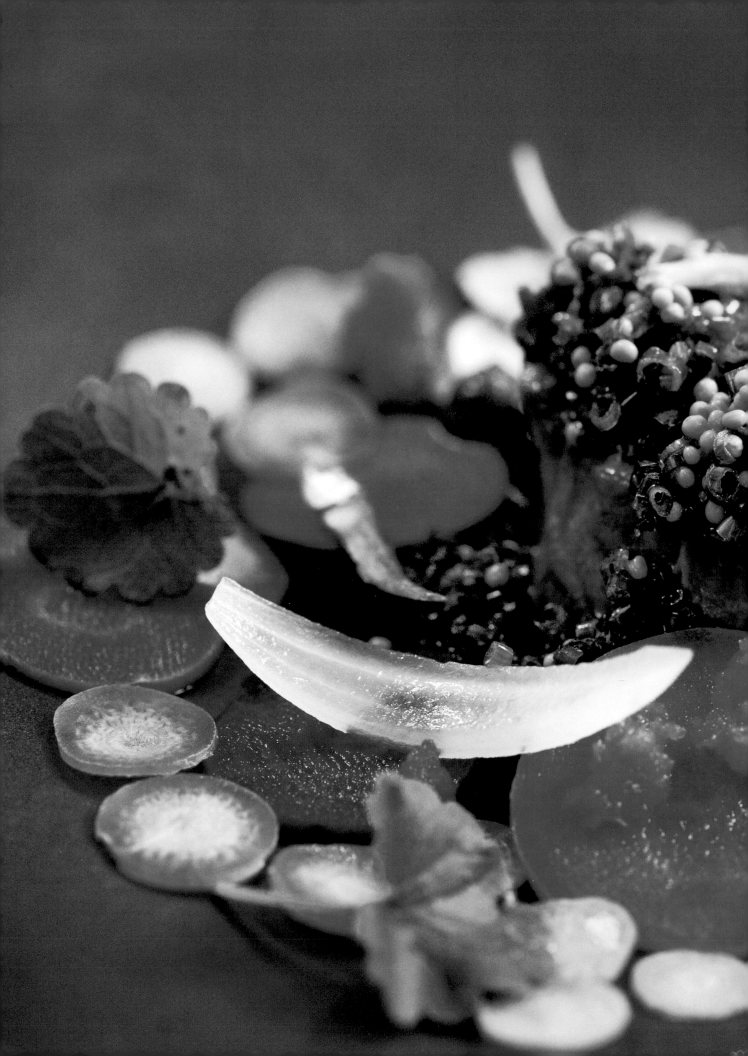

Beef, pickled vegetables, chives, brown butter, and crunchy anchovies.

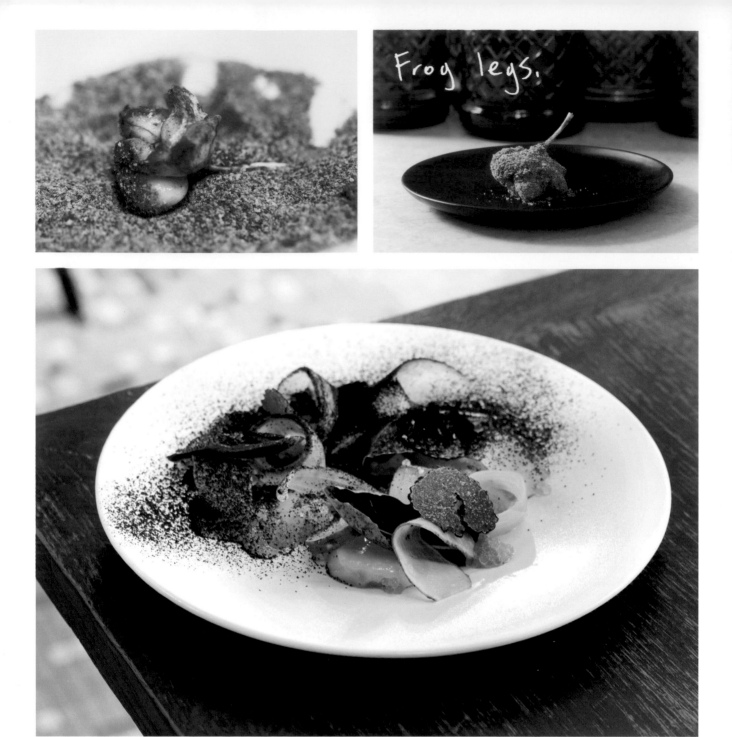

Frog legs.

Scallops, root vegetables,
mushrooms, and black
truffles.

THE FOOD

Hi Inaki!. what is the most fun you have ever had in the kitchen?
The Most ENJOYABLE TIME I've had whithin the kitchen has been watching
when the clients looking for the toilets in front of the kitchen end up in
the walk refrigerator.

How has Paris changed for you in the past 5 years?
☮ Wow, it seems, in Paris that there are cops on every street corner. Ⓐ

Could I have a Chateaubriand inspired recipe to do at home?
chocolate cream whith Espelette Pepper and Red pepper Jelly

1 l cream
408 g chocolate 70% SIMMER CREAM & espelette → Strain → pour onto the chocolate → leave it for
1,5 g Espelette 5 mn → mix → pour into the pots → frige
 juice SOME Red pepper → STRAIN → 16g gélatine / l → pour 2mm on the
 the top of the pots after 1ʰh.

could you draw the end result of this recipe ↝

what is important about food?
THELOVEOFTASTE as welle
 THETASTE of love ♡

what are your 4 favorite cookbooks?
① "CLORFILA" ③ THE ACIDIC COOKING OF
 ADRVITZ MICHEL TROISGROIS
② MICHEL BRAS ④ ENCYCLOPEDIA OF
 BOOK INGREDIENTS

what are your 4 favorite ingredients right now?

 X VENISON X TRUFFLE

 X RADISH X FROG LEGS

M. WELLS

Husband-and-wife team Hugue Dufour and Sarah Obraitis ran the quirky M. Wells in Long Island City, Queens, for a little over a year. I would describe the food at M. Wells as gourmet Canadian-American diner fare with a bit of a Russian and Korean vibe. Basically, the place and the food were a lot of fun. The restaurant was based out of an old chrome diner on a pretty bleak corner next to the train tracks. M. Wells temporarily closed in 2011, and hopefully by the time you read this it has reopened elsewhere in New York City.

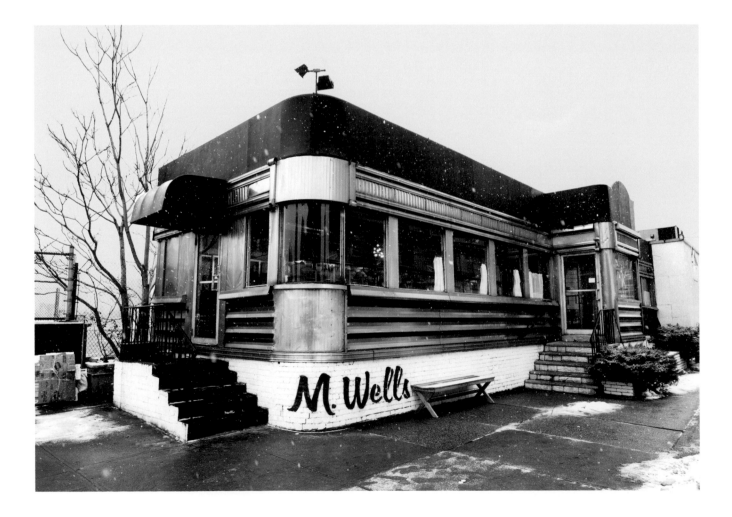

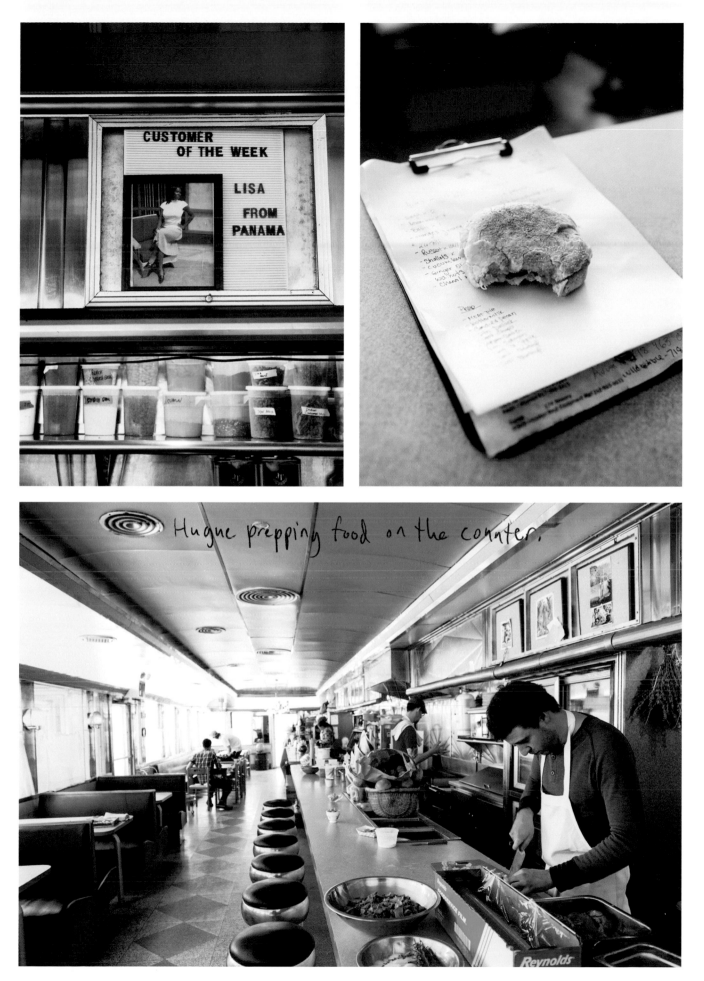

Hugue prepping food on the counter.

THE DINER

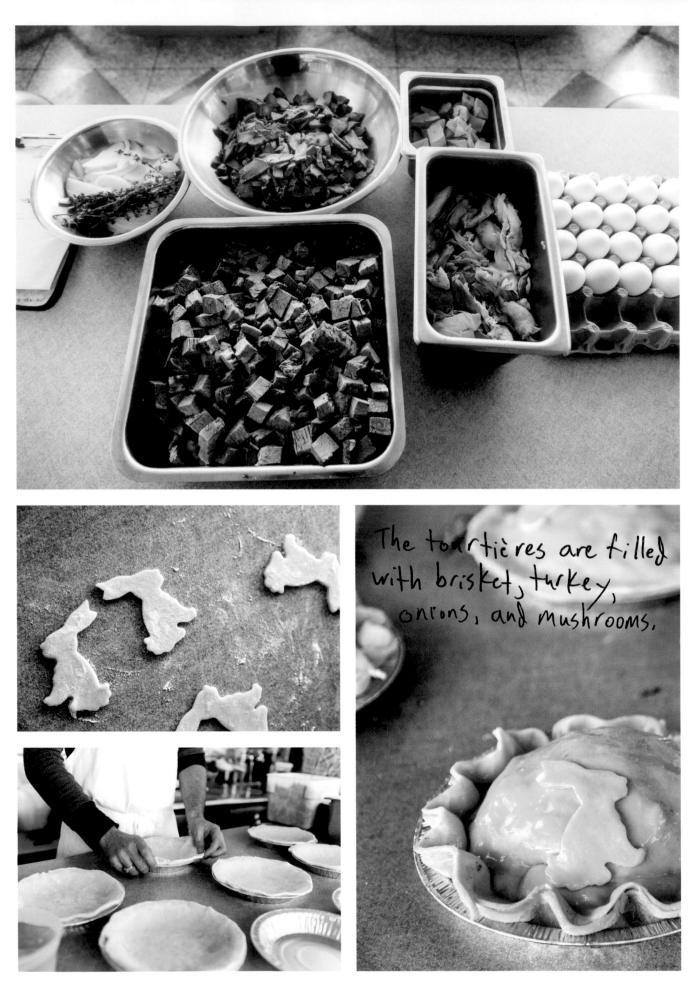

The tourtières are filled with brisket, turkey, onions, and mushrooms.

THE FOOD

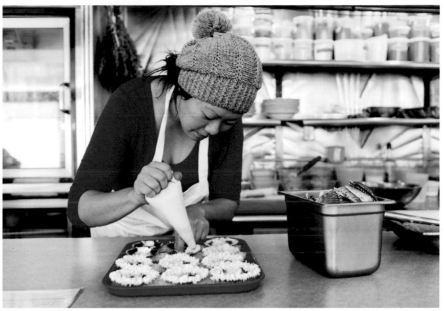

Caroline Hahm piping a potato duchess around a seashell for Coquille St. Jacques.

The start of the cranberry Ketchup. It comes with each slice of meat pie. It is made with cranberries, onions, garlic, cloves, and other spices, →

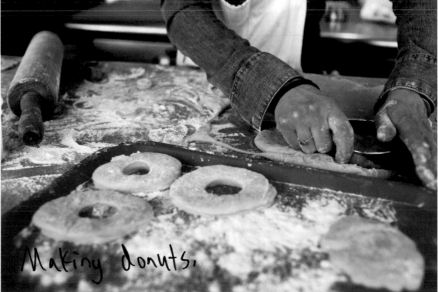

Making donuts.

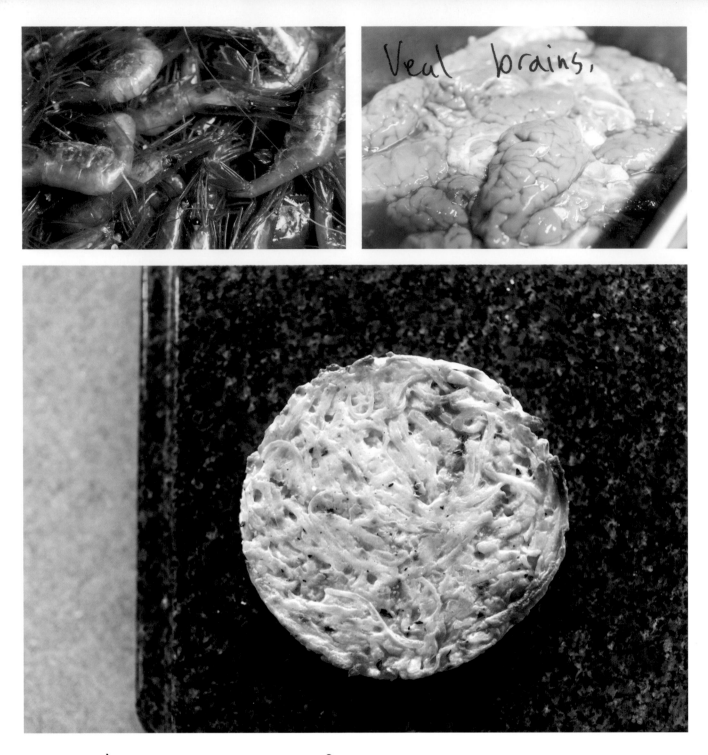

Veal brains,

Hugue how do I make shrimp + brain tortillas?

#1 overboil a few potaToes

#2 crush potaToes add a lot of olive oil and 1 diced oignon cooked down

add 2 beaten eggs To the potaToes mix

#3 poache 3 calf brain, cut it into slices

Peel #2 main shrimps mix everyThing and cook it in castIron pan and Tigido

TORTILLA ESPAÑOLA WITH VEAL BRAINS

"Hugue had this in Spain. He stayed with a lady who wanted her kids to eat brains, but they balked so she'd hide it in the tortilla." -Sarah

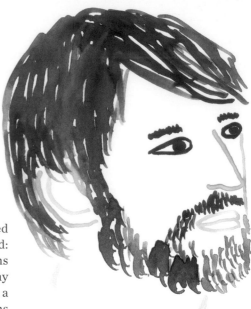

NOMA

I walked into Noma thinking I knew what would happen—perfectly executed Scandinavian food. Luckily, the meal was so much more than what I expected: surprising to the point of being philosophical and challenging my assumptions on fine dining. A cook emerged once I'd sat down and said there weren't any waiters, that the chefs serve and describe the dishes directly. He added with a half smile that the first dish lay before me, and I looked again at the only items on the table: my knife, napkin—and the flower in a white vase. The flower was filled with delicious snails, its twigs thin pieces of rye bread. The next course was one of the most intense I've ever eaten: a beautiful, clear shrimp I took from an ice-filled container the chef brought out. When I dipped it in sauce, the creature woke up and started biting. Seized with a fight-or-flight response, I popped it into my mouth and swallowed. What makes Noma singularly unique is chef René Redzepi's ability to merge these quandaries, tricks, and jokes into the confines of haute cuisine.

Flowerpot with Nasturtiums, snails and edible branches made of malt dough, spruce spice, and juniper berry spice. ←

Hay Dessert, made with strawberries, hay cream, hay parfait, herbs, and chamomile broth. →

Egg Tableside, with herbs, thyme butter, spinach, ramson sauce, hay oil, and potato chips. →

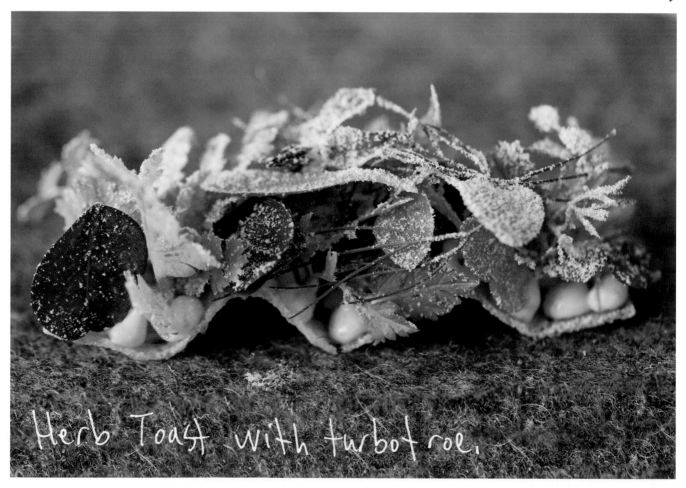

Herb Toast with turbot roe.

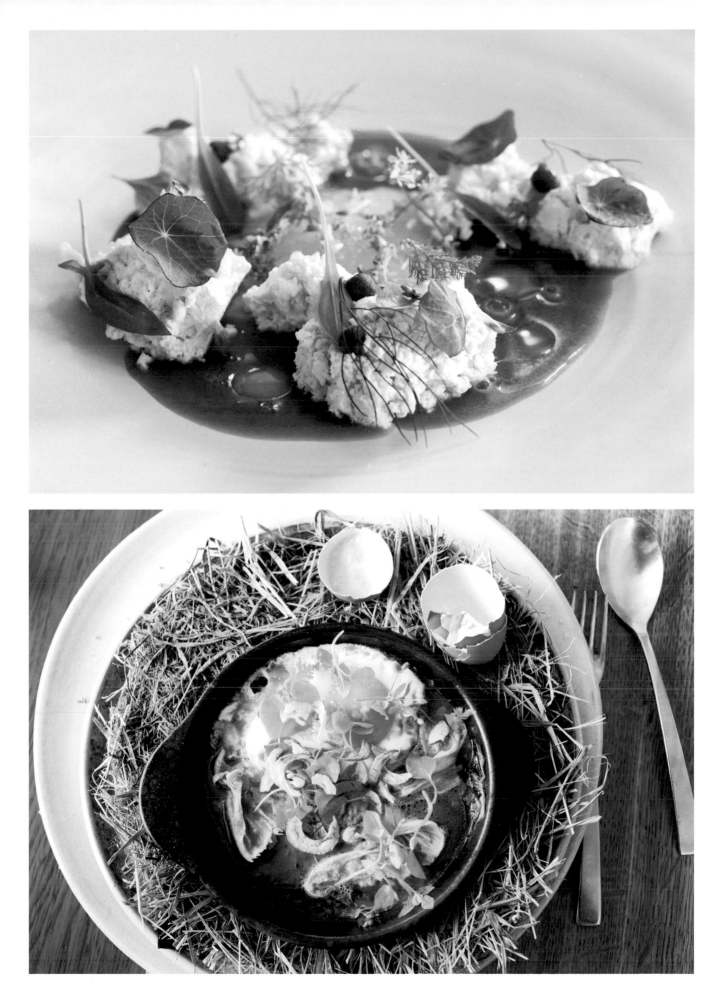

Bitter Dessert.

Cucumbers and Elderflowers.

Live shrimp and brown-butter emulsion.

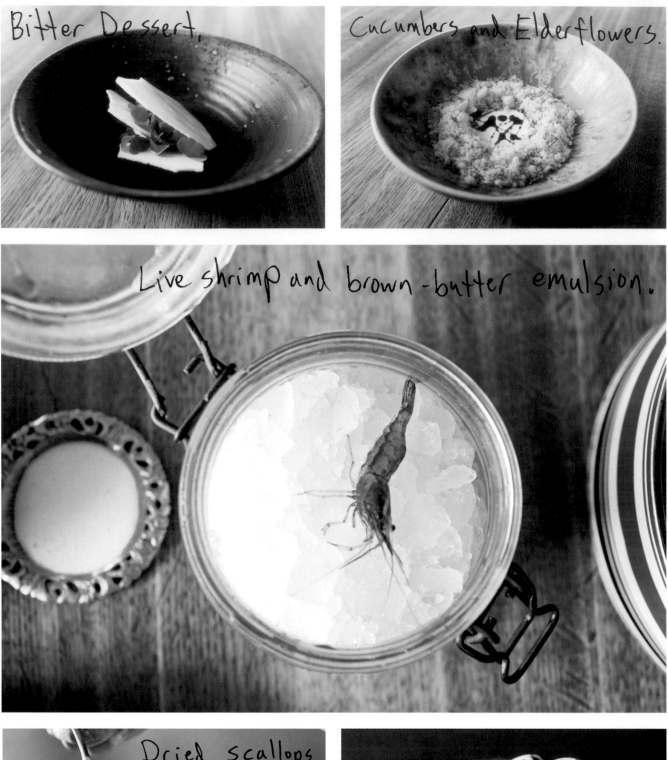

Dried scallops and grains.

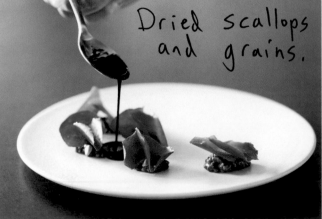

MORE FOOD

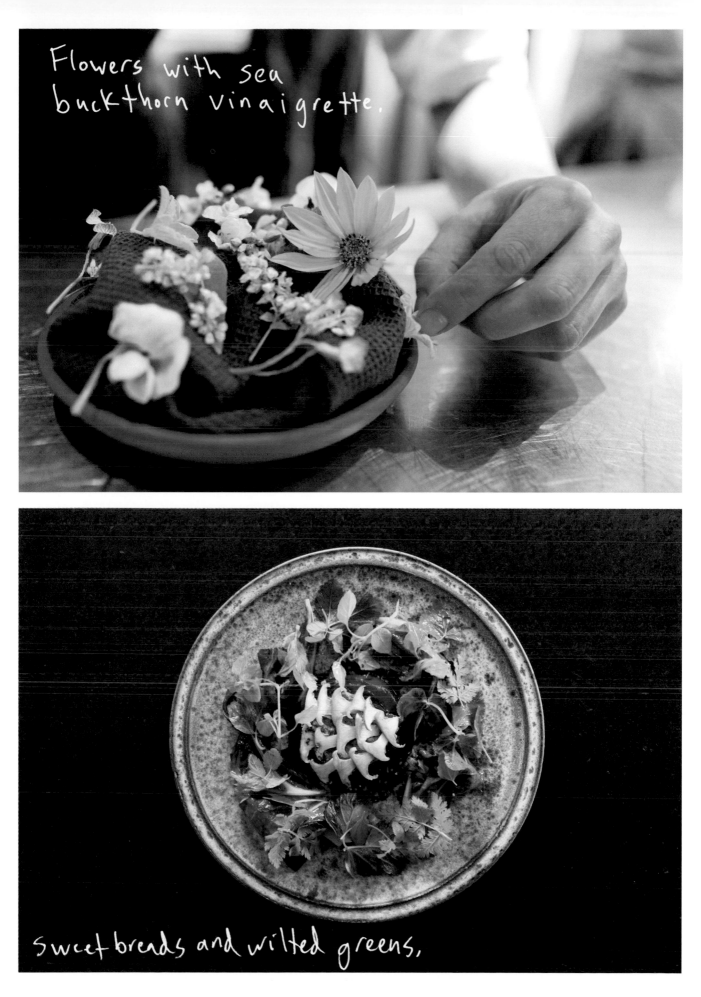

Flowers with sea buckthorn vinaigrette,

sweet breads and wilted greens,

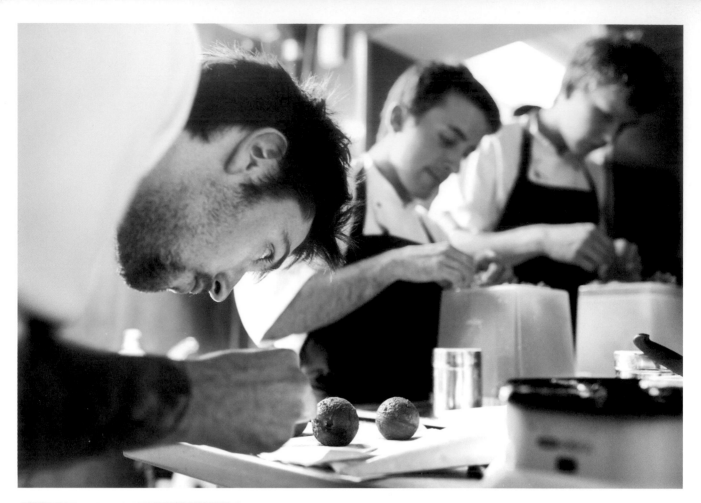

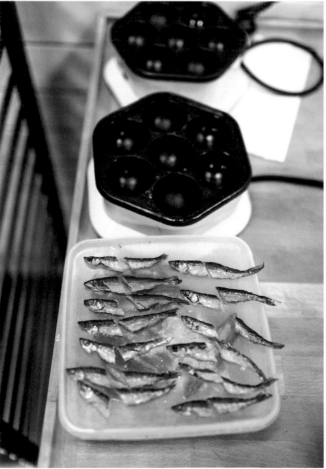

Æbleskive are traditional Danish pastries. Noma's is a savory version served with pickled cucumber, vinegar powder, and smoked muikku,

ÆBLESKIVE

COOKBOOK

Cookbook is a neighborhood greengrocer specializing in "responsibly grown, super-tasty food." Every week, owners Marta Teegan and Robert Stelzner pick a cookbook to cook from for their prepared-foods menu. Cookbook works with a bunch of backyard growers, whom they help get certified with the county so that they can buy their fruits, vegetables, and eggs. Echo Eggs has a small flock of Easter Egger chickens that they raise up the hill, and supplies Cookbook with beautiful blue and green eggs.

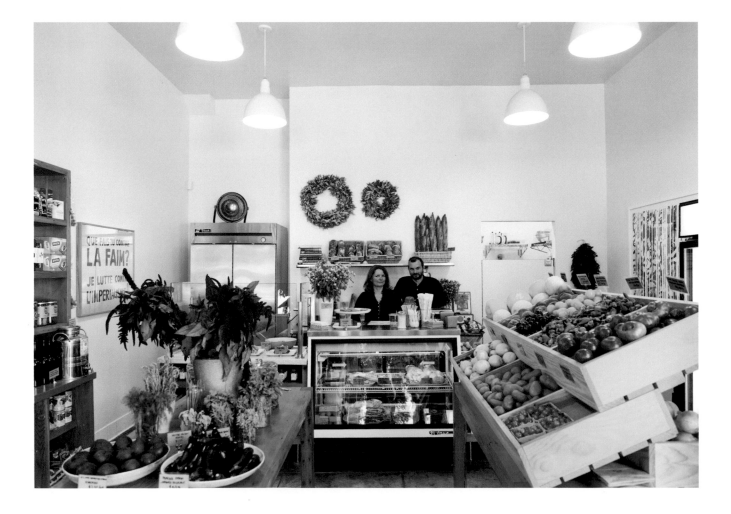

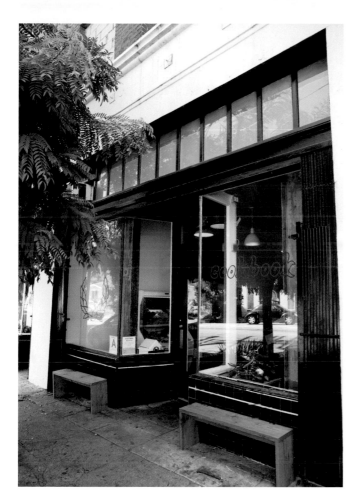

Cookbook's tiny storefront in a 1920s brick building in Echo Park.

THE SHOP

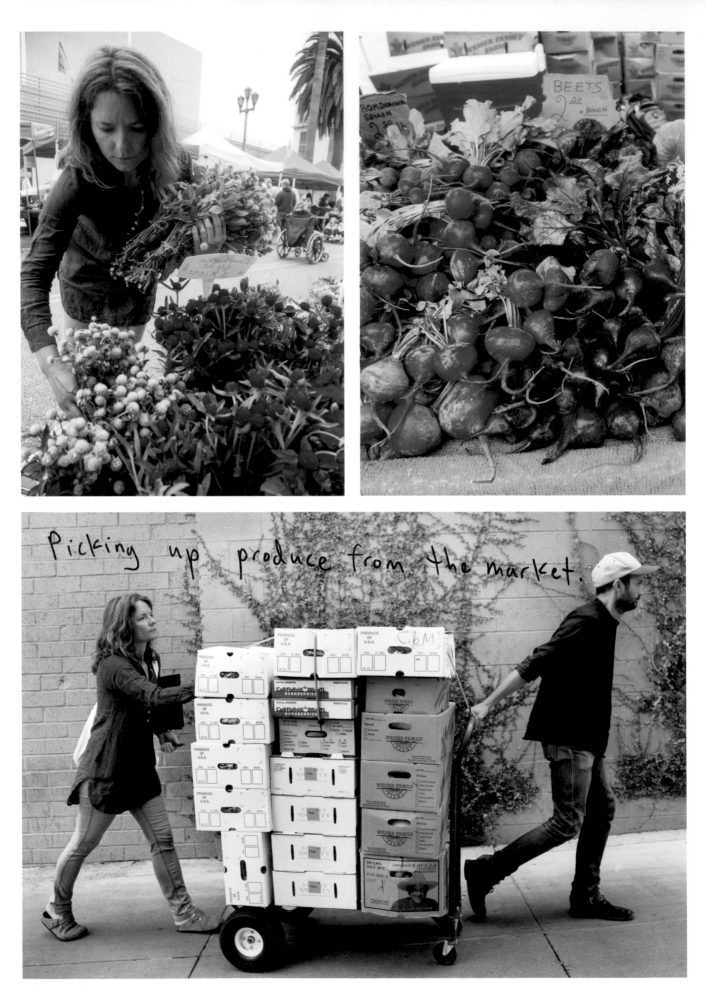

Picking up produce from the market.

SANTA MONICA FARMERS MARKET

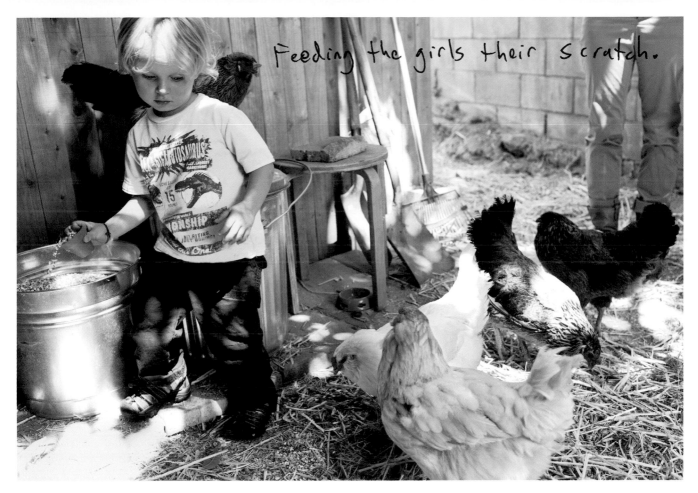
Feeding the girls their scratch.

Blue eggs from Echo Eggs'
Easter Egger chickens.

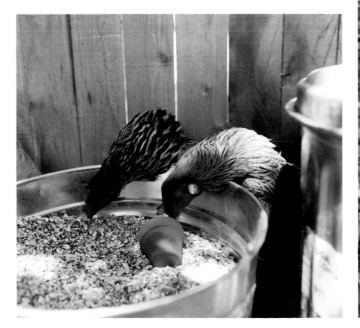

ECHO EGGS

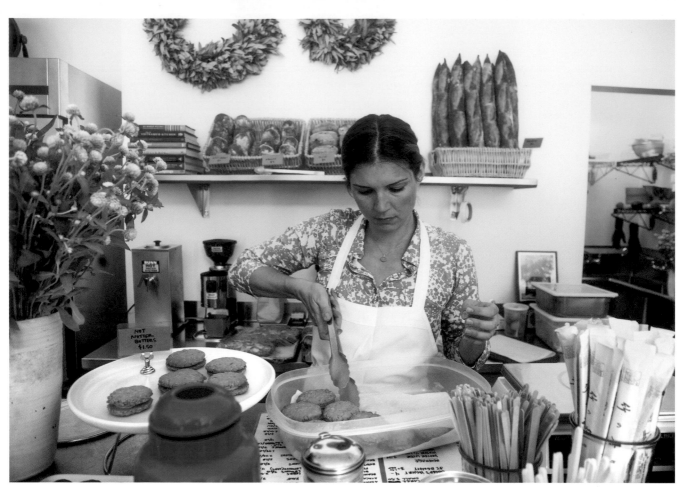

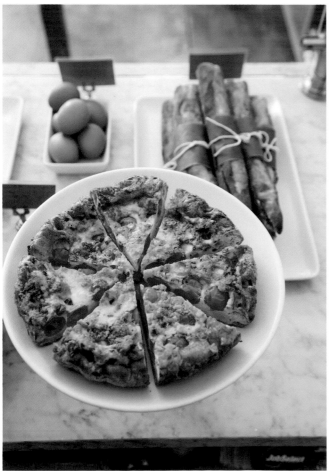

Peanut butter cookies based on Nancy Silverton's Not Natter Butters recipe.

TAKEAWAY

Hi Marta + Robert! Could you draw and label the produce stack in your store Cookbook?

CANARY MELON WEISER
CAVAILLON MELON WEISER
PEACOCK FARMS PEACHES
PADRON PEPPERS WEISER FARMS
FLOTA BELLA NECTARINE / GOLDEN NECTARINE / NIXON PLUMS
TUTTI-FRUTTI HEIRLOOM TOMATOES

PODWINS FIGS
LEMONS SCHARWEL
RUTIZ GOLD GRETTA
WEISER FRENCH FINGER (RED)
RUTIZ SUN GOLD CHETTY TOMATOES

Could I get the recipe for your Beans + Greens?

kale, good mother stallard beans, red onions.

cook your beans with onion, garlic + thyme

pickle your red onions with red wine vinegar.

brush each leaf of kale with olive oil + grill on each side for 30-45 seconds. Chop kale, mix with beans + onions.

Could you draw + label your 6 favorite recipes from cookbooks?

TERRINE OF PORK + DUCK LIVER

HEART OF THE ARTICHOKE

CUMIN! RED PEPPER!

LENTIL-SWEET RED PEPPER SOUP WITH CUMIN + BLACK PEPPER

ZUNI

THE BEST BEANS EVER

CRANBERRY BEANS WITH GARLIC, SAGE + OLIVE OIL

MY FAVORITE INGREDIENTS

GRILLED MACKEREL IN VINE LEAVES

MORO EAST

LAVENDER·ORANGE·ALMOND CAKE

CRAZY WATER PICKLED LEMONS

* AMAZING *

NOT NUTTER BUTTERS

NANCY SILVERTON'S SANDWICH BOOK

AMAZING

Could I get the recipe for your eggplant + walnut dip?

This is an amazing recipe based on a 10C Baghdadi cookbook! japanese eggplant, walnuts, caraway, olive oil, red wine vinegar roast the eggplants whole, skin on. fry the walnuts + caraway seeds in olive oil. blend eggplants, walnuts + caraway seeds with red wine vinegar and more olive oil. Delicious with warm ciabatta!

SEA FORAGER

Kirk Lombard worked for the government for seven years as a fisheries observer in the San Francisco Bay Area, monitoring fishermen's catches on countless boat trips. He memorized all the relevant facts about every fish in the Pacific Ocean simply to prepare for the job interview. Kirk's wife says this was like "giving an alcoholic a job in a whiskey mill." After Kirk was laid off he decided to start Sea Forager, which includes an element of commercial fishing done in a very targeted, small-scale, sustainable way, along with an educational component through the fishing tours he gives around San Francisco. On our day together, Kirk showed me how to fish out of a storm drain. We also kayaked under old piers to catch black surfperch, threw nets on a beach to catch surf smelt, and went poking for the elusive monkey-faced eel. It was surprising to see that so many different kinds of fish live with us in urban areas, and that monkey-faced eels are so cute.

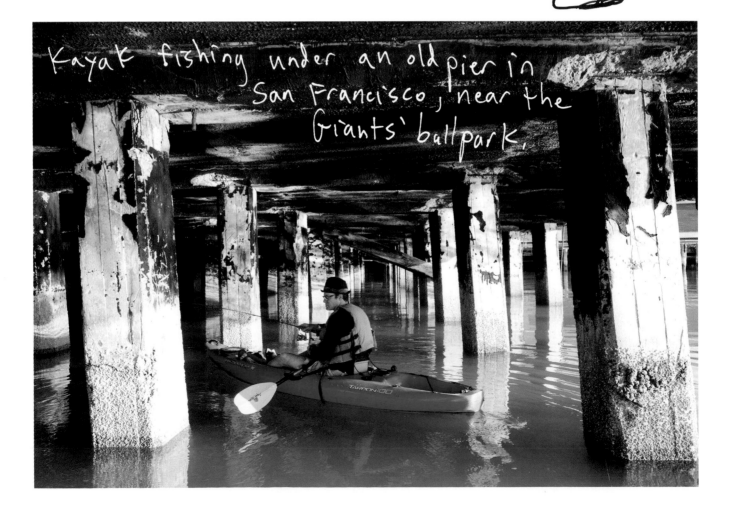

Kayak fishing under an old pier in San Francisco, near the Giants' ballpark.

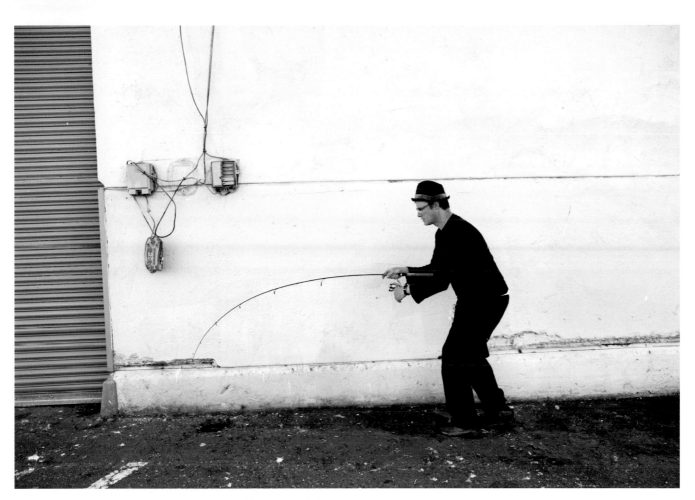

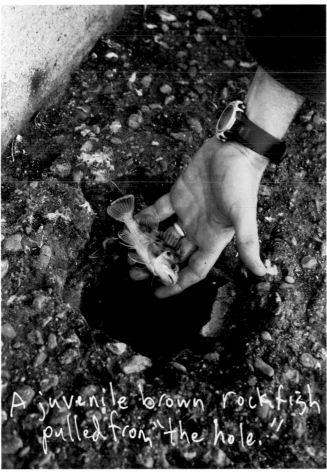

A juvenile brown rockfish pulled from "the hole."

"One rainy day, I saw a guy sitting in his truck with a fishing rod sticking out of the window. I pulled up and was astonished to find he had a bucket literally teeming with fish. The fisherman was a local character who goes by the handle 'Pissed-off Pete.' I promised Pete I would never tell the location of his 'fishing hole.'"

STORM-DRAIN FISHING

"Not to brag, but I actually own the California record for the largest monkey-faced eel ever caught."

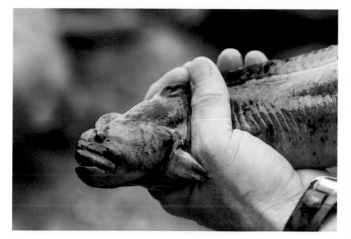

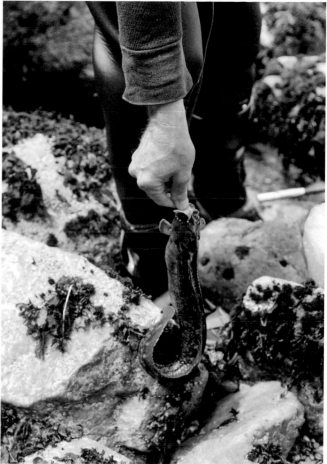

A medium-size monkeyface prickleback (cebidichthys Violaceus), otherwise known as a monkey-faced eel.

Monkey-faced eel leather spine.

Kirk's Monkeyface News zine.

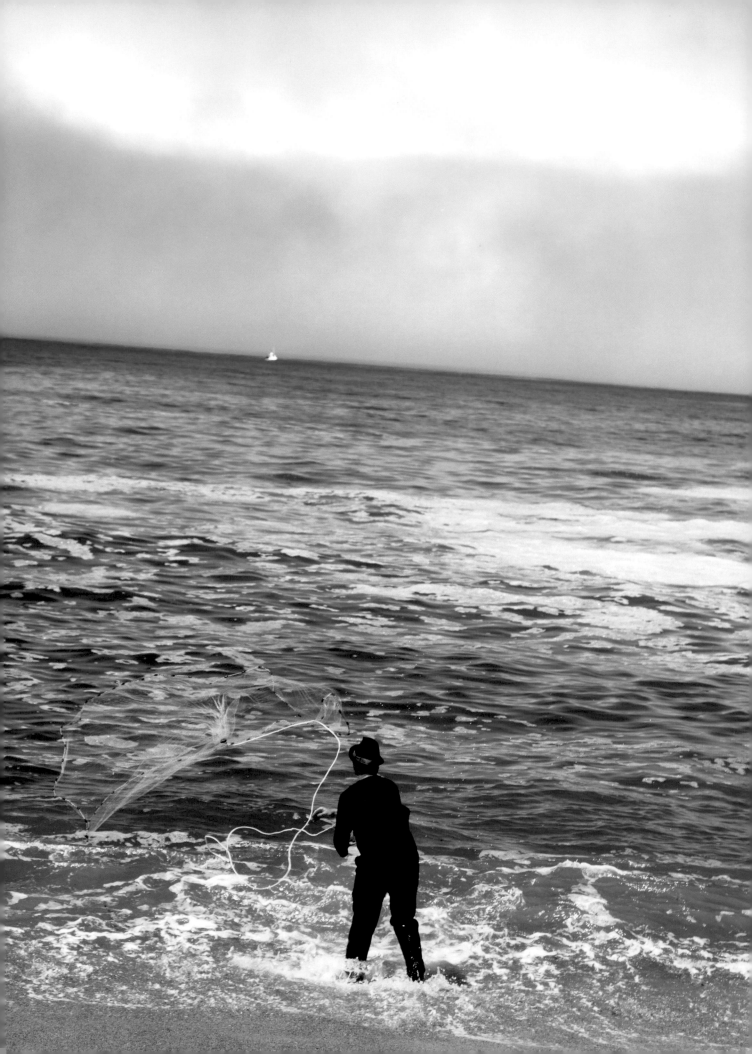

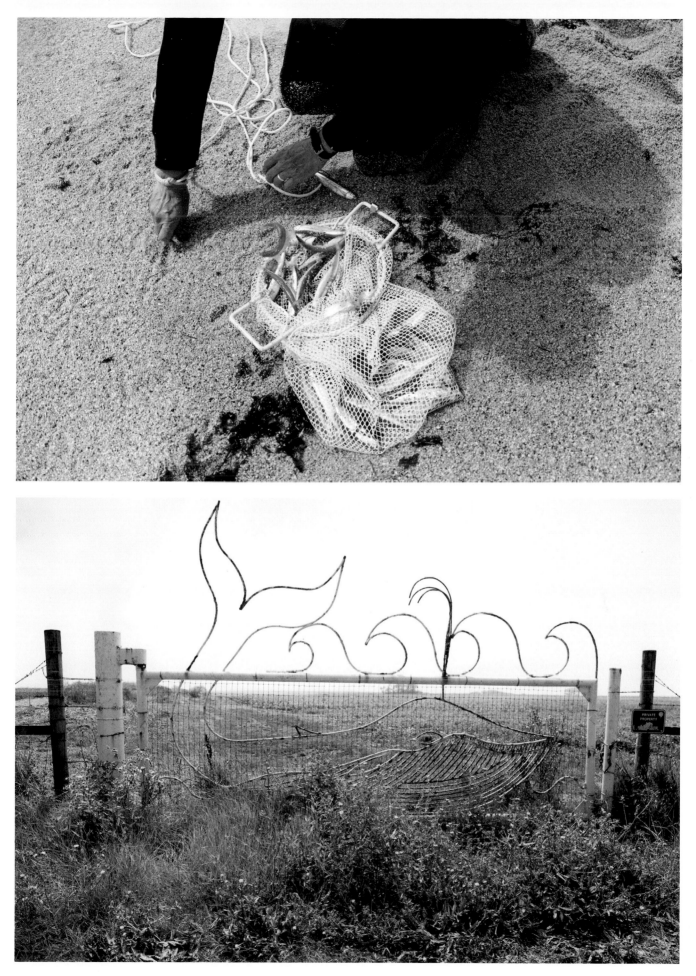

SURF-SMELT FISHING AT COWELL BEACH SAN FRANCISCO, CALIFORNIA 127

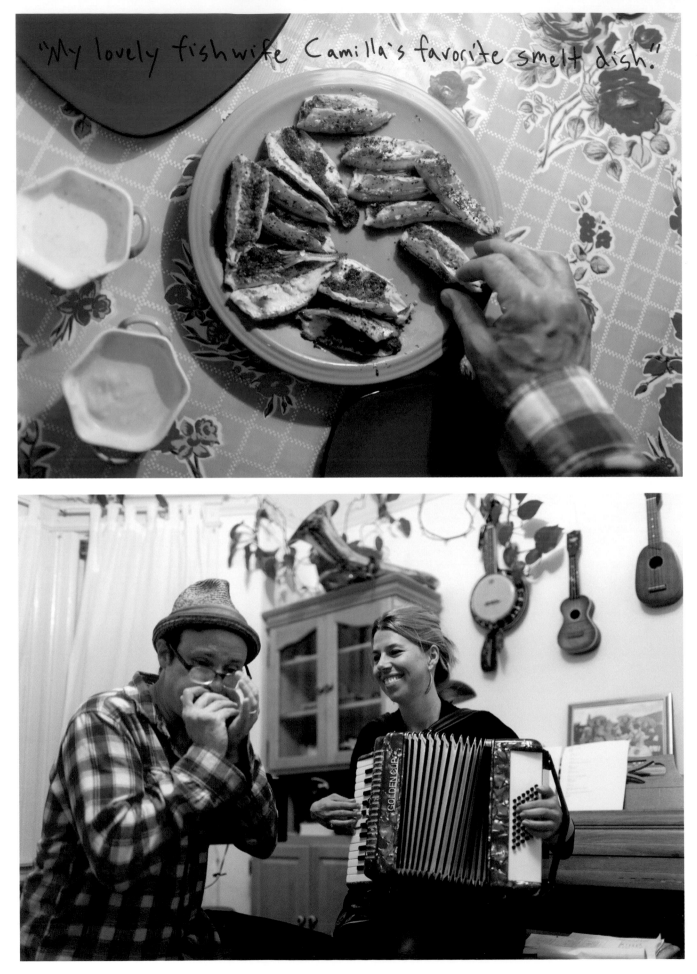

"My lovely fishwife Camilla's favorite smelt dish."

AT HOME

Hi Kirk! Could you draw a map of SF with your favorite sea creatures labeled?

Could you write a haiku inspired by monkey faced eels?

#1 VIOLACEUS.
 Slip thru chasms in the dark,
 ~~Towards my sharpened~~
come, let me ~~bamboo hook.~~
 clutch thee. ~~poke pole~~

Could you write a haiku inspired by surf smelt?

Surf smelt in the foam
OH HOW I WANT TO EAT you
Thou cucumber fish!

why do you like fishing in urban areas?
 A. Because there are awesome species in urban waters.
 B. Because I live in an urban area
 C. Because it is important to me that "wilderness" includes
 these dilapidated old forgotten shorelines - for aesthetic reasons
 that only I
could you draw a monkey faced eel's head in profile ↳ could possibly
 understand

could I get your recipe for surf smelt panko fried?

Egg wash - 1 egg + 2 shot glasses of milk
Flour
Panko
Salt.
Dip smelt (headed & gutted or deboned)
in flour. Then in Egg wash. Then in panko. Drop
in hot oil. (That high oleic peanut oil rawks!)
Fry to brownness. SCARF.

SEIRINKAN

Susumu Kakinuma-san loves Italian women, Italian cars, and Neapolitan pizza. He went to Napoli on vacation and ended up staying there for a year. He became obsessed with eating at all the best pizzerias in Napoli, and from that adventure he learned how great pizza could be. At the time there was nothing like that thin-crust Neapolitan pizza in Japan. He returned to Tokyo and spent many months perfecting his own recipe: 1 cup of water to 1.6 cups of flour. He imported a beautiful vintage pastel Italian dough-mixing machine that uses two steel arms to mix the dough like "the arms of a dead Italian grandma." That apparently is a good thing. Being a purist, Kakinuma-san only has two kinds of pizza on the menu, Margherita and Marinara. If you are in the know (as you now are), he may let you order the Pizza Bianca.

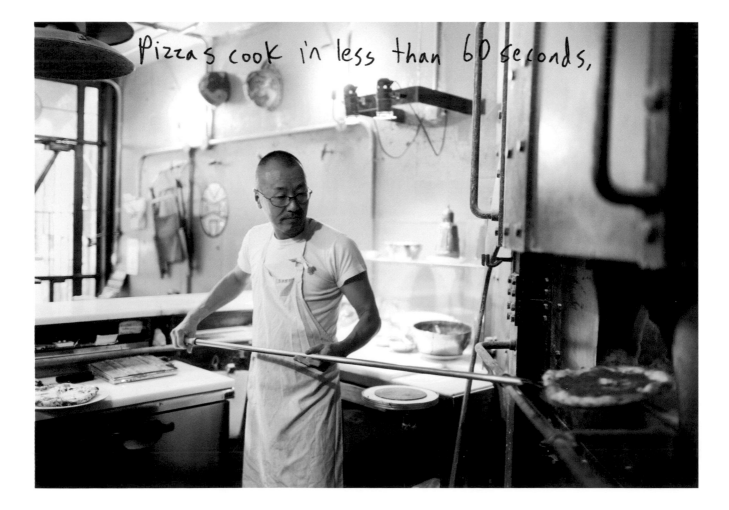

Pizzas cook in less than 60 seconds,

what are the two kinds
of pizza in your menu?

マルゲリータ. マリナーラ.

Margherita and Marinara.

why just two kinds?

人 → 男. 女.

ピッツァ → マルゲリータ, マリナーラ

People → Man. Woman.
Pizza → Margherita. Marinara.

what do you like
about Italian women?

 キレイ. コワイ. ! !

They're beautiful. And scary!!

NEAPOLITAN PIZZA

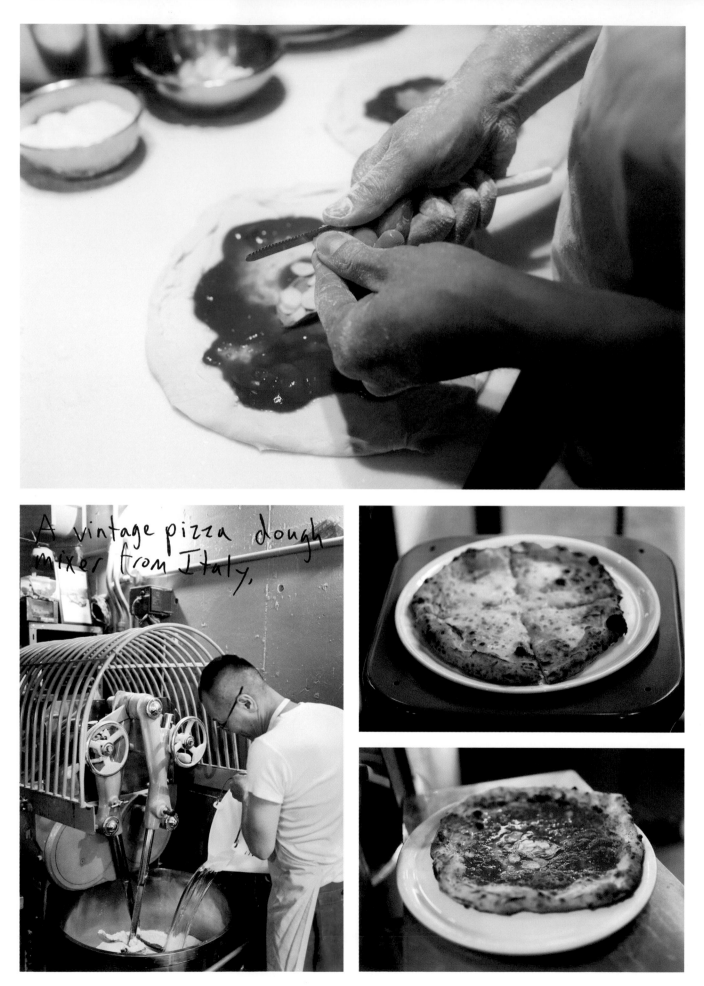

A vintage pizza dough mixer from Italy,

TWO (MAYBE THREE) KINDS OF PIZZA

Could you draw + label a map of your man cave "Radio King" that is hidden under your restaurant?

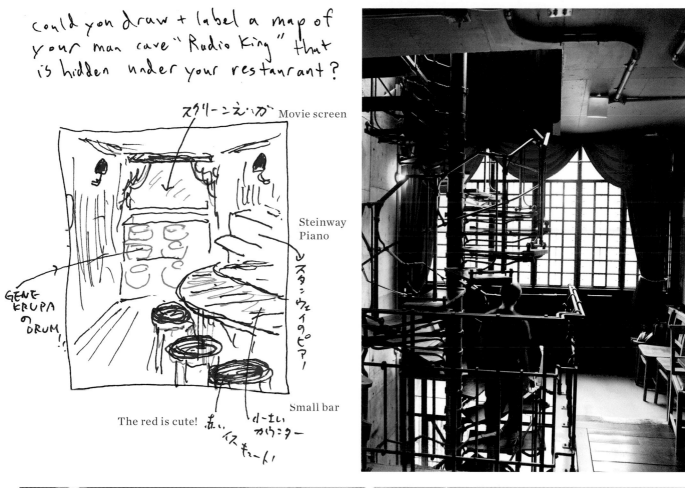

スクリーンえいが Movie screen

Steinway Piano

スタンウェイのピアノ

GENE KRUPA の DRUM !!

Small bar

The red is cute! 赤いイスキュート!

小さいカウンター

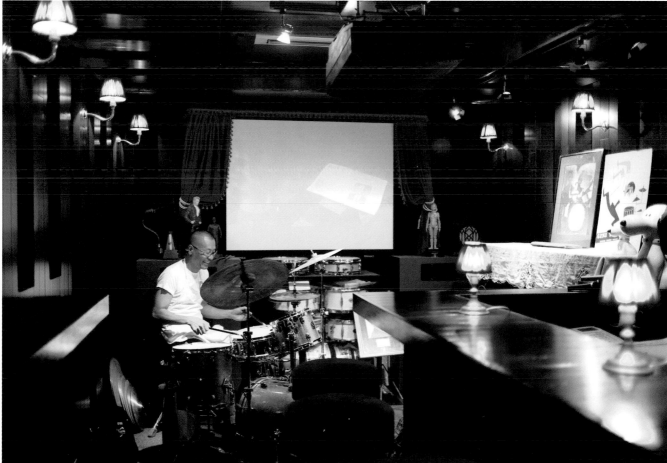

MAN CAVE

HARTWOOD

Eric Werner and Mya Henry fell in love with Mexico while on vacation in Tulum in 2010. They talked about realizing their own dream of starting an open-air restaurant in the jungle, using just a wood-burning grill and oven to cook. What is crazy is they actually did it. Hartwood's "Mexican farmhouse rustic" food reflects Eric's love of traditional American recipes combined with his respect for the local spices, produce, and seafood. The wood that makes up the restaurant was all harvested by local Mayans under the full moon—apparently that is good luck.

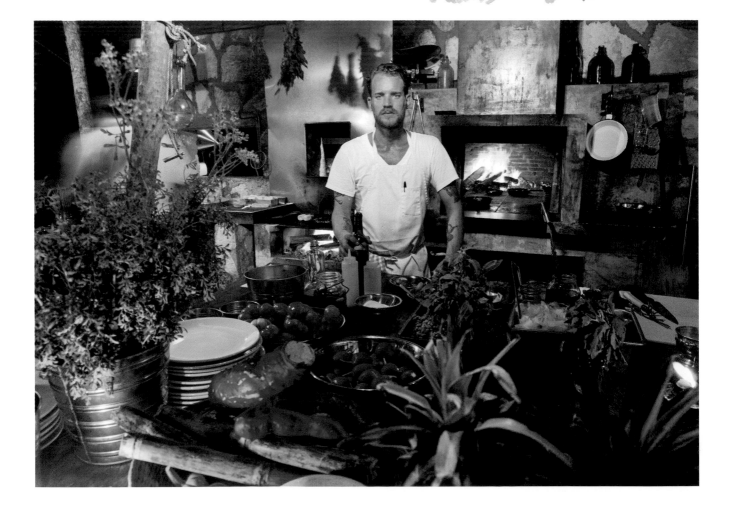

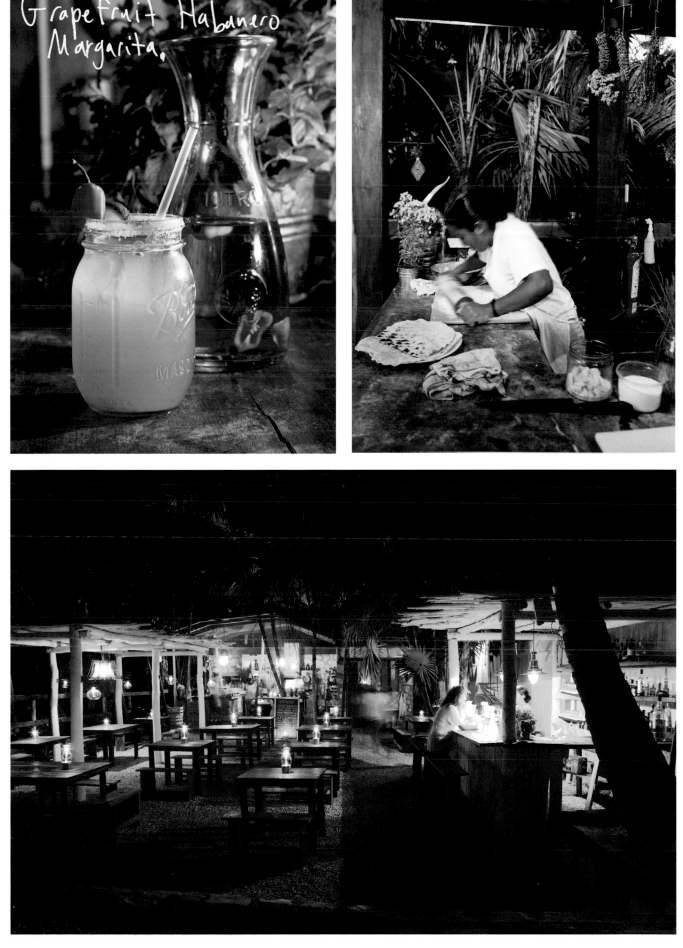

Grapefruit Habanero Margarita.

AT NIGHT

AT THE VALLADOLID MARKET

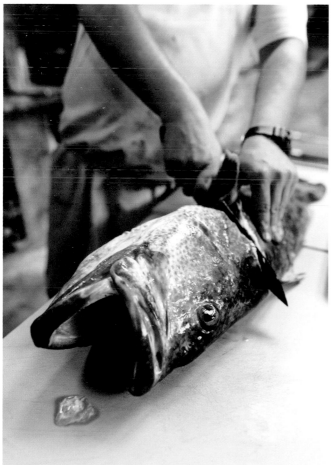

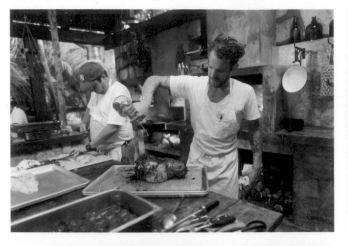

Pork loin.

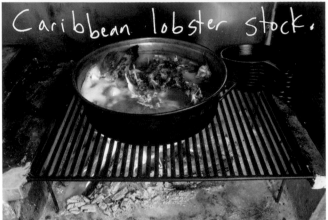

Caribbean lobster stock.

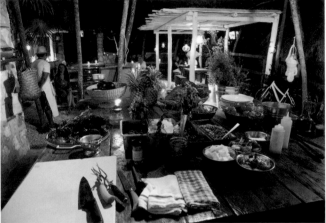

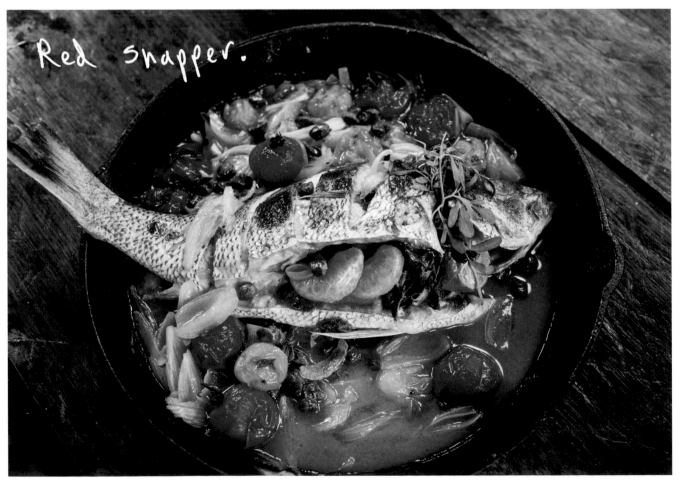

Red snapper.

AT THE CHEF'S TABLE

Hi Eric + Mya. Mya could you draw + label a plan of Hartwood ↳

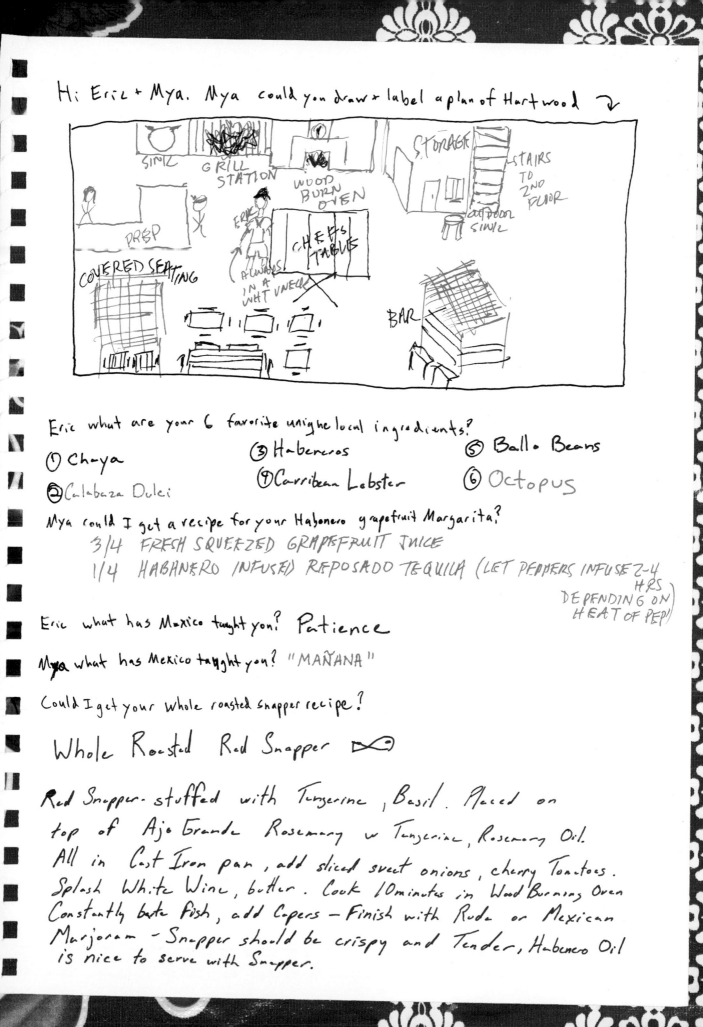

Eric what are your 6 favorite unique local ingredients?

① Chaya ③ Habaneros ⑤ Ball. Beans

② Calabaza Dulci ④ Carribean Lobster ⑥ Octopus

Mya could I get a recipe for your Habanero grapefruit Margarita?
 3/4 FRESH SQUEEZED GRAPEFRUIT JUICE
 1/4 HABANERO INFUSED REPOSADO TEQUILA (LET PEPPERS INFUSE 2-4
 HRS
 DEPENDING ON)
 HEAT OF PEP!)

Eric what has Mexico taught you? Patience

Mya what has Mexico taught you? "MAÑANA"

Could I get your whole roasted snapper recipe?

Whole Roasted Red Snapper ⊂⟩⟩

Red Snapper stuffed with Tangerine, Basil. Placed on
top of Ajo Grande Rosemary w Tangerine, Rosemary Oil.
All in Cast Iron pan, add sliced sweet onions, cherry Tomatoes.
Splash White Wine, butter. Cook 10minutes in Wood Burning Oven
Constantly baste fish, add Capers — Finish with Ruda or Mexican
Marjoram — Snapper should be crispy and Tender, Habanero Oil
is nice to serve with Snapper.

VIOLET CAKES

Claire Ptak opened Violet Cakes as a market stall in 2005 when she moved to London from California. In 2010 she moved her shop and bakery into a little free-standing white house in Hackney. She describes her concept of baking as "not really conceptual, it's just good-ass cake." I politely disagree. I think there is a very strong concept of understated purity to her baking style, which always feels wholesome, even if what you're eating is pure sugar. Some of Claire's specialties are whoopie pies, English strawberry cupcakes with naturally colored frosting, blood-orange almond-polenta cakes, and her namesake candied violet cupcakes.

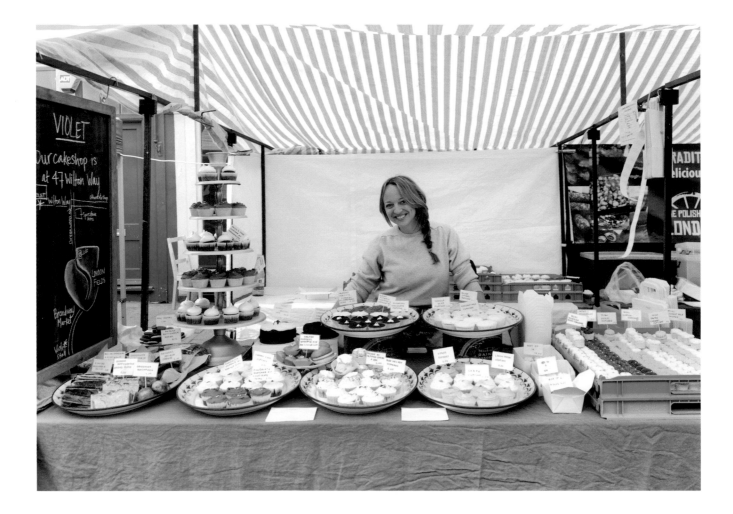

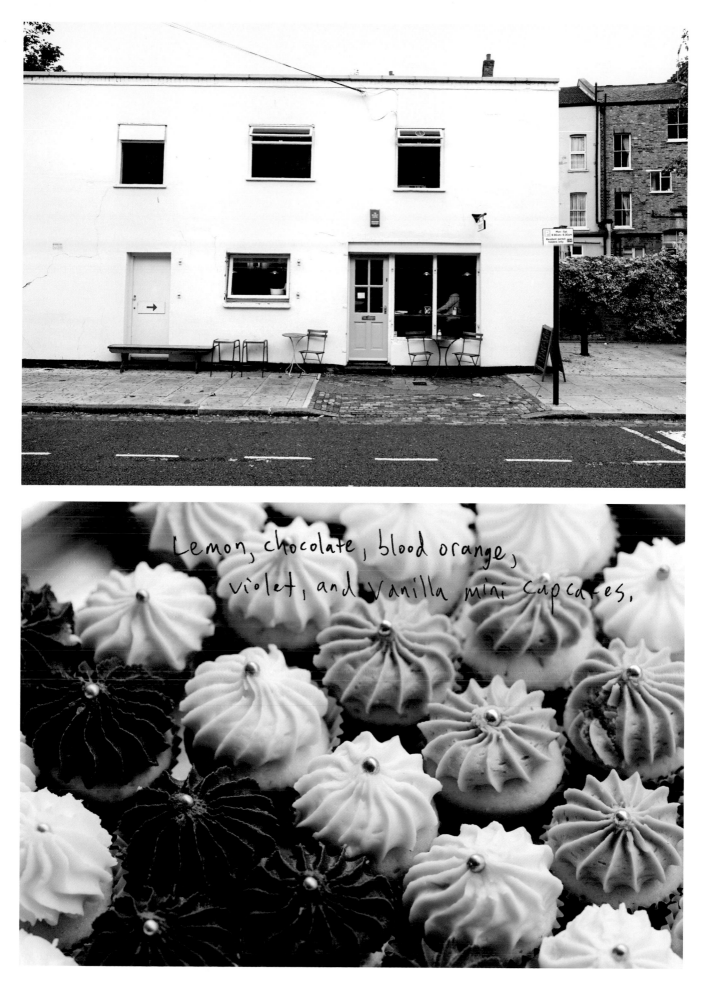

Lemon, chocolate, blood orange,
violet, and vanilla mini cupcakes.

THE STALL AND THE STOREFRONT

"Candied rose petals are the one girly thing about my cakes."

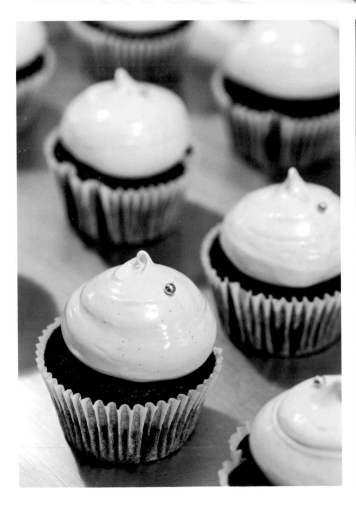

GOOD-ASS CAKE

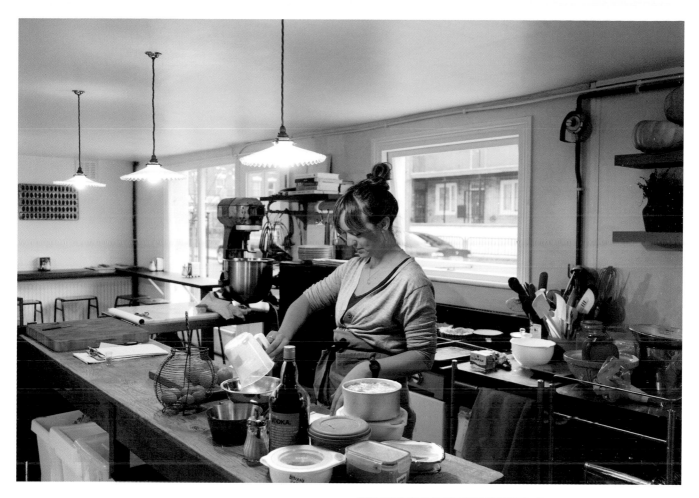

Chocolate devil's food
cupcakes with marshmallow
icing and almond-polenta;
raspberry cupcakes
with cream cheese icing.

This is a giant heart-shaped cookie cutter that Claire bought in Palermo. It comes down once a year for Valentine's Day. ↗

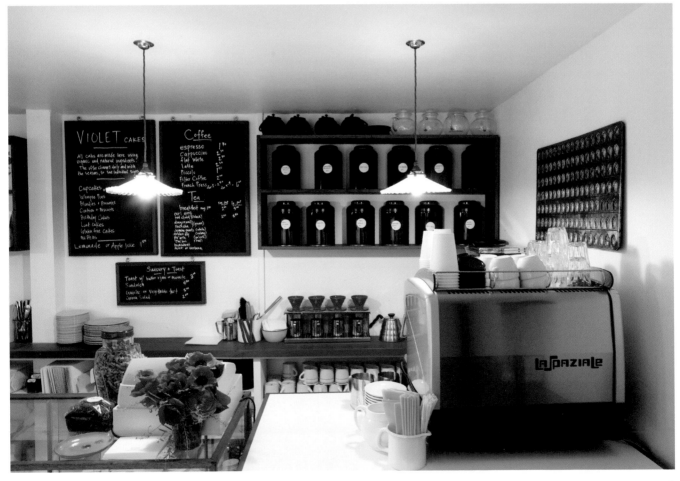

THE CAFÉ

Hi Claire! Could you draw + label a whoopie pie inspired by S.F.

what do you love about whoopie pies?
 Eating them —

whats the best part of being a baker?
 That my name has now become
 "cakes", shortened from "Claire cakes"

How has London surprised you?
I was so surprised that they love
cake more than any other place
I have been — They're nuts for it!

what 4 things did you discover during your time at Chez Panise?

① How to taste

② How to choose fruit

③ Domaine Tempier Bandol Rosé

④ That LOVE is more
 important than work.

The mini Huckleberry Geranium Whoopie

golden
gate
statue

Huckleberry
icing

plain
whoopie

Wild Huckleberry / Rose Geranium
butter cream

what is the recipe for grapefruit frosting?
Some butter — about 375g. Some Icing sugar — about 750g-1 kilo
the Juice of a PINK grapefruit and its zest.
 Start by softening the butter — whip it up + add sugar little
by little — add some Juice — and add more sugar — Fold in the zest.
could you draw and label the ground floor layout of violet COVER the cupcake w/ the
 Frosting.

what are the 5 best deserts you
have ever eaten

① A coconut bun baked on a fire of
coconut husks made with coconut
oil + coconut fruit in a hut on
a Island off of Honduras.

② Flakey pastry with milk and
orange blossom water in Marrakech

③ Pierre Herme's mille Fuile

④ tangerines + dates @ Alice +
Fanny's house

⑤ Apple tarts we make in Davos
For the W.E.F. with GLOKEN Apples — It was all down to those apples!!

Back Door Todd looking through
 the back door

THE
cakes!

TEAS

pour over
coffee

stairs to
dining area
more tables

Damian's
espresso
machine

our cooriutop

Fridge

sugar flour

Big mixer

dish room

mixers oven another
 oven

Bar + stools

Front door

ROCKAWAY TACO

Rockaway Taco started in 2008 as a shack on a blighted corner of the Rockaways in Queens, serving tacos to surfers who would come out to shred the closest wave to New York City. Chef Andrew Field learned how to make tacos by spending a few years in Mexico "looking over the shoulders of various taqueras and shoving my way into their kitchens offering help of any kind." Over time the shack grew to include a group of creative people trying to do something different, and the more they built, the more people came. By summer 2011 the Rockaway Taco building had grown to include a homemade ices shop, a veggie stand, a coffee shop, a surfboard rental, a rooftop garden, and beehives. All summer Andrew sleeps on the roof next door and wakes up with the sunrise to have his morning coffee with the bees. When he closes up in the winter, he travels the world in search of the best surf spots.

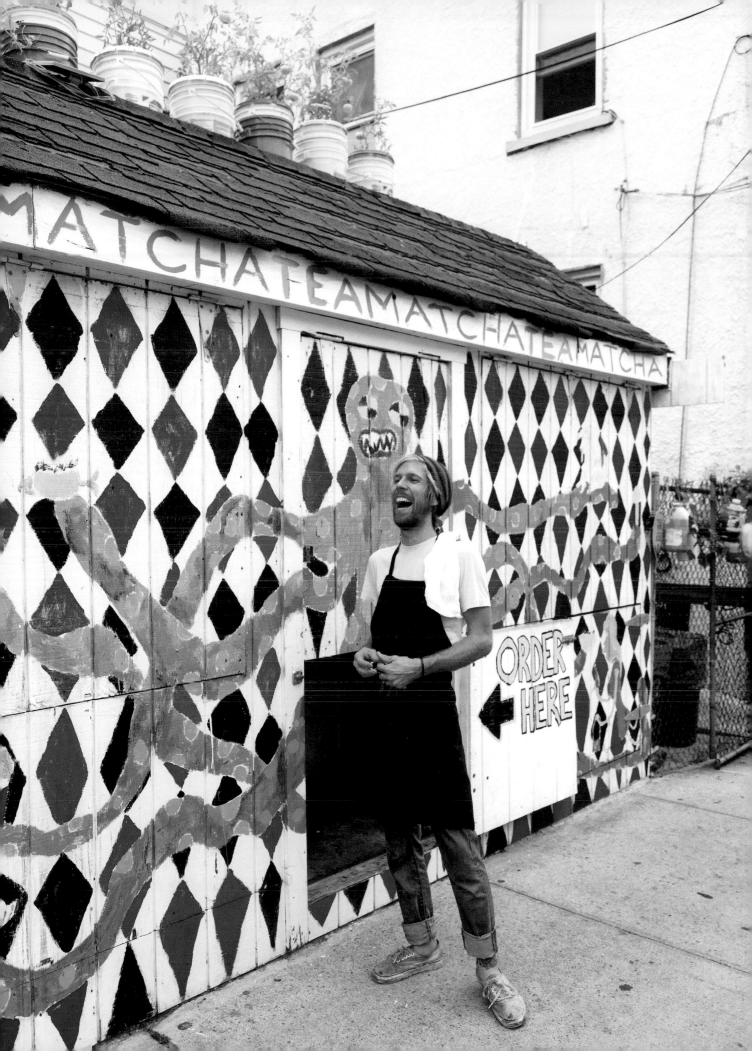

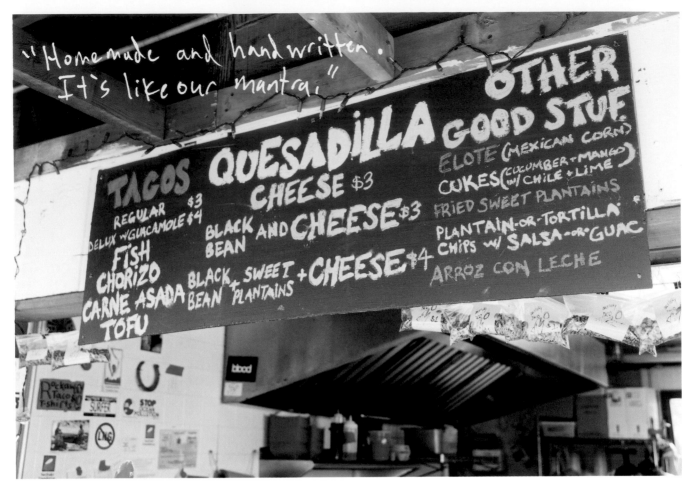

"Homemade and handwritten. It's like our mantra."

Making chilaquiles.

Tofu, because "Vegetarians enjoy a day at the beach, too."

TACO TIME

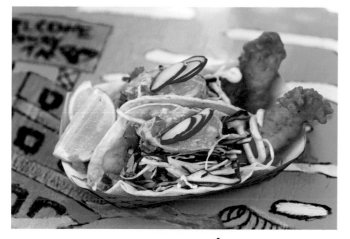

Street-style ↑
 Mexican fish tacos.

Cucumber, jicama, and
mango tossed with chile
and fresh lime. →

Sweet plantain
quesadilla.

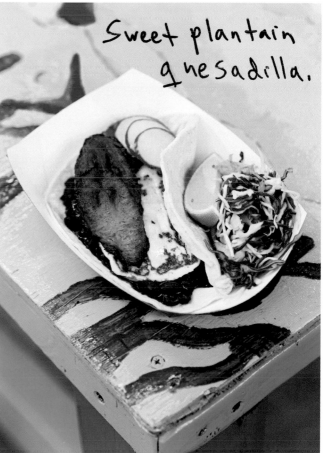

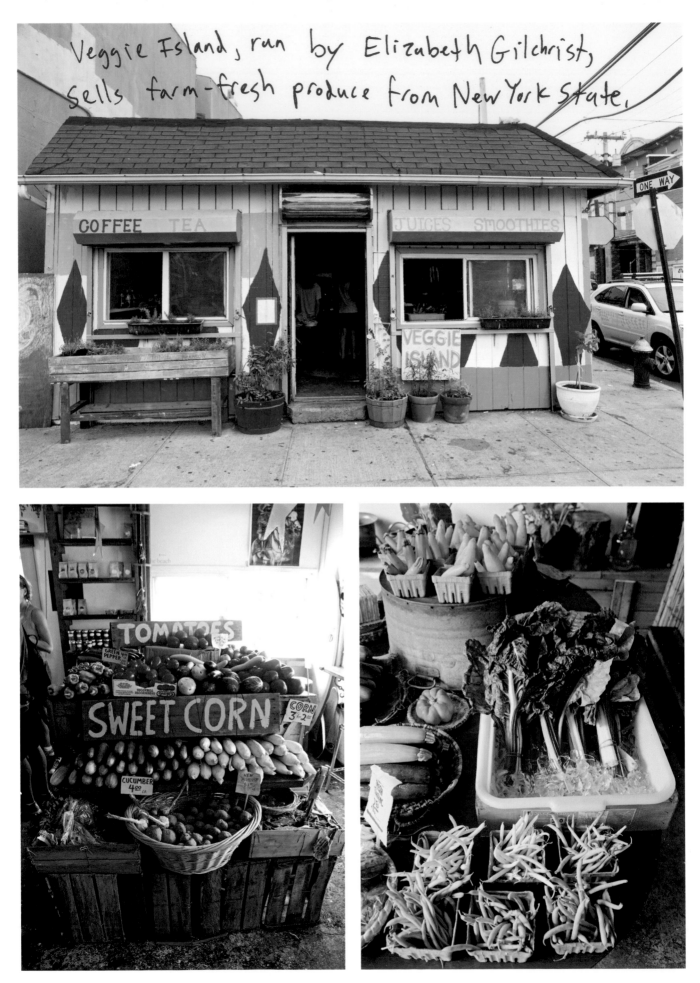

Veggie Island, run by Elizabeth Gilchrist, sells farm-fresh produce from New York State.

VEGGIE ISLAND

Hi Andrew! What does community have to do with food?
I like the community to be a part of my food &
I like to buy food from my community

Could you give a recipe for salsa: Rockaway Taco Green Sauce
2. Roasted Jalapeño peppers "Salsa Verde"
10. Roasted Garlic Cloves 1. Bunch of the freshest Cilantro
15. Tomatillos (cut in quarters) Salt to Taste. **Blend!!**

Could you draw a map of "the new formula for a strip mall" as its developed
in the Rockaways ↴

What have been the 4 top lessons you have learned starting
Rockaway Taco?
① Try to keep it Simple. ③ Keep it Fresh.

② Everybody likes good food! ④ It's all hard work, but
 being by the beach makes
 it all seem better.

What 4 chefs inspire you?
① Jean Adamson ③ Matt Matheson
③ Steven Gardner ④ Chris Field
 ↳ My Lil Brother

How did you catch the bees when they swarmed and left the roof?
Step one ...get Bee Suit & A Box
Step two... dig through Rose Bush to find Swarm.
Step three... Put Box under Swarm of Bees.
Step four ... Shake tree vigorously & Hope that queen
 falls into box. Wherever the Queen goes
 the workers will follow.

Billy the Bull

WHANGARIPO BUFFALO CHEESE CO.

Three generations of the Wills and Armstrong families work together to make the cheese that they sell at the Matakana Farmers Market. Buffalo are very new to New Zealand; as of 2011 there were only two herds in the whole country. Annie Wills describes buffalo as "quite quirky and personable animals," even though they are huge and have sharp, giant horns. Also it's important to note that the more relaxed and calm you are, the more chilled out they will be. Their milk is very high in protein and produces super-delicate cheeses. Whangaripo makes fresh soft cheeses, a halloumi, a blue cheese, and occasionally salted butter caramel ice cream.

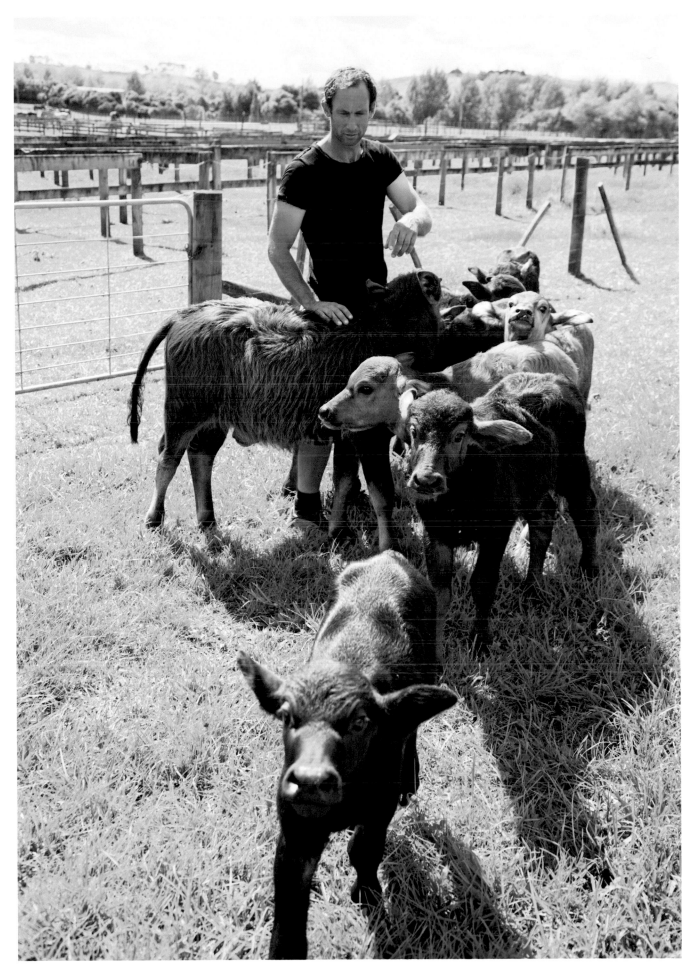

BABY BUFFALO

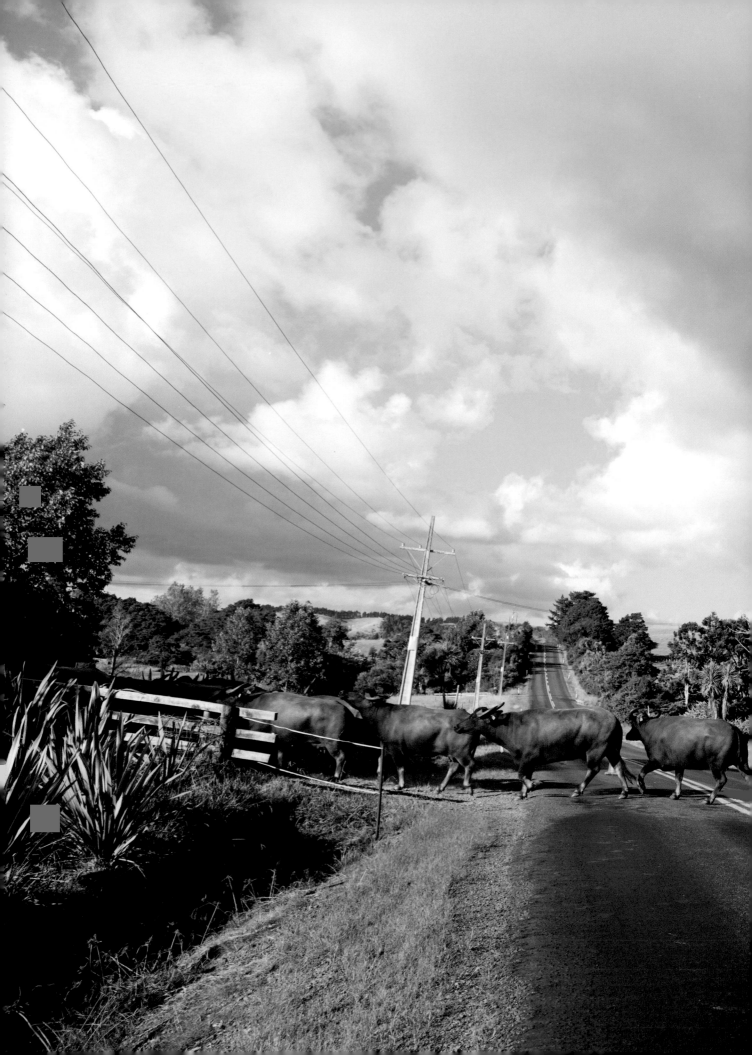

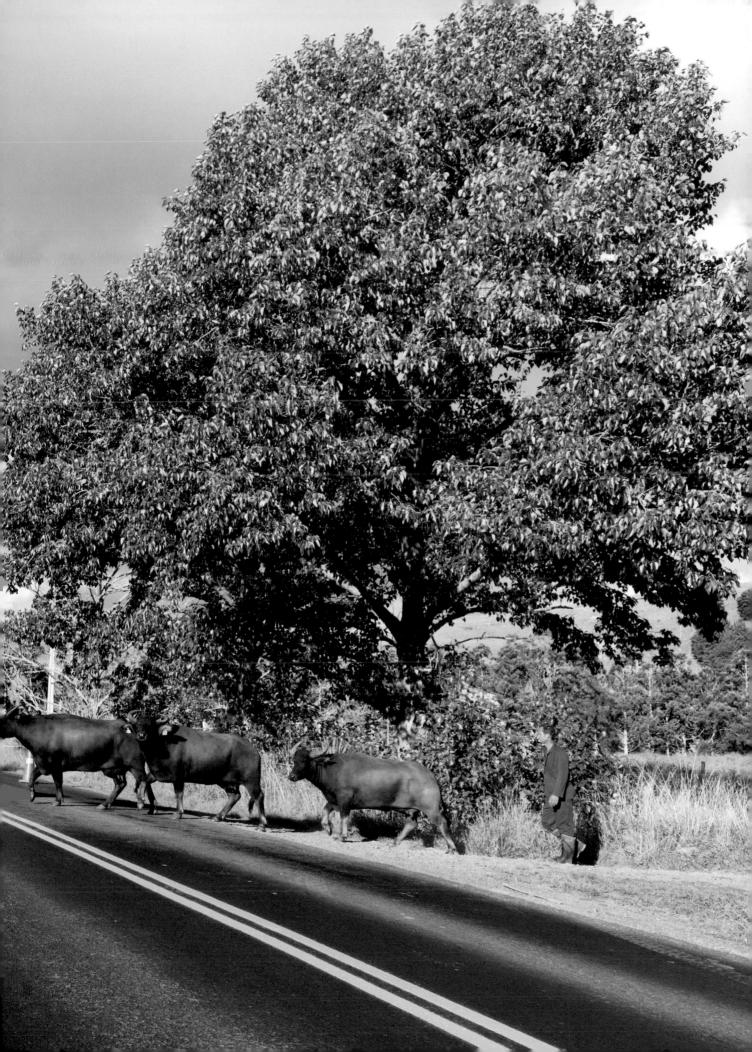

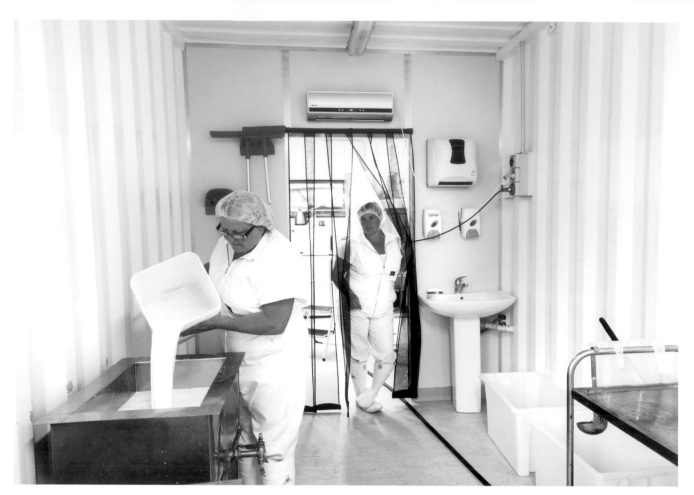

Pam and Annie starting mozzarella in the factory.

Buffalo Fresca cheese.

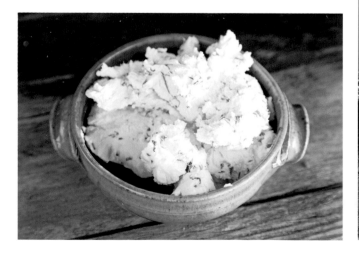

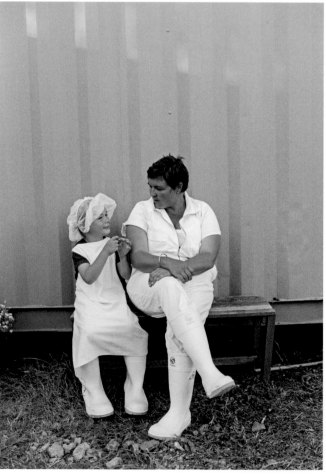

MAKING CHEESE

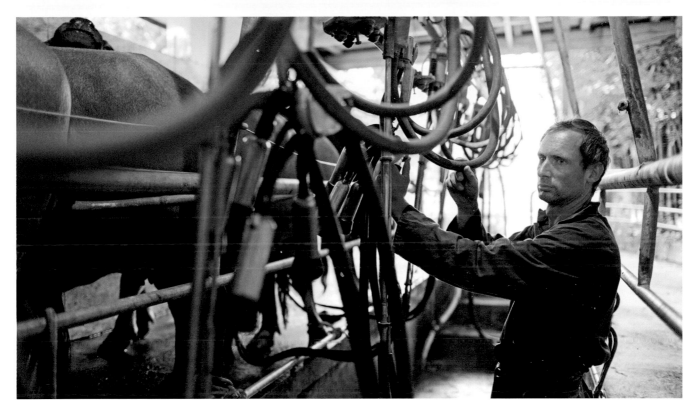

Annie what are the different cheeses you make from Buffalo milk?

Traditionally mozzarella but also, brie, blue, pecorino, fresca, grado (labneh) yoghurt. Fabs icecream.

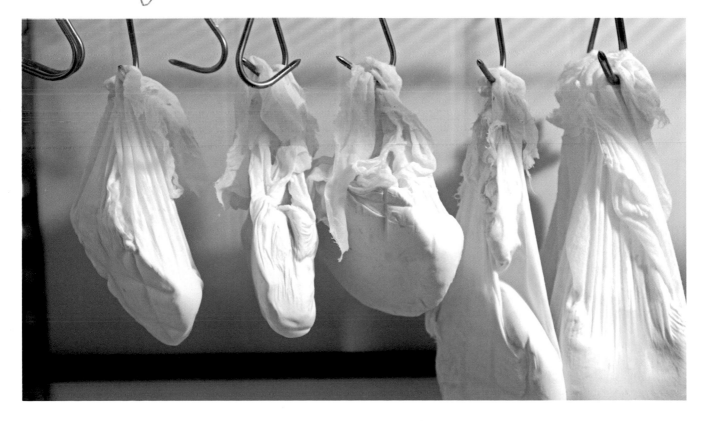

MISTRAL

Fredrik Andersson started Mistral in downtown Stockholm in 2003, but it has since moved to the outskirts of town. His idea was to "create a place where we could be free," and to make food that is "always pure, honest, and in a constant state of movement." Fredrik only works with local ingredients, and personally forages for many of the herbs and mushrooms he serves. Everything about Mistral is minimalist, but at the same time it has a strong human touch. It's these contradictory elements that make the restaurant so intriguing. The 14-seat dining room initially seems very empty, until you notice the quirky small personal touches like the doilies, flowers, feathers in vases, and cork collections. The cooking style is also stripped down—one Mistral specialty is a white plate of small onion rounds filled with thimblefuls of onion soup. It is really inspirational to see how dedicated Fredrik is to his unique vision.

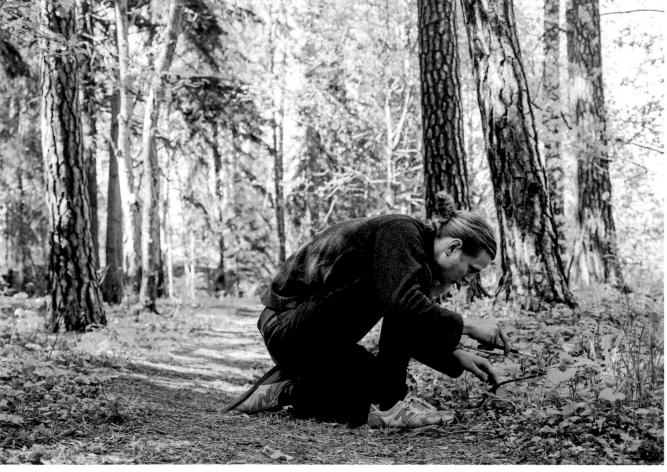

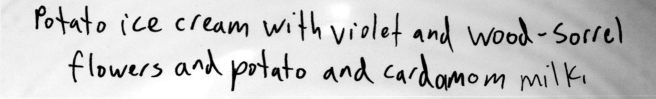

Potato ice cream with violet and wood-sorrel flowers and potato and cardamom milk.

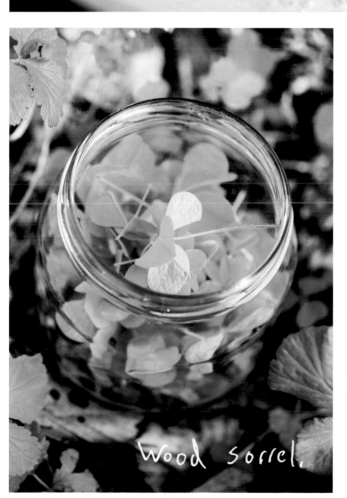

Wood sorrel.

Frozen spring garlic milk with herb ice, rhubarb sugar, and wild herbs,

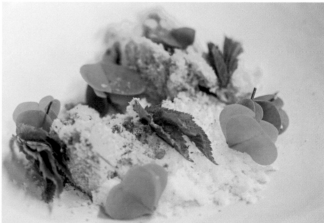

FOREST HERBS

Baked and then grilled winter onions filled with shredded duck neck and onion juice whipped with duck fat, beside cooked duck gizzard and early spring herbs.

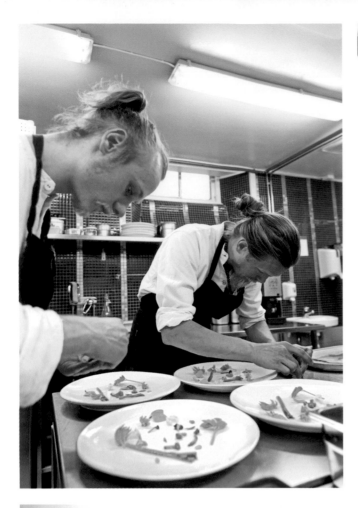

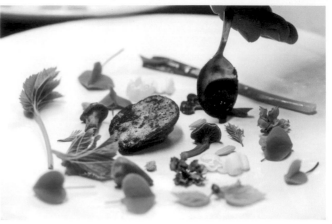

Winter potatoes in whey bread and forest butter, pickled mushrooms, and spring greens.

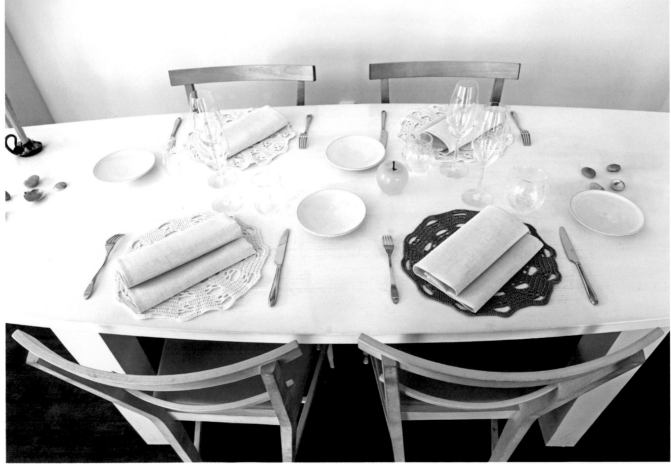

DINNER SERVICE

Hi Fredrik! Could you draw + label your potato with herbs dish ?

Could I get the recipe for your potato + herbs dish?

- poche the potatoe in whey (80° 3h) and brown in butter (1h)
- brown butter and season with dried mushrooms and dried pine

~ serve with forest herbs and pickeled mushrooms

Could you draw + label your favorite wild plants that are around Sept/oct
↙ in the area around Stockholm?

Could I get the recipe for potato ice cream?

① cook sliced potatoes in milk (2min) and rest in the fridge (48h)

② make an icecream with potatoe milk, honey and eggyolk

③ season two batches of milk with karaleman cend violets

• serve icecream covered with milk and wild violets + wood flowers

what is the relationship between chef and farmer?
They provide the guide and backbone to our cooking

what is special about an onion?
we feel that everything is unique and an onion is as beautiful as everything else ~ cooking "simple" things with that intension is eye opening

what has the forest taught you?
To look at natural shapes and that everything changes (and that's good)

what is special about swedish cooking?
Cooking like all things is about emotion and intention so you must look at why and why it is done - not where

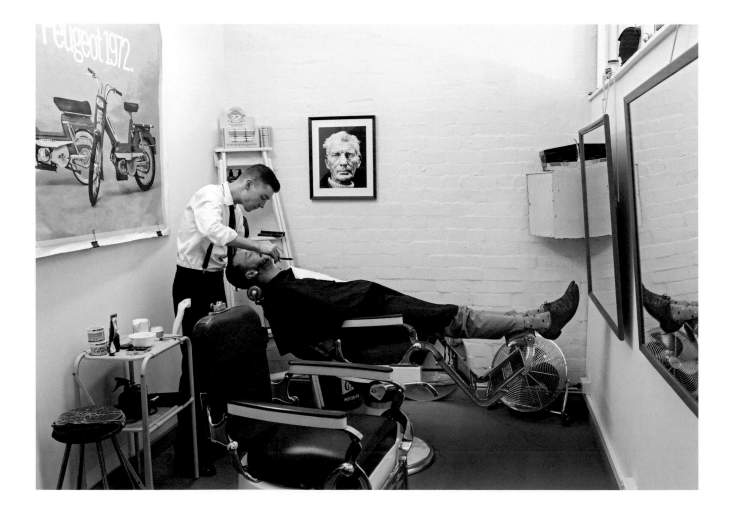

CAPTAINS OF INDUSTRY

James Roberts and Thom Grogan started Captains of Industry because they thought there was a "lack of handsome handmade goods to buy" and because they couldn't find "a place to get a decent cut and shave." At Captains they make custom kangaroo shoes and made-to-measure suits, as well as offer that decent haircut. Their original idea grew into the concept of a café where everything is made in-house. They make their own ginger beer, slow cook their pork, and serve locally roasted coffee. Nothing at Captains is pre-made, and "everything is made to order," from the clothes to the food. These old-school concepts also translate into their customer service, which is always extremely polite and respectful.

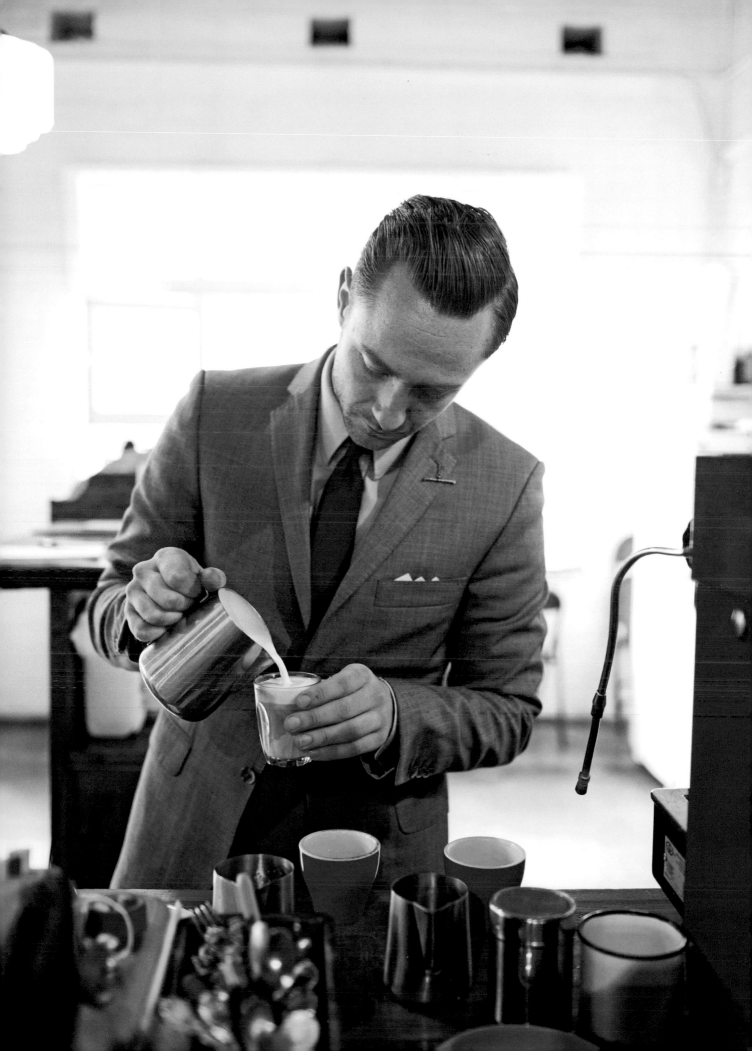

The Knuckle Sandwich...

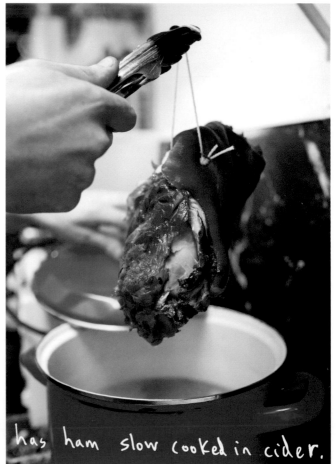

has ham slow cooked in cider.

GENTLEMEN'S FARE

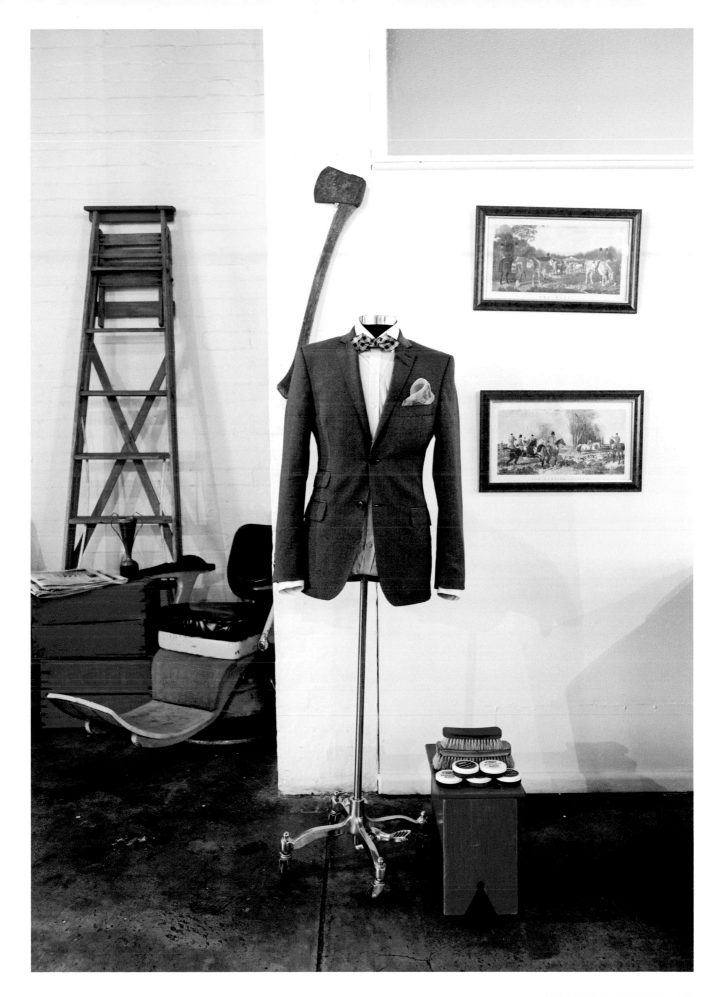

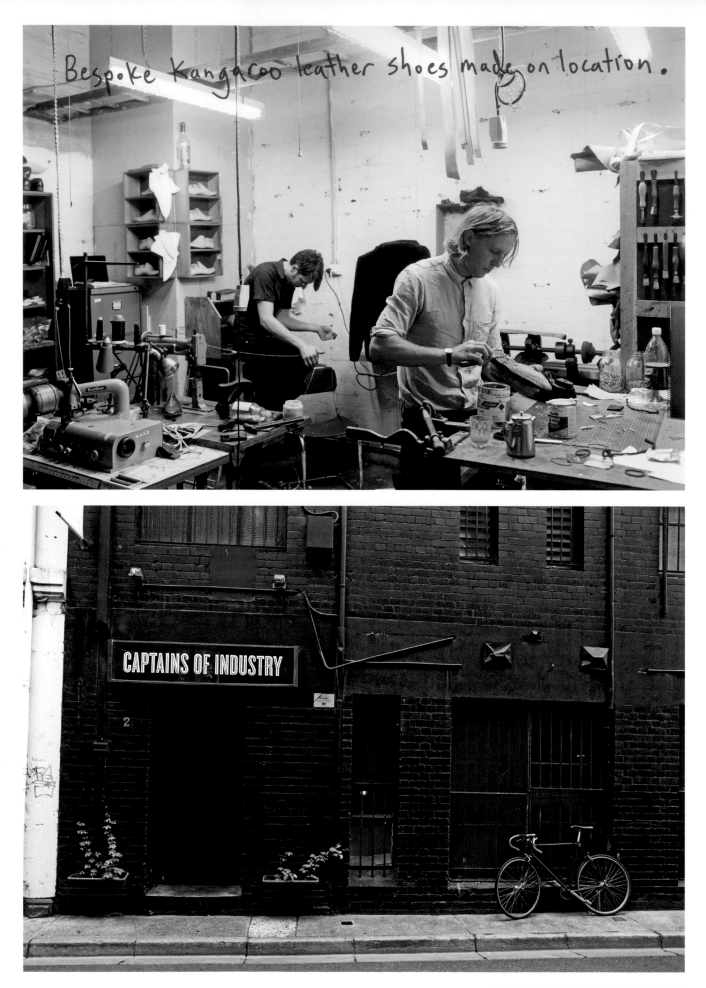

Bespoke kangaroo leather shoes made on location.

THE WORKSHOP

Hi Thom, James + Sam! Thom what is Captains of Industry?

CAPTAINS IS A OUTFITTERS & CAFE. A FOCUS ON SERVICE & THE SHOPKEEPER IDEALS. BY SUPPORTING THE LOCAL COMMUNITY.

James could I get the recipe for ginger beer?
- Its not a traditional, alcoholic ginger beer. (we aren't licensed - yet).
- You will need ~½kg roughly chopped ginger, 2.5 cups of sugar, at least 2.5L of water (hot!) - some ginger is stronger than others, so adjust to taste. Juice of 2 lemons & 2 tsp of yeast. Don't put the yeast into boiling water, that will kill it. Leave it in a warm, dry, dark place overnight. Serve on ice. Yum

Sam could you draw and label your 2 favorite hairstyles you cut? *classic shapes mixed with military cuts.*

Sharp part
Tapered edges
Square angles
CLASSIC SHORT BACK + SIDES

Nice + short, worn forward w/ texture
the STEVE McQUEEN

James could you draw and label your Knuckle Sandwich

7 grain loaf
pickles
rocket
vintage cheddar
ham hock
cauliflower & herb mayo.

Thom could you draw + label a layout of Captains of Industry

DESK
TAILOR
FITTING ROOM
CHAIR CHAIR
BARBER
SHOE MAKER
BAR
RETAIL SECTION
* NOTE MAY NOT BE TO SCALE *

Thom how is the food/drink here informed by the tailoring/shoe making/barber shop?

JUST LIKE OUR SHOES, SUITS & CUTS NOTHING IS PREMADE. MADE FRESH WITH CARE & PRIDE, BY US.

James could you draw + label one of your shoes?

- Vintage Bone Shoe Buttons
- Hand-dyed chocolate brown
- Vegtan Roo Upper
- Leather stacked heel
- Classic 60° Almond toe
- Good-year welted sole - stitched by hand

James could I get the recipe for strawberry cordial?
- You will need; 500g strawberries, 2x cups sugar, 2x cups of water, 2x cinnamon sticks & a dash of balsamic vinegar. + juice of ½ lemon!
- Simmer for 10 mins then push through a sieve.
- Serve over ice with soda or mineral water.

Thom who are your style icons?

① SERGE GAINSBOURG ③ MICHAEL CAINE ⑤ MY GRANDAD

② ROBERT REDFORD ④ DAVID BOWIE ⑥ CLINT EASTWOOD.

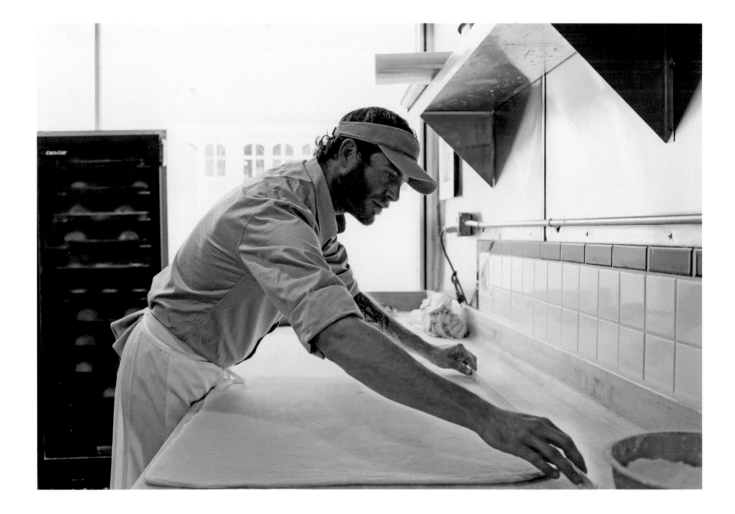

TARTINE BAKERY

Chad Robertson and Elisabeth Prueitt started their first bakery in Point Reyes in 1995. Chad baked the bread and Liz made the pastries, which they sold at the farmers market. They baked everything behind their house and traded a lot of bread and pastries for their groceries. Tartine is now a San Francisco foodie destination—people line up to get a pastry in the morning and for the bread when it comes out of the oven in the late afternoon. Liz learned baking on her Easy-Bake Oven that she got as a little kid, and still makes a lot of her favorite childhood treats, like lemon bars and brownies. The cakes at Tartine are decorated with leaves and edible flowers from a neighbor's plot in a community garden a block away.

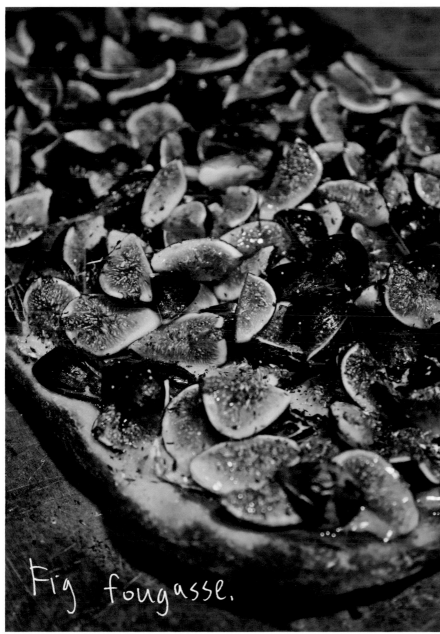

Fig fougasse.

Frangipane croissant

BREAD AND PASTRY

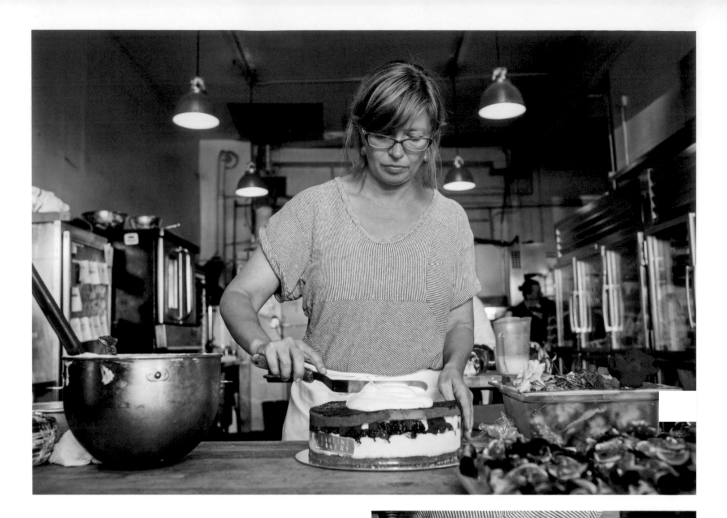

The flowers used to decorate the berry cream cake come from a neighborhood garden.

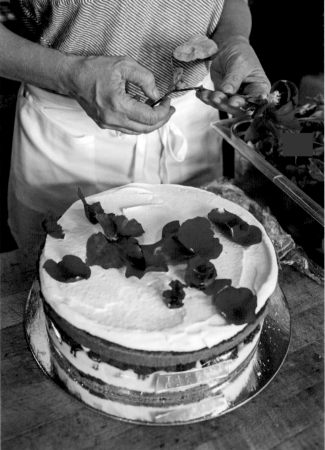

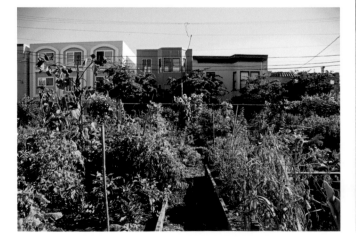

BERRY CREAM CAKE

Hi Chad + Liz! Chad what's fun about old bread?
 infinite potential: making great food
 from leftover crusts

Chad how should I make toast?
 heat some butter in a cast iron
 skillet, cut a thick slice and fry
 until crispy and tender on one side

What's your tuna tartine recipe? chop pickled caper berries and mix
with mayo - spread on toast - use the good chunky tuna
in glass jars - drain and layer onto mayo spread - season
with zater or smoked paprika chili and squeeze
 of lemon juice

Liz when is the last time you licked the bowl? TODAY. BUT THAT'S
BECAUSE YOU ASKED ME WHEN & I WAS INSPIRED TO. I WILL MAKE A
POINT TO DO THAT MORE OFTEN NOW.
Chad what is the most fun you have ever had baking?
 making bread for people
 on holidays - always fun
 LIZ: TODD, WHY DIDN'T YOU ASK ME THIS QUESTION?
ANY TIME I'M TRAVELLING & I HAVE TO PULL SOMETHING
OUT OF A HAT. THE PRESSURE IS GOOD FOR CREATIVITY.

Chad could you draw a self portrait made from bread

Liz what are the top 4 underrated baking
ingredients?

① NUT FLOURS
② HONEY
③ FIGS
④ CORN

Birthday Head Bread
(made by Trevor)

Chad what is the best thing you have
ever smelled? toast fried
 in butter

L'OSTERIA SENZ'OSTE

The most prestigious area to grow Prosecco in Valdobbiadene is a hill called Cartizze. If you walk up the right stone trail through the grape vines, you will arrive at an old stone farmhouse restaurant called L'Osteria senz'Oste. What makes this restaurant totally unique is not just its incredible location and view, but the fact that no one works there. Most of the time, you have the whole place to yourself. You walk in the front door and can help yourself to Prosecco from the fridge and a picnic of salami, cheese, hard-boiled eggs, and bread. You leave euros in the ceramic cow and enjoy your meal. The founder of L'Osteria is Cesare De Stefani, the owner of a local salami factory, who had the idea to share this unique place with everyone in the spirit of freedom and personal responsibility.

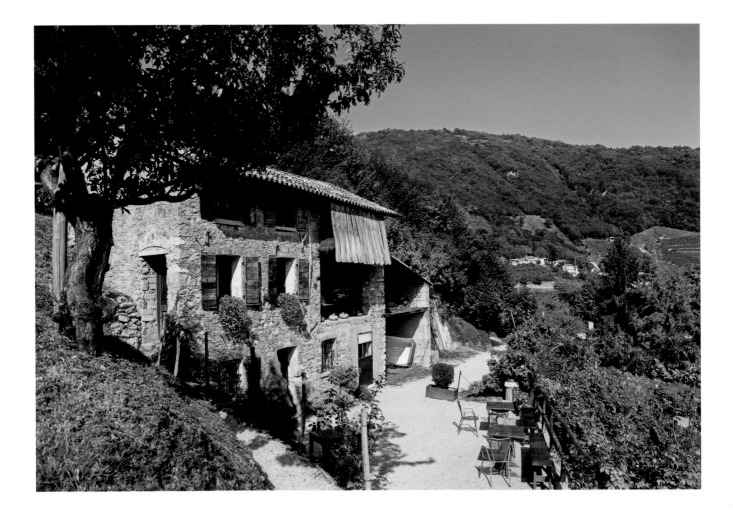

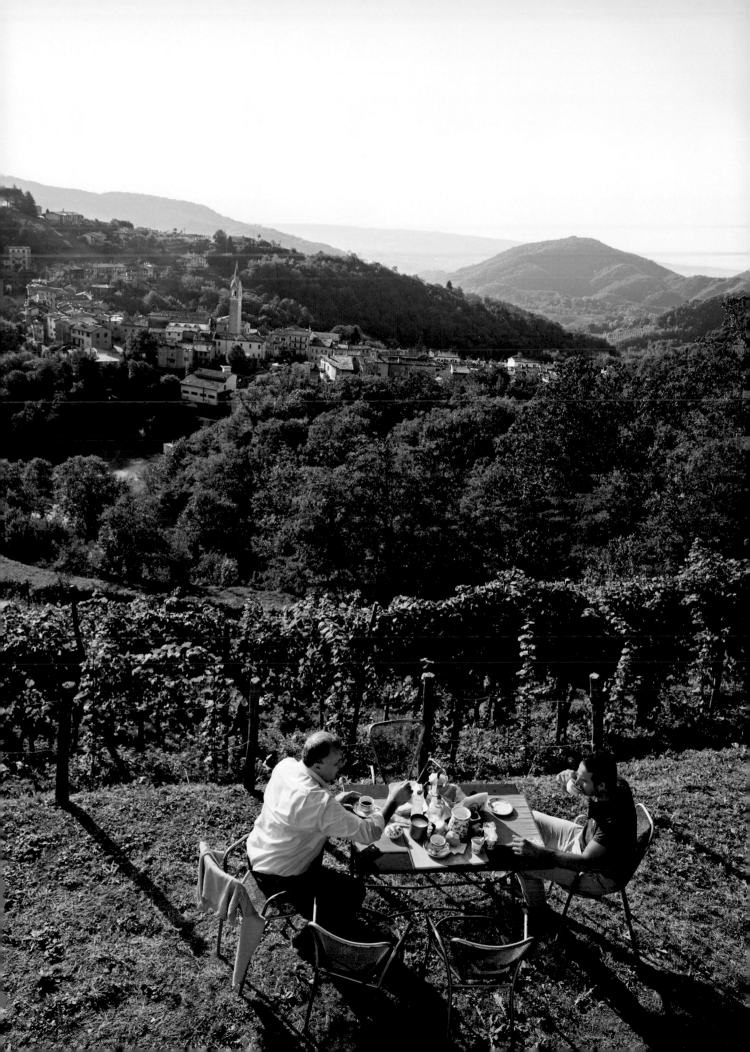

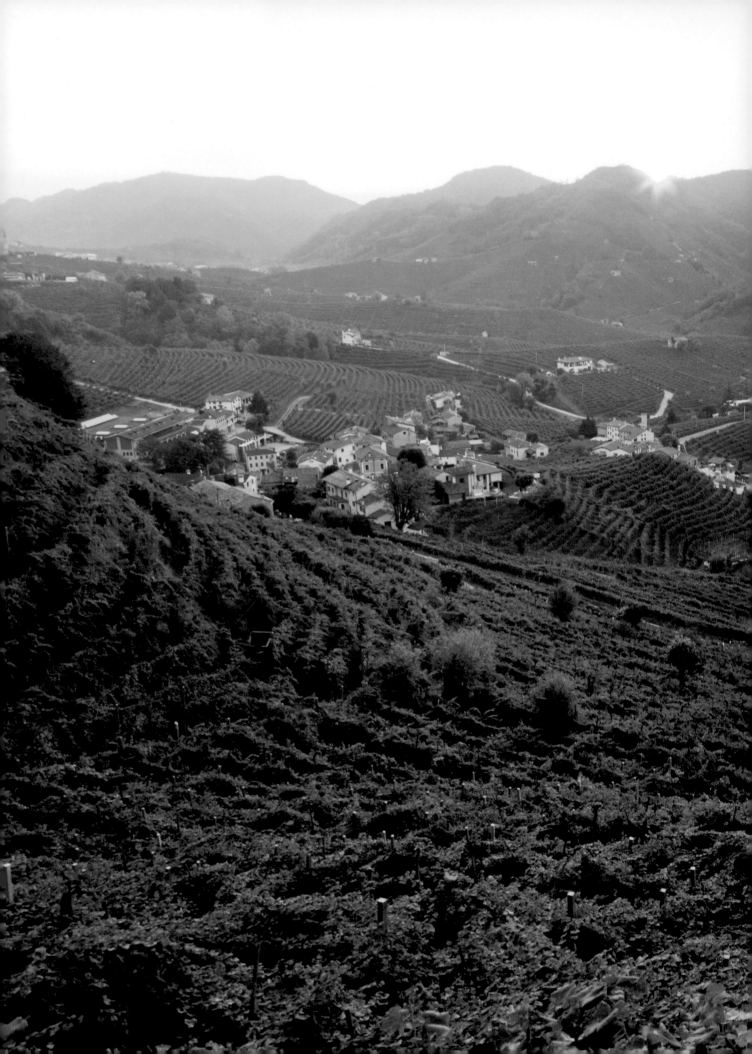

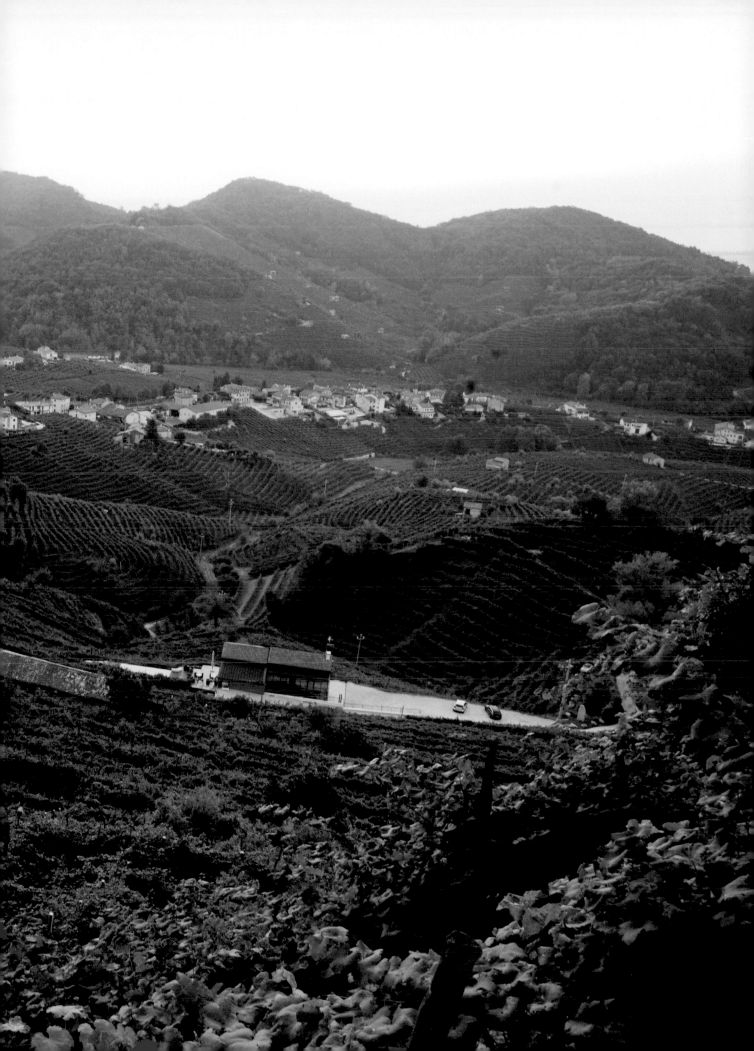

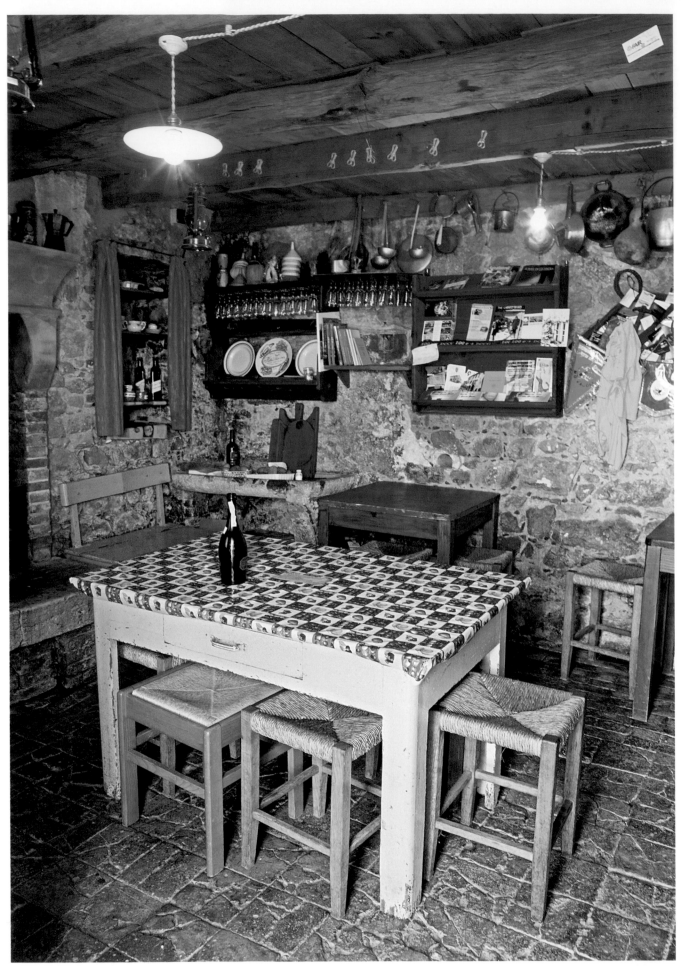

HELP YOURSELF

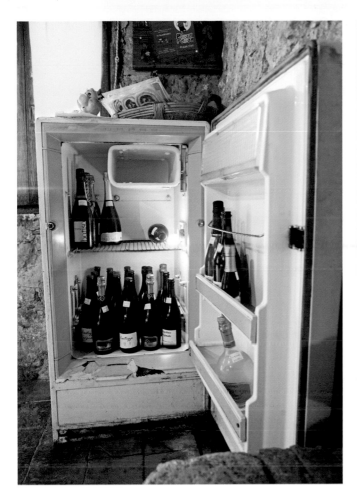

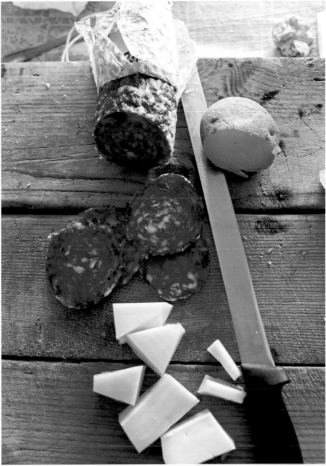

Prosecco from Valdobbiadene,

Cesare sausage, mountain cheese, and a boiled potato.

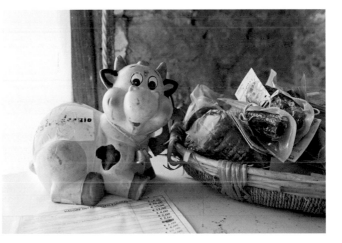

Leave your euros in this piggy bank.

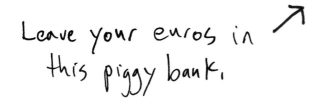

The old cottage's kitchen is now L'Osteria's main dining area.

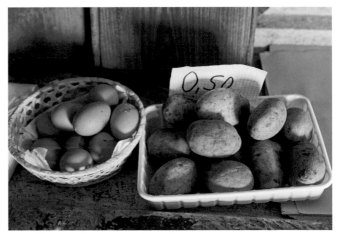

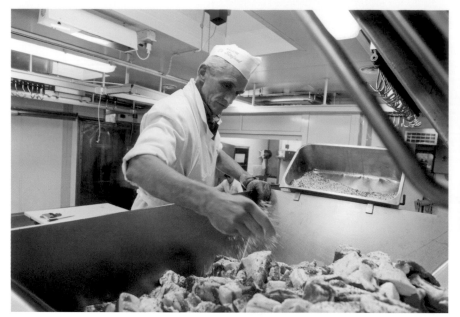

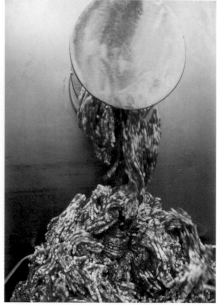

Spraying Prosecco so the salami absorbs the aromas. →

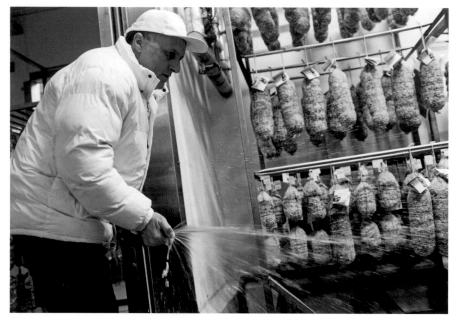

Sopressa Dama Bianca is sausage stuffed with seasoned pork fat.

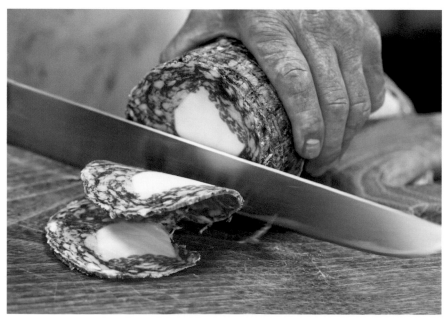

SALUMIFICIO DE STEFANI

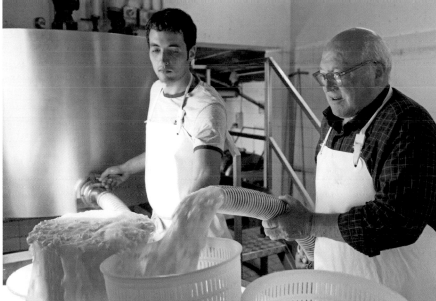

Every week the
Curto family
delivers cheese
to the Osteria.

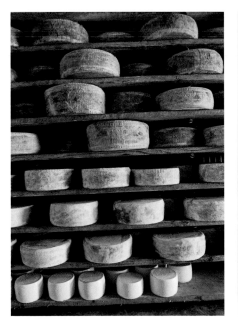

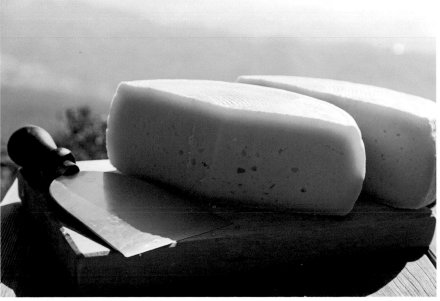

MOUNTAIN CHEESE

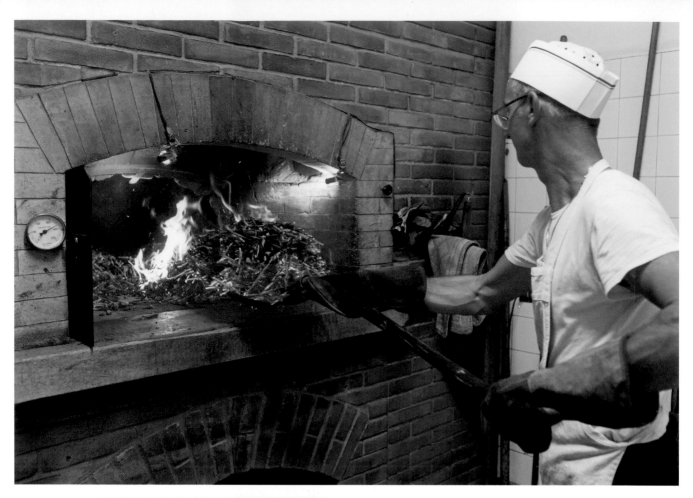

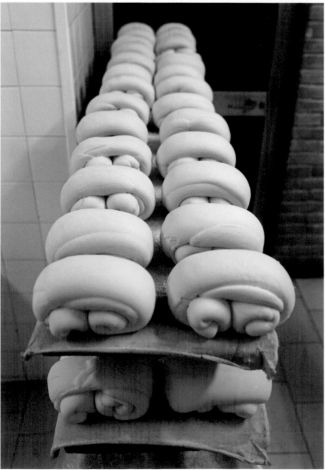

Paolo Vanzin bakes the bread for the Osteria with dried grapevines.

THE BAKERY

Hi Cesare! Could you draw me a map on how to get to Osteria Senz'Oste?

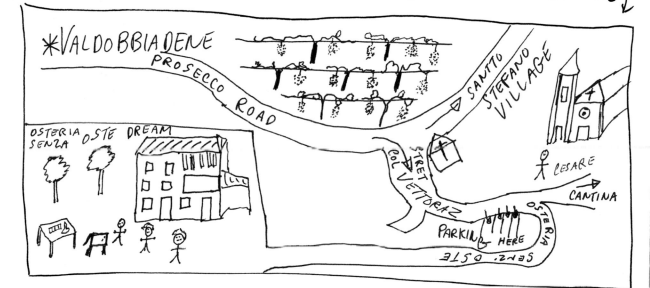

*VALDOBBIADENE
PROSECCO ROAD
SANTTO STEFANO VILLAGE
OSTERIA SENZA OSTE DREAM
SAN TO
STRET Col VETTORAZ
CESARE
CANTINA
PARKING HERE
OSTERIA SENZ'OSTE

What 6 things make Osteria Senz'Oste so unique
① THE FEELING OF BEING IN A PRIVATE HOME
② THE OPPORTUNITY TO TRY SALUMI AND CHEESE FROM LOCAL PRODUCERS
③ TO EAT LIKE YOU ARE HOME
④ TO PAY WHAT YOU THINK YOUR MEAL IS WORTH
⑤ THE MANY COLORS AND TRADITIONS OF THE COUNTRYSIDE
⑥ FREEDOM TO SHOW YOUR RESPECT AND RESPONSIBILITY

How are you like a tiger? I FEEL WELL AND MY LAND GIVE ME ENERGY ⚡⚡⚡

How many visitors does Osteria Senz'oste get a year? 50.000 PEOPLE A YEAR

Can you draw the place people put the money for what they take →

Why did you start Osteria Senz'Oste?
TO PROVIDE HOSPITALITY TO MY FRIENDS AND ALL THE PEOPLE OF THE WORLD WHO I CONSIDER MY FRIENDS AS WELL

What do you love about sausages?
I LIKE SAUSAGES BECAUSE I MAKE THEM !!!! OK MY FRIENDS ?!!!

FOR MONEY
(0 FOR NOTHING)
SALAMI
PROSECCO

Could I get a recipe for a dish made with prosecco? RISOTTO WITH PROSECCO
280 GR WHITE ITALIAN RICE
20 GR ONION - A GLASS OF PROSECCO - PEPPER AND SALT (SOME) - BUTTER
CUT THE ONION AND PUT IN A BOWL WITH OIL EXTRA VIRGINE D'OLIVE
AFTER WHEN THE ONION IS BLONDE PUT THE RICE AND TOASTED' FOR FEW MINUTE. WHEN THE RICE IS HOT PUT THE WINE PROSECCO AND EVAPORATE IT. AFTER THAT COOK WITH VEGETABLE BULLION FOR 20 MIN. AT THE END MIX WITH A PAT BUTTER
CIAO

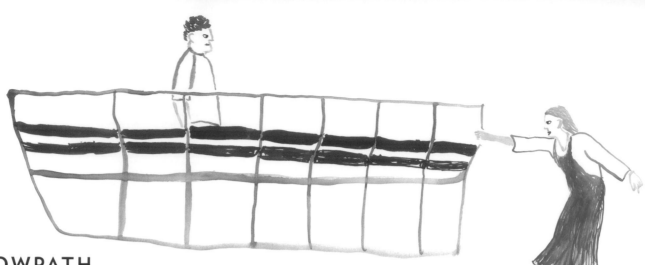

TOWPATH

Jason Lowe and Lori De Mori started Towpath café in a small hole-in-the-wall space that opens onto a canal in Haggerston, London. This canal is a peaceful, strange place that has so many birds, boaters, and fishermen, but is still very urban. Lori describes Towpath as "a sort of hitching post, where people step out of their crazy city lives for a minute." Jason is a food photographer and Lori is a travel writer, and both of them have gone all over the world and brought back their favorite recipes and ideas and integrated them into Towpath. In good weather Jason rows a pontoon that has a circle of benches on it in front of the café for people to relax on while they drink their coffee. Chef Laura Jackson takes pride in making food that you would be happy to eat every day, inspired by Jason and Lori's travels and also by the changing seasons, which you experience very strongly on the canal.

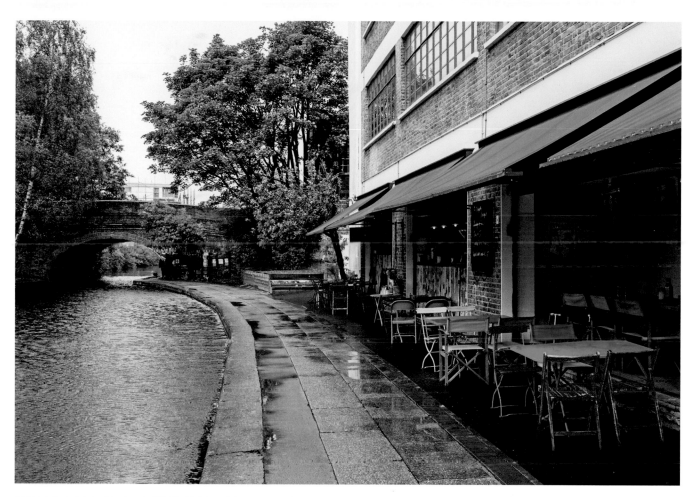

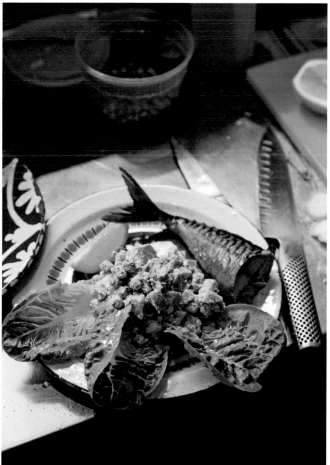

Smoked mackerel, Russian Salad, and Little Gem lettuce.

Potted brown shrimp from Morecambe Bay.

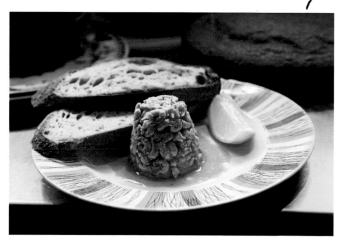

CAFÉ ON THE CANAL

Chef Laura Jackson putting the yogurt to bed. ⟶

Olive oil cake.

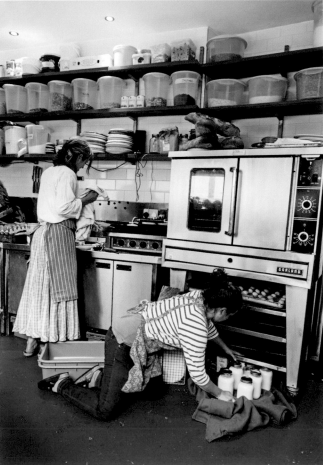

MAKING BREAKFAST

Hi Laura, Lori + Jason, could you draw + label an aerial view of Towpath including the barge + a fire?

Could I get the recipe for potted shrimp?

For 5 potted shrimp.
Melt 250g unsalted butter.
Add 1 tablespoon mace, 1 tablespoon cayenne,
salt + pepper + juice of 1 lemon. Mix well.
Let cool a bit + add 500g brown shrimp.
POT into glasses. Set in fridge overnight.

Jason could you draw + label your car?

Sloop built b: 15 Citroen. 1953

Leather
Wood
Lucas electrics
Slow motion

Could I get the recipe for your olive oil cake?

For 1 cake.
3 eggs
300g castor sugar
¾ cup olive oil
¾ cup milk
zest + juice 1 orange
300g self-raising flour

① Line + grease tin
② Beat eggs + sugar til white + fluffy.
③ Slowly add oil, milk + orange
④ Fold in flour.
⑤ Bake @ 170°C til skewer comes out clean ~40 mins

Jason what are your 6 favorite restaurants in France?
① LA MERENDA NICE. ③ CAFE DE TURIN. NICE ⑤ LE RUBIS, PARIS.
② AUBERGE DE CHASSIGNIOLLES ④ MICHEL-BRAS ⑥ L'AMI LOUIS PARIS.

Lori what are your 6 favorite restaurants in Italy?
① Sostanza (Florence) ③ Pizzeria Lo Spela (Ferrone) ⑤ Al Covo (Venice)
② Coco Lezzone (Florence) ④ Solo Ciccia (Panzano) ⑥ Da Bruno (Forte dei Marmi)

Laura what are your 6 favorite restaurants in England?
① Mangal (Dalston) ③ The Sportsman (Whitstable) ⑤ St. John (Spittafield / Smithfield)
② Sushi Say (Willesden) ④ Barrafina (Soho) ⑥ Majjo's (East Finchley)

what are the craziest/funniest things you have seen happen on the canal?
MANY!! ... naked man sunning himself at one of our tables
man in homemade canoe made out of matchsticks
towpath crew nighttime swimming in canal
assorted people falling into canal
parade of signets, baby coots and various other water fowl
swan admiring itself in reflective glass
bird trying to eat eel + it won.
man walking barefoot to Scotland

NEXT

The thing that inspires me the most about chef Grant Achatz is his dedication to asking questions and coming up with his own answers. When you eat at one of his restaurants, Alinea or Next, Grant's dedication to questioning assumptions is obvious. At Alinea, Grant asks questions like "Why should we eat off plates?" and at Next he asks "Why should a restaurant stay the same?" Every three months Next's theme will change, and chef Dave Beran will be cooking totally different cuisines. The first three themes after Next opened in early 2011 were Paris 1906—Escoffier at the Ritz; Tour of Thailand; and Childhood.

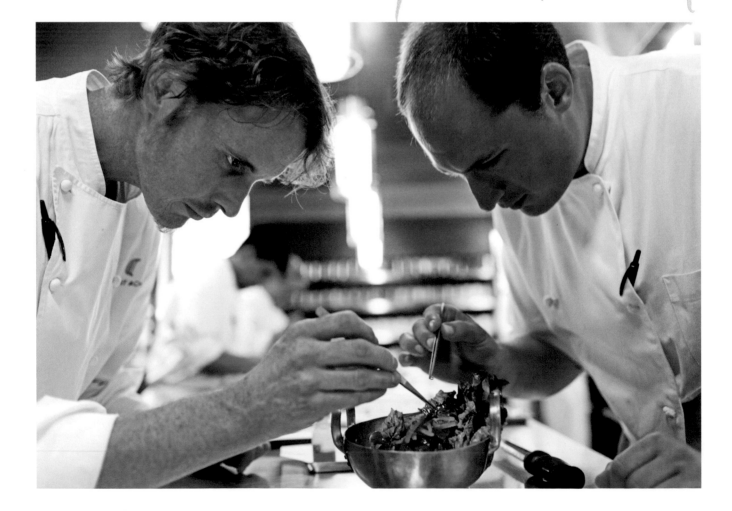

↑

Coconut Dessert—
licorice tapioca,
golden strands,
candied mango,
corn pudding, and
fennel pollen.

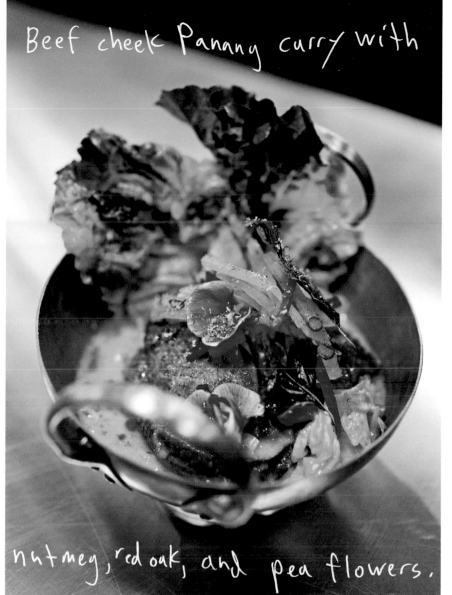

Beef cheek Panang curry with

nutmeg, red oak, and pea flowers.

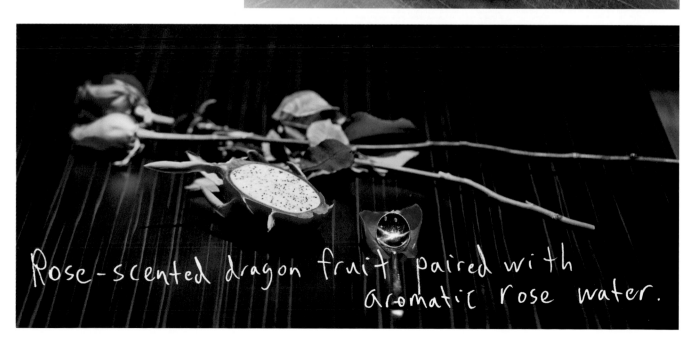

Rose-scented dragon fruit paired with
aromatic rose water.

THE THAI MENU

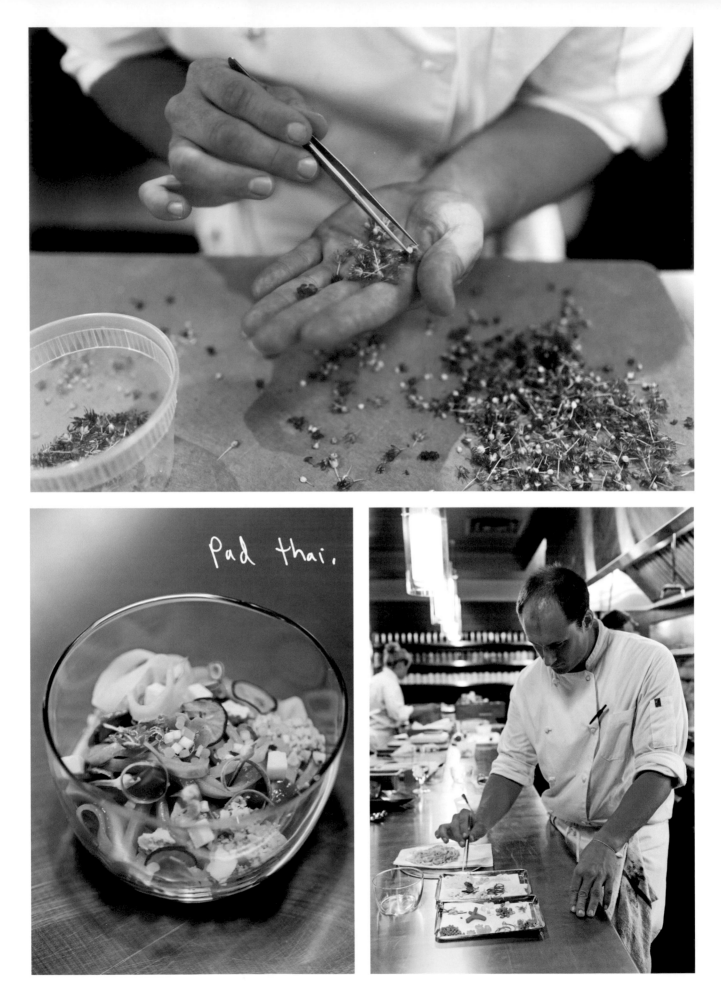

pad thai.

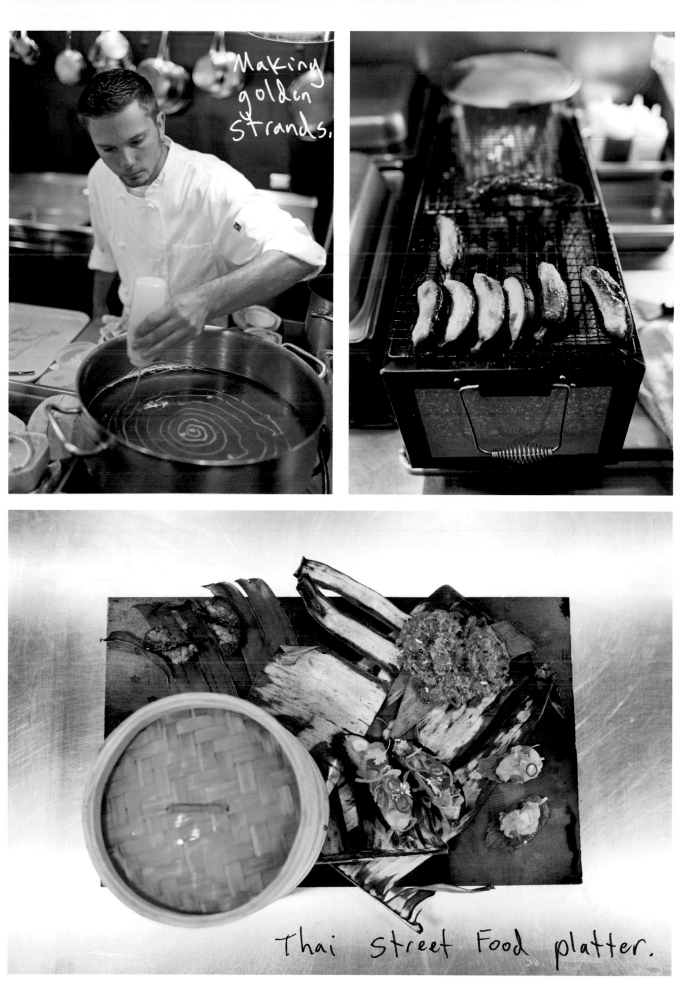

Making golden strands.

Thai street food platter.

IN THE KITCHEN

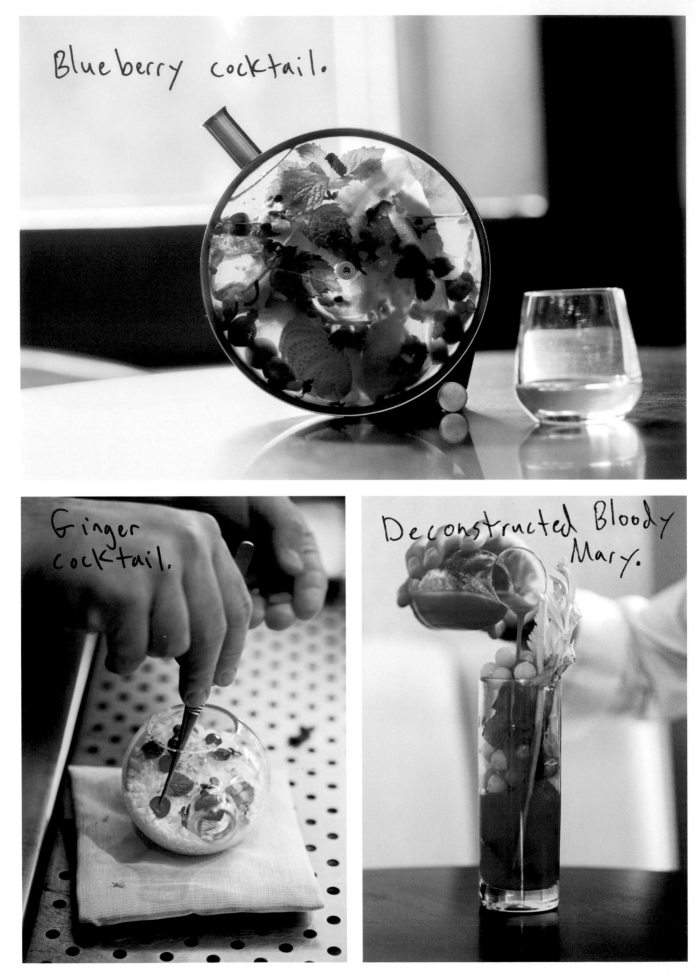

Blueberry cocktail.

Ginger cocktail.

Deconstructed Bloody Mary.

COCKTAILS AT THE AVIARY

Hi chef Achatz. Could you draw + label the Next Pad Thai ↓

when is food art?
Always. if the person eating
it or cooking it.... or serving
it allows it to be in their mind.

what are all the elements of a
cocktail? Exactly. why do
they have to be defined ??

ground peanut
cilantro
chili powder
tofu
bean sprouts
lime
Pink radish
carved carrot flowers
rize noodle
salted dickon
long beans
egg yolk

Could I get the recipe for your Panang Curry?
Yes. But not Here. It will not
fit in this space. Does mean
you liked it?

What motivates you?
Failure, Freedom. Friendship

Could I get the recipe for your blueberry cocktail?
Yes. See above. BTW, the two won't
pair well together

How many kinds of Ice do you have available at Aviary? Currently 23
different forms
and counting.

Why did you choose Thai food for Next's menu?

We wanted to do something drastically
different the Our opening menu of paris 1906.
Techniques, ingredients, ways of serving and
overall fell are obviously different.

Thanks!

ISHIMIYA

Seiji Nojiri-san is one of the top tuna wholesalers in the world; his company, Ishimiya, buys and sells the highest quality tuna out of Tokyo's Tsukiji Market. Nojiri-san goes to the auction early in the morning to poke, prod, and examine every inch of the fresh wild tuna that catch his eye. It's critical that he chooses wisely, as the fish can regularly fetch over $100K each, and he has to decide the quality mainly on his intuition. It's a sad fact that wild tuna are dwindling in number, and most of the high-end tuna one normally consumes is probably farmed and frozen, which gives it a slightly metallic taste.

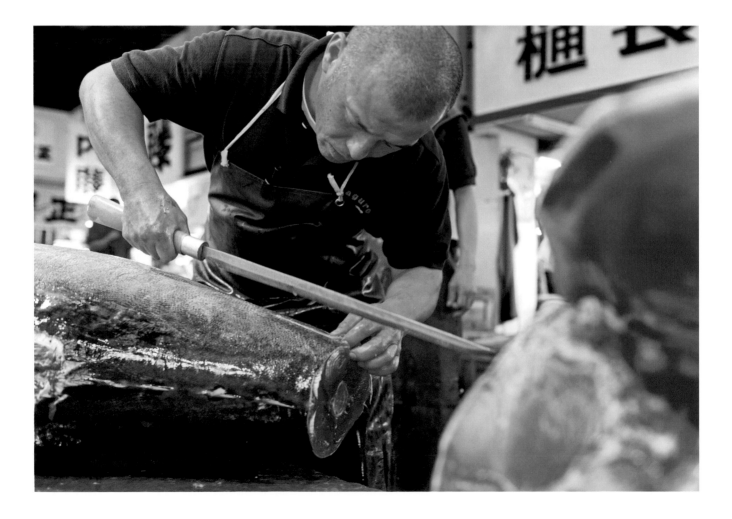

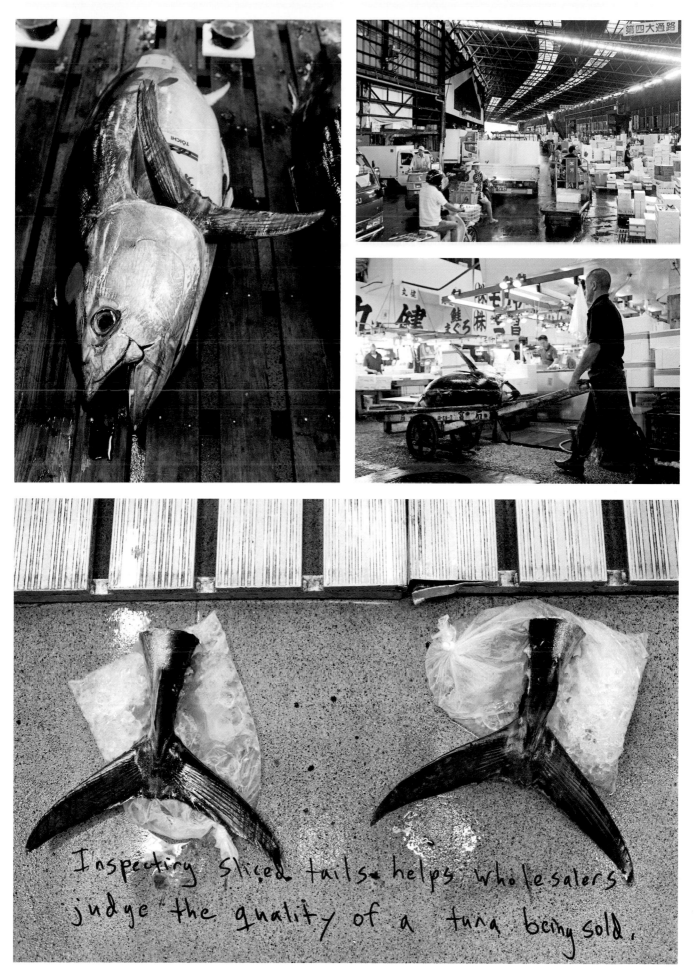

Inspecting sliced tails helps wholesalers judge the quality of a tuna being sold.

TSUKIJI FISH MARKET

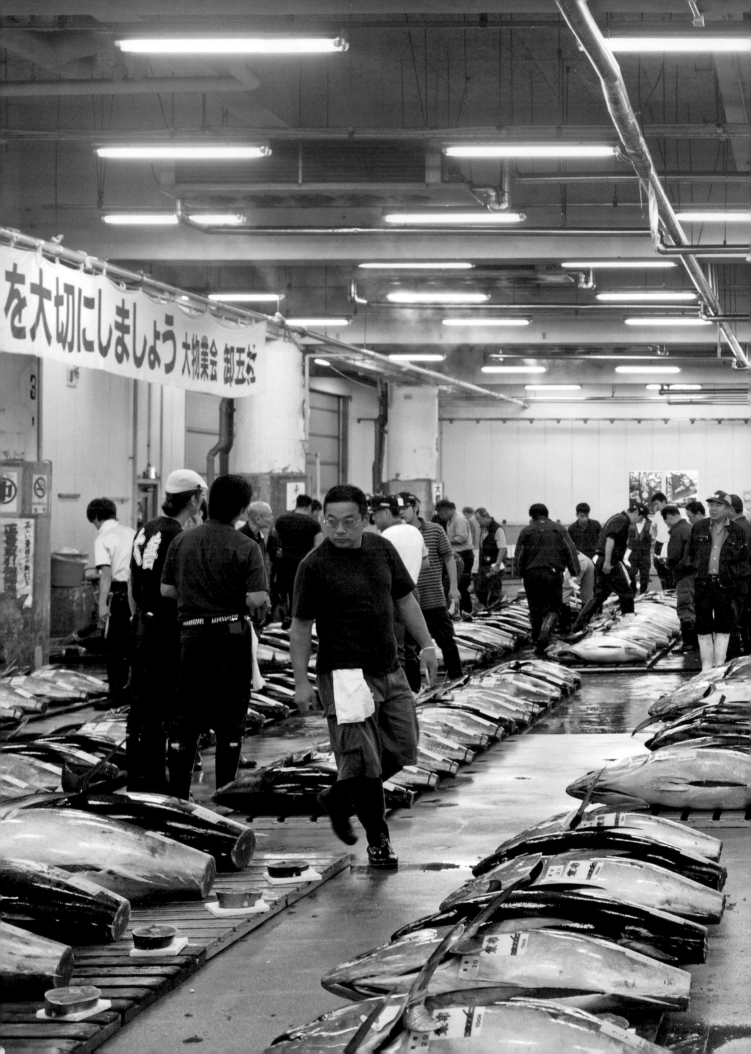

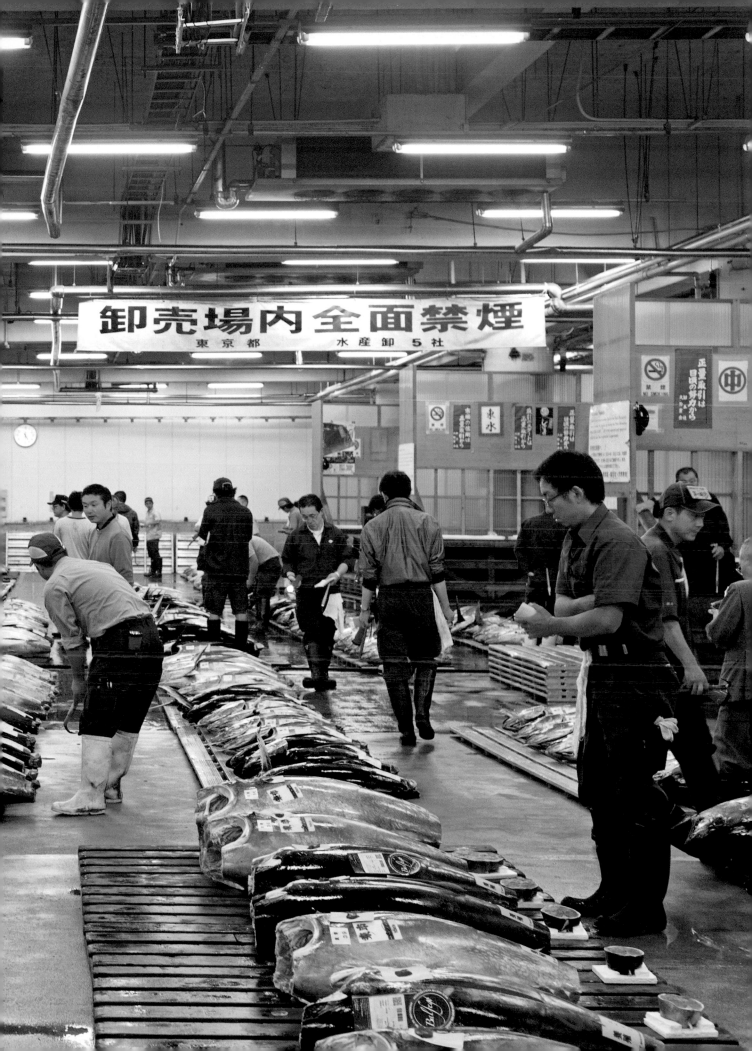

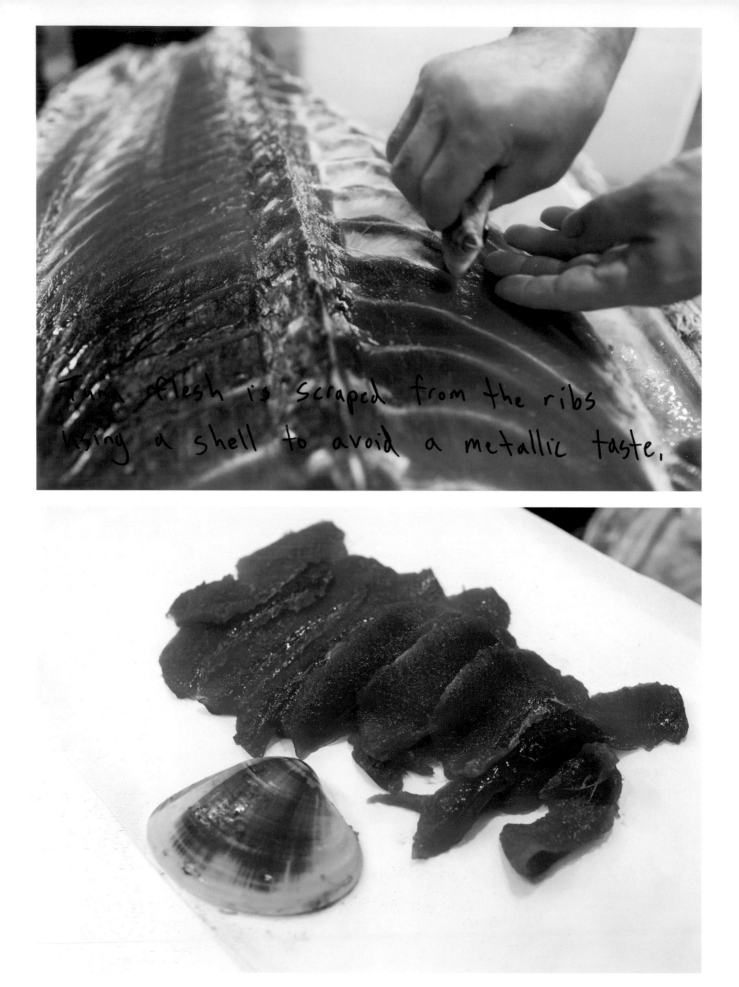

Tuna flesh is scraped from the ribs using a shell to avoid a metallic taste.

SCRAPING NAKAOCHI

Hi Nojiri-san! Could you draw + label the different parts of a tuna?
What are the reasons that tuna is king of all fish?

王様かどうかは？ですが
好きな人が一番多いのは確か
だと思います。お寿司の代名詞と
言えば当然、ま〇〇です!!

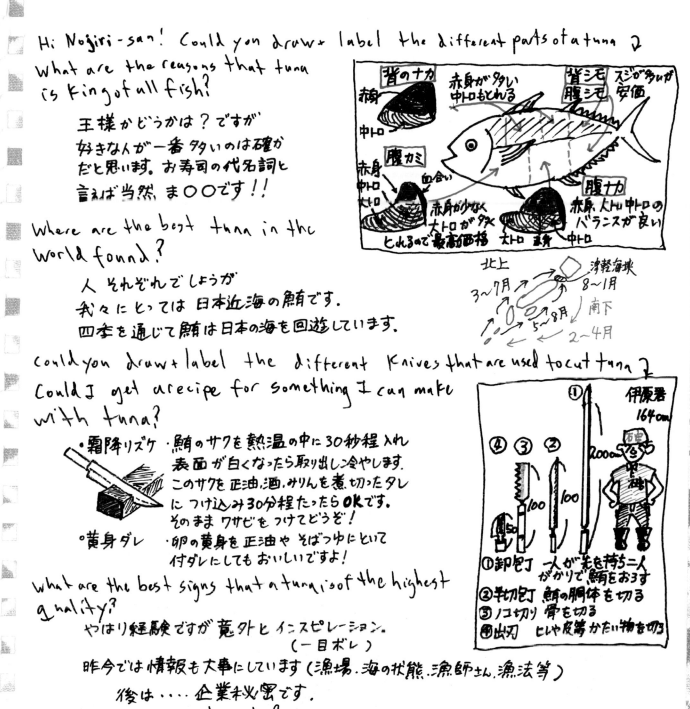

背のナカ　赤身が多い　中トロもとれる　背シモ　スジが多いが　腹シモ　安価
鮪
中トロ
腹カミ
赤身
中トロ
大トロ
血合い
赤身が少なく大トロが多い　とれるので最高の価格　大トロ　赤身　中トロ
腹ナカ
赤身、大トロ、中トロのバランスが良い

北上　3〜7月　津軽海峡　8〜1月
5〜8月　南下　2〜4月

Where are the best tuna in the world found?

人 それぞれでしょうが
我々にとっては 日本近海の鮪です。
四季を通じて鮪は日本の海を回遊しています。

Could you draw + label the different knives that are used to cut tuna?
Could I get a recipe for something I can make with tuna?

・霜降リヅケ ・鮪のサクを熱温の中に30秒程入れ
表面が白くなったら取り出し冷やします。
このサクを正油、酒、みりんを煮切ったタレ
につけ込み30分程たったらOKです。
そのまま ワサビをつけてどうぞ!

・黄身ダレ ・卵の黄身を正油や そばつゆにといて
付ダレにしても おいしいですよ!

①　伊原君　164cm
④③②　石〇
2000g
150　100　100
①卸包丁　一人が先を持ち二人
がかりで 鮪をおろす
②半切包丁　鮪の胴体を切る
③ノコ切り　骨を切る
④出刃　ヒレや皮等 かたい物を切る

What are the best signs that a tuna is of the highest quality?

やはり経験ですが 意外とインスピレーション。
（一目ボレ）
昨今では情報も大事にしています（漁場、海の状態、漁師さん、漁法等）
後は‥‥企業秘密です。

How has Tsukiji changed?

天然本マグロの漁獲量が激減しています。その分 養殖マグロ
が増えており 養殖鮪率 が天然を上回っている日も多くなりました。
ですが、我々はこれからも変わらず天然鮪にこだわっていきたいです。

Can't read Japanese? See page 292.

CAMINO

Russell Moore was the chef at Chez Panisse for 13 years, and during that time he did a lot of cooking at Chez events all over the world and in all sorts of unusual environments. One time he made a meal in a perfectly preserved 17th-century Viennese game kitchen that had no gas, electricity, or running water. That experience had a strong impact on Russell and helped inspire Camino, which he runs with his wife, Allison Hopelain. She describes the dining room as "a feasting hall—long tables, big iron chandeliers, with lots of stone and wood," where the meals are prepared with a wood fire. He describes the food as "appearing super simple," but it's actually very complex. In a lot of ways it reminds us "how all people have cooked forever," but it still feels really modern in its focus and restraint in both cooking and plating.

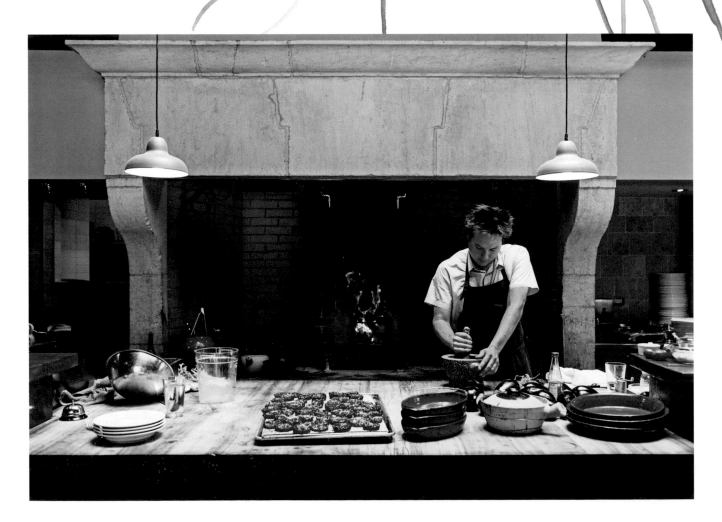

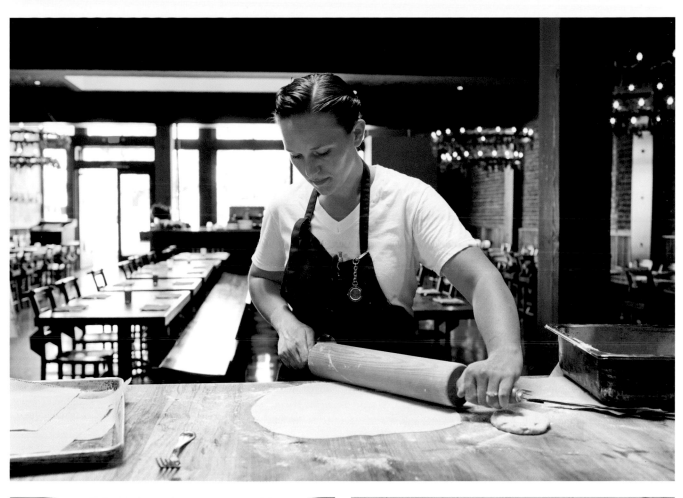

Sardines.

Tomato confit.

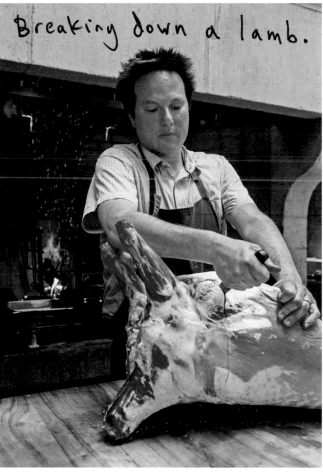

Breaking down a lamb.

COOKING AT THE FIREPLACE

"We don't have any art at Camino except for these goofy papier-mâché pig masks...

They were used in a civil action protesting big fat corporate-pig war profiteers!" —Allison

THE FOOD

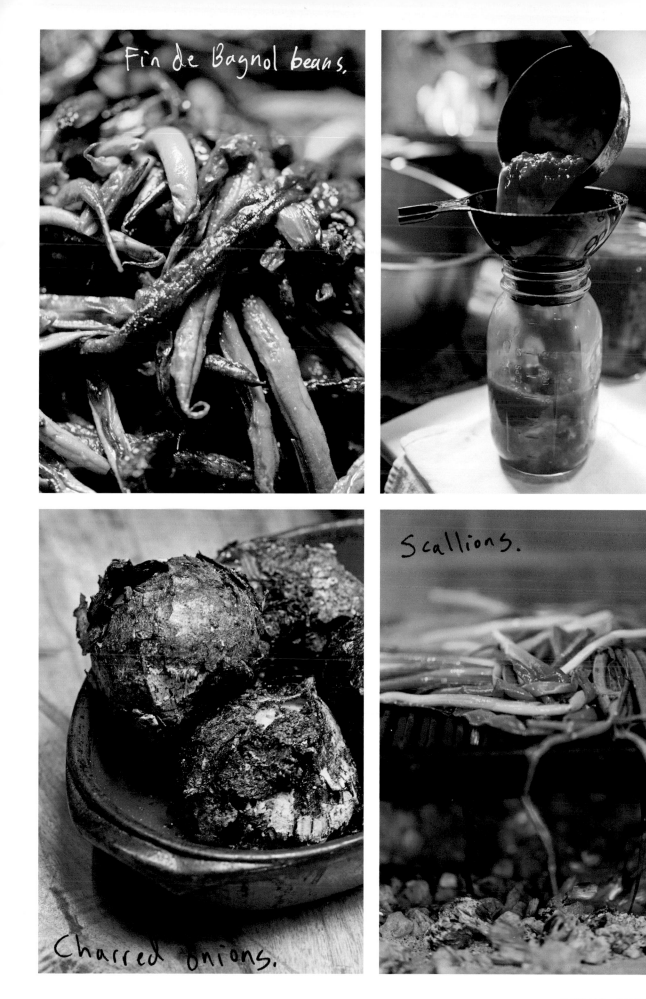

Fin de Bagnol beans.

Charred onions.

Scallions.

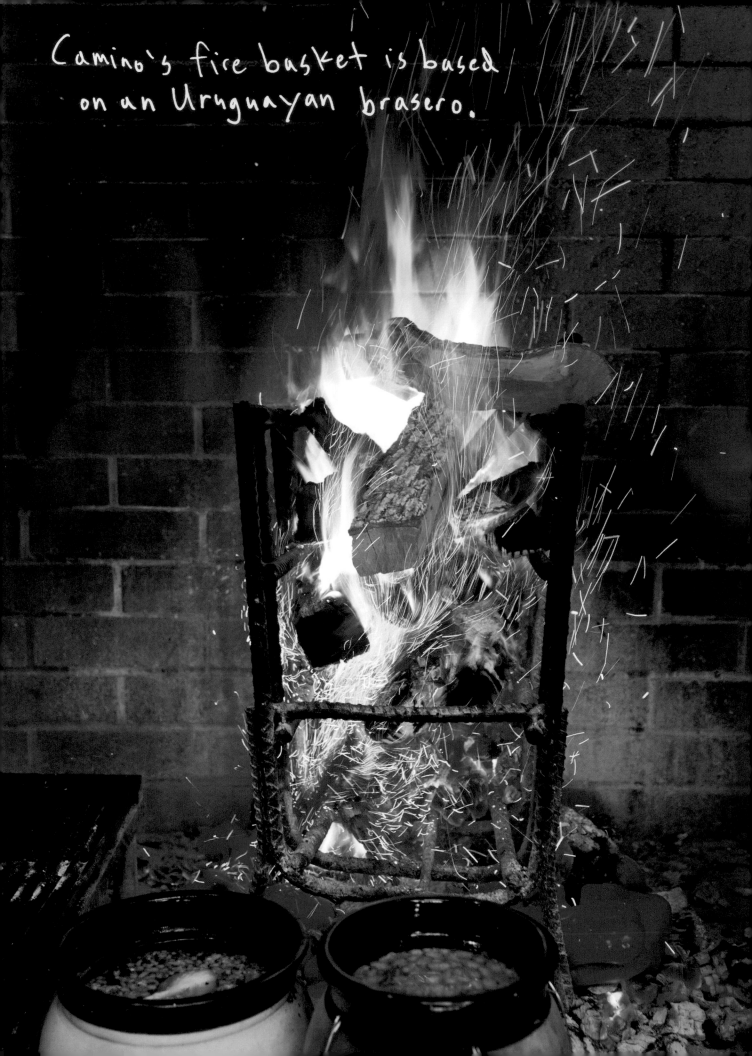

Camino's fire basket is based on an Uruguayan brasero.

Hi Russell! Could you draw + label your fireplace cooking area?

Hooks for hanging meat

olde French grille

aromatic vapors

Fire!

Coals

broken cazuela

over built trivet

coal-raker

How can I make wine vinegar?
If you have enough self control to not finish the bottle, save the ends of your wine until you have enough to fill a barrel add some vinegar that is alive (you need to have some cool vinegar-making friends!). Let the wine sit for 4-6 months and then ... you should have delicious vinegar. siphon most of it out of the barrel + start again (you don't need to add vinegar). Don't use corked wine!

that looks like this in.

what is tweezer cuisine? Tweezer cuisine is when everything has to be very precise + every plate has to look perfect. Here we use really long tongs + our short stubby fingers; we are elegant barbarians.

what are 4 great things about cooking on an open fire?

① Everything changes all the time
② you get to buy beautiful old-world clay pots to cook in
③ If you think something will taste better cooked in the fire It will.
④ It's really hot

what is the most important thing you have learned from a farmer?
 work is hard, tedious + wonderful

How do I make Lamb leg à la ficelle?
season a lamb leg, rub it with pounded herbs, tie it up. Build a fire in your fireplace or outside in front of a wall. Hang the leg from the mantle in front of the fire - not over it! Spin the leg without letting it swing back + forth. Have a dish of beans, parsley, root or potatoes under the leg to catch the lamby, herby drippings.
 Cook 'till done. Rest for 1/2 hour. Eat like Henry VIII.

YOSHIDA FARM

Zensaku Yoshida-san was a businessman working in Tokyo at an office job when he decided in 1984 that he wanted to take his family and move to the countryside. They settled in rural Kibi in Okayama, and started raising Brown Swiss cows and making cheese from their small herd's milk. The farm is largely family-run and they do not buy milk from other farmers. This ensures that the quality of their cheese is always top-notch. Yoshida-san and his son went to France and Italy to learn different cheese styles and now make some very special European-style cheeses that you may be surprised to see coming out of rural Japan.

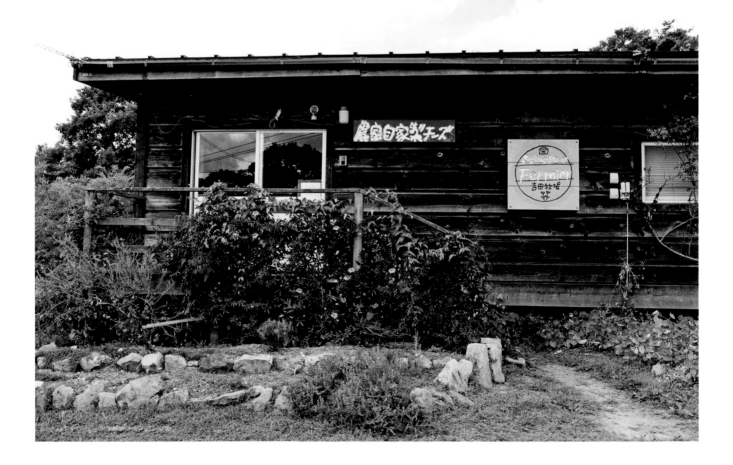

Brown Swiss cows' ears stick out horizontally—
it's an adorable characteristic.

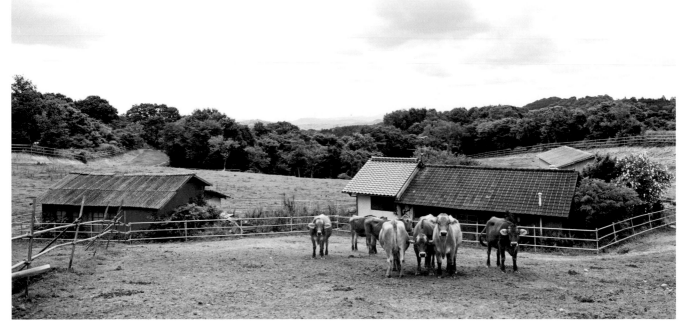

THE FARM

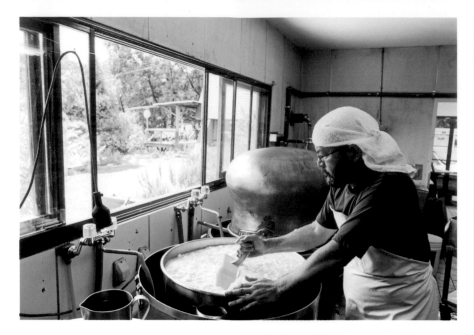

Father and son
making ricotta
using milk from
their cows.

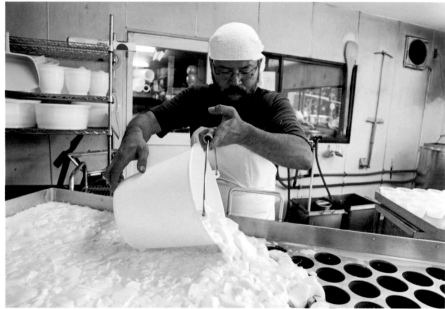

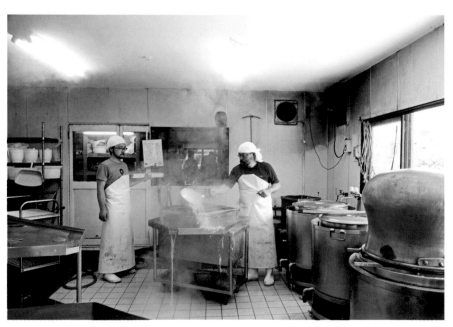

MAKING CHEESE

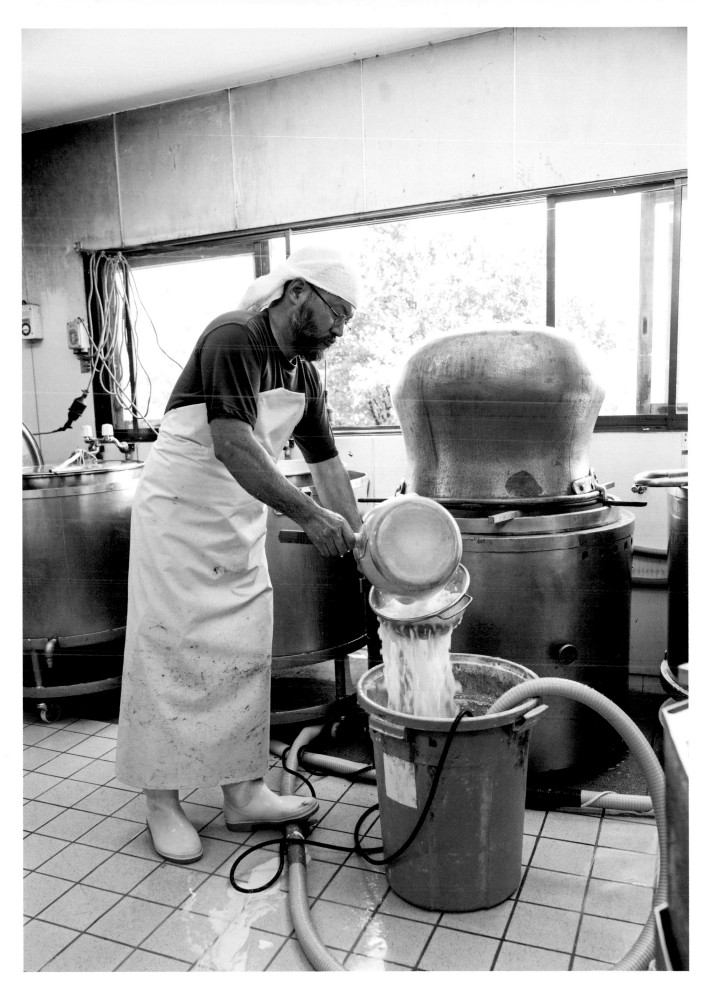

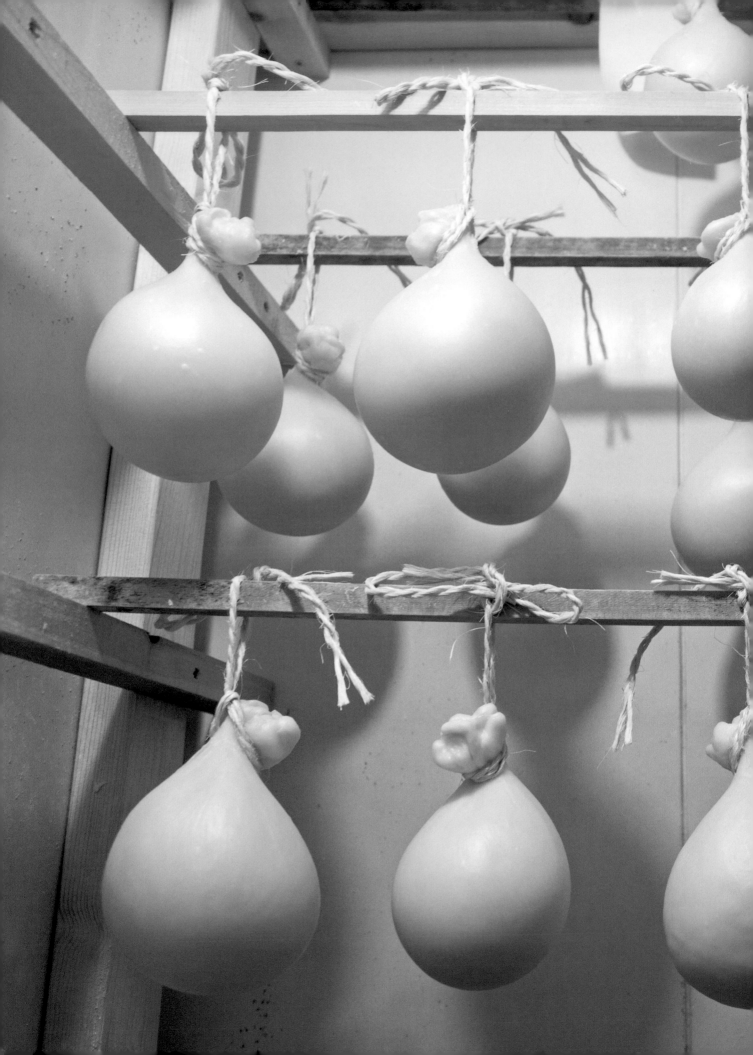

CacioCavallo.

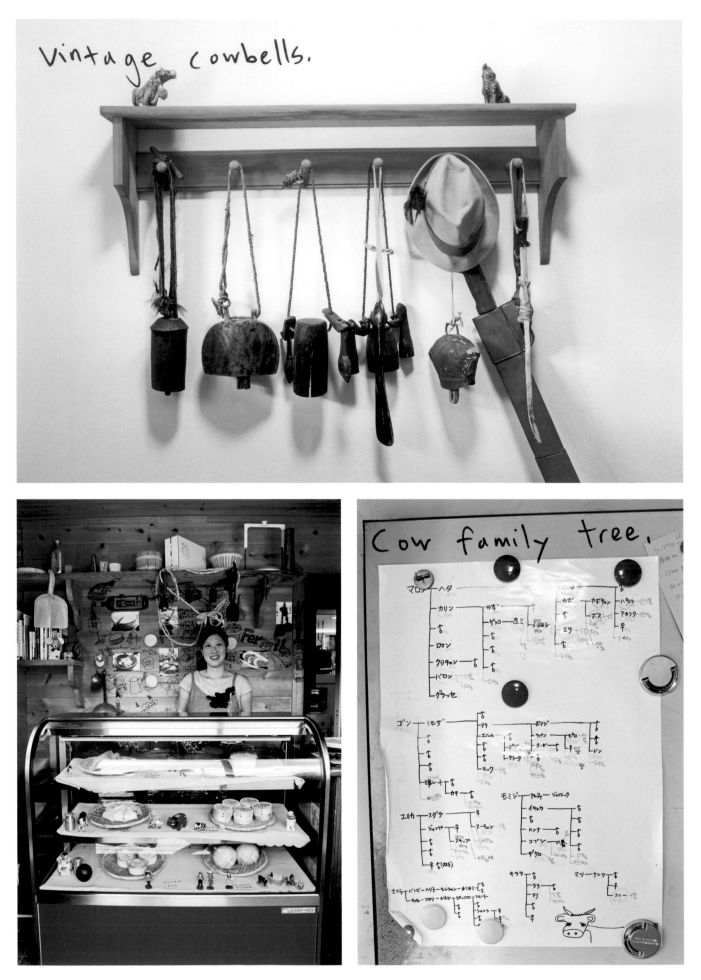

Vintage cowbells.

Cow family tree.

THE SHOP

Hi Yoshida-san! Could you draw + label the 8 cheeses you make →

How do I make mozzarella tempura?

（材料）加水方を切ったモッツアレラ
　　　・いか
　　　・トマト
　　　・バジル
（作り方）全ての材料を1cm角に切り、水で溶いた
　　　　小麦粉にからめ、かきあげする。
（食べ方）ゴミめを入れた塩につけて食べるとウマイ!!

How do I make ricotta sashimi?

リコッタにワサビをのせ、正油をかけて
食べる。簡単。

Why did you quit your office job to start your femier?
　①．食いしん坊　③．物作りが好き
　③．人に使われるのが嫌い　④．東京が肩に合わない。
　⑤．犬な時代、探検部で好き勝手していた。

What are your 6 favorite cheeses that you don't make?
① ロックフォール　　　③ チェダー　　　⑤ パルミジャーノ
② ペコリーノ　　　　　④ ビット　　　　⑥ ミモレット

Could I get the recipe for mozzarella てyke?

小さめのモッツアレラ（チリエーぜ）を、正油、みりん、酒に漬けて
1週間ほど置いおく。

What has cheese taught you?

どんなものを作るのにも、原料（この場合牛乳）の質が大事だと
　　　　　　　　　　　　　　　　　　　　　　　　　いうこと。

What have the cows taught you?

すべての生物には、絶えず個性があり。各々にいとおしい
存在だということが、よく解った

Can't read Japanese? See page 293.

RELÆ

Relæ was created "from the idea of moving an ambitious, gastronomical, and creative kitchen away from the luxurious fine-dining restaurant." It's a modern and refreshing concept Christian Puglisi and his team have developed to strip back all the unnecessary service and "leave people to themselves." One way they do this is by placing the cutlery, menu, and napkins in a drawer at each table for you to set out yourself when you sit. The food itself is also quite stripped back; it's "cut to the bone, creative cooking," which transforms and highlights their amazing produce.

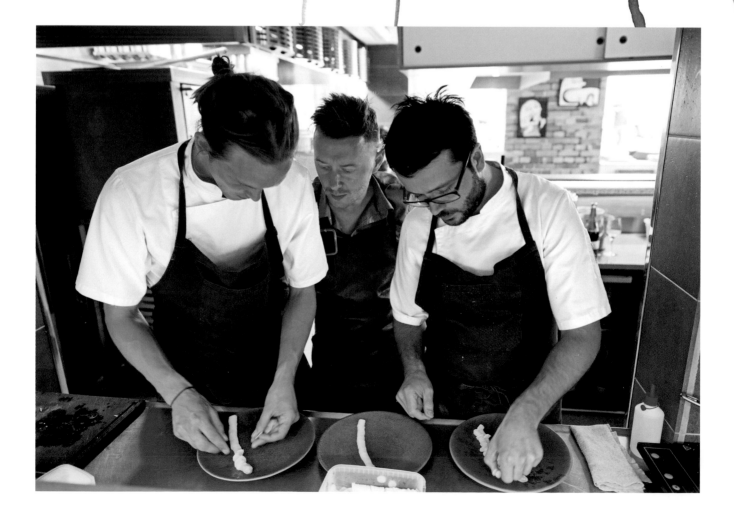

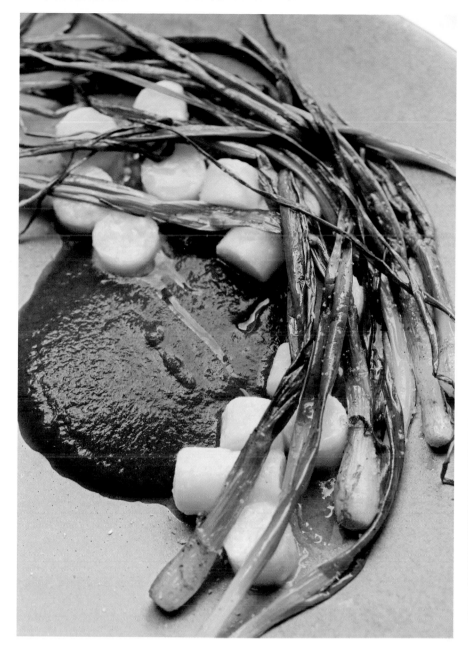

Grilled onions with creamy polenta balls and a puree of charred shallots.

A dish made with raw and cooked slices of white asparagus, and finished with anchovy, asparagus juice, and pear vinegar.

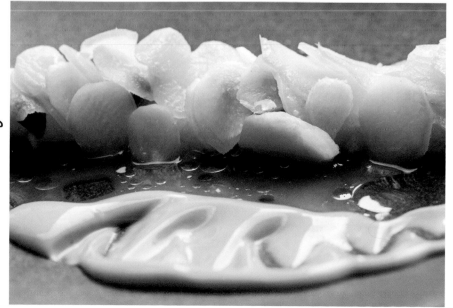

SPRING VEGETABLES

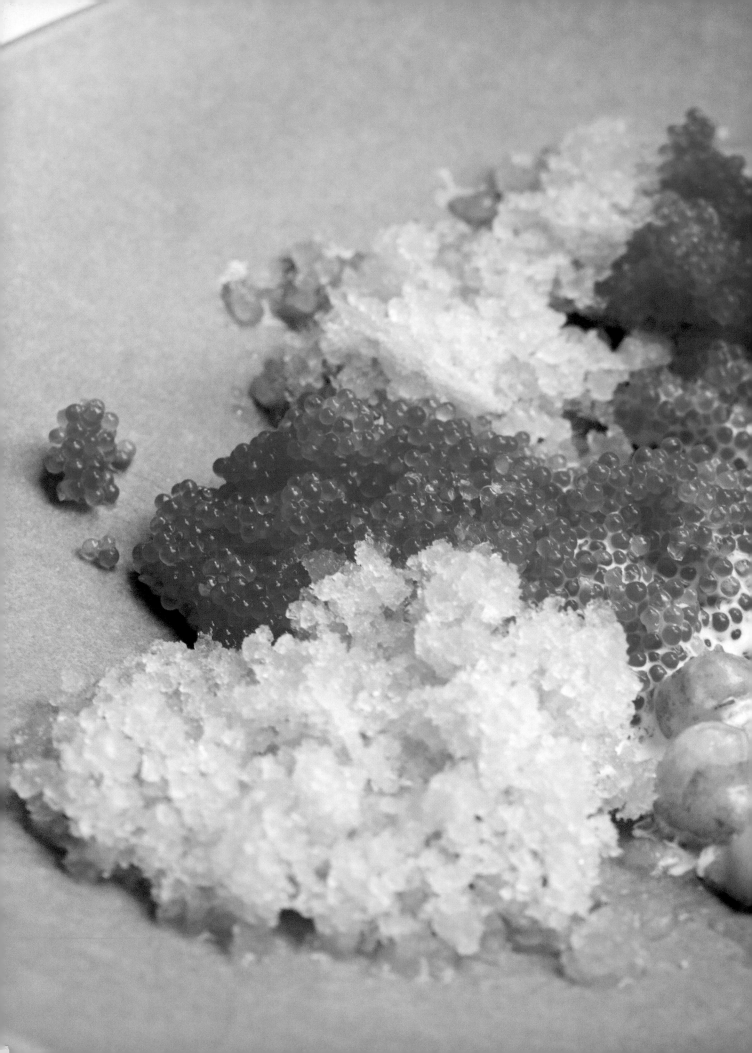

Lumpfish roe with a granité of grapefruit and raw crosnes topped with hazelnut milk.

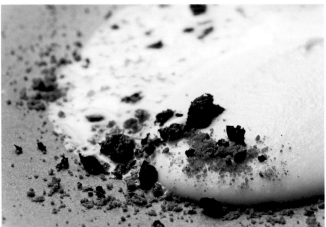

Baked potato puree with dried buttermilk and olives.

Turnips with ramson sauce and shoots.

Rhubarb compote, almond milk, and vinegar sorbet.

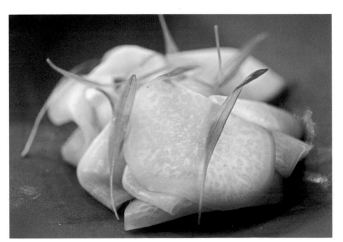

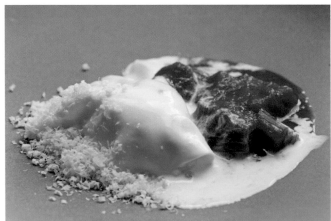

THE FOOD

Hi Christian. What is your philosophy about the service at relae?
Less is definitely more... We wanna have fun and let our guests the same!

Could you draw a map of your favorite things on jægersborggade st?

MEYERS - SOUR DOUGH BREAD

REDE

Inge Vincents - pottery - ...

Where i spend all my time

OUR SOON TO OPEN WINE-BAR ...

Uh La La makes our plates!

Coffee Collective - best coffee. ever!

MANFRED

I get my hair cut here.

Could I get the recipe for your lumpfish roe w/ grapefruit granita?
. Juice a grapefruit / freeze it and grate it.
. Mix hazelnuts and water, blend it and pass it.
. Clean lumpfish roe and scrub the crosnes. cut them in pcs.
. Plate and EAT IT. FAST. - before it melts.

What excites you about vegetables as the main component of a dish?
DIVERSITY

Could I get the recipe for your asparagus w/ parmesan?
Get a tantastic asparagus from "Lammefjorden" (a place in Dk)
cover the asparagus w/ a nice, acidic mayonnaise put crumble of bread and parmesan all the way around it. add lemon juice and eat with the tips as a snack.

Why has Copenhagen become such a food leader?

NOMA 90%

10% The great products, great and talented cooks and chefs.

- definately not the weather.!

FOUR & TWENTY BLACKBIRDS

In the late '80s Emily and Melissa Elsen's family ran the only restaurant in their hometown of Hecla, South Dakota. Their grandma Liz made all the pies—fruit pies in season and cream and chocolate pies in the winter. The young sisters helped out and learned her recipes, and 20 years later they started the Four & Twenty Blackbirds pie company out of their home in Crown Heights, Brooklyn. Now Four & Twenty Blackbirds bakery and café is housed in a brick building in Gowanus. The Elsens describe their pies as "pretty serious—it's not candy pie, retro, or confectionery." The space reflects their unique sensibility, from the hand-painted rug treatment on the floor to the rustic wood counter and chipped pressed-tin walls.

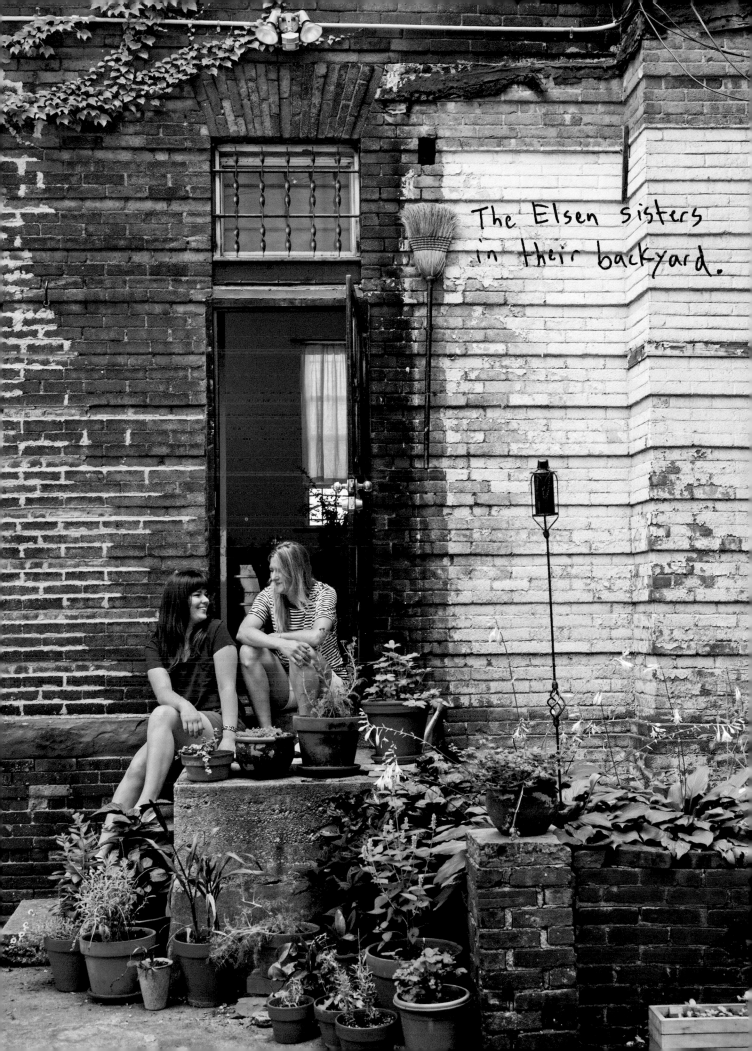

The Elsen sisters
in their backyard.

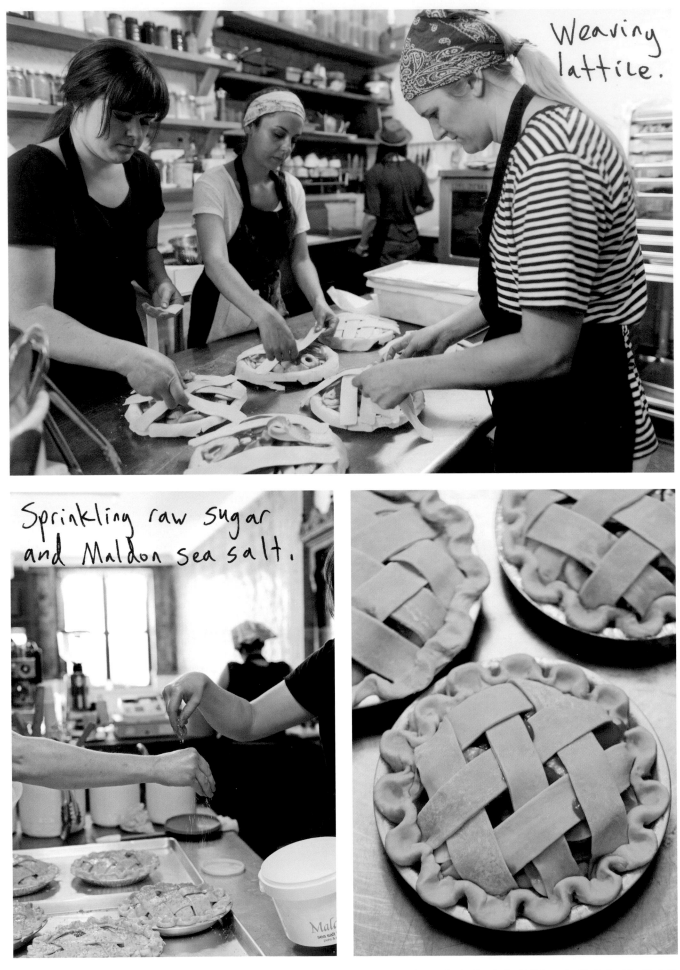

Weaving lattice.

Sprinkling raw sugar and Maldon sea salt.

SALTED CARAMEL APPLE PIE

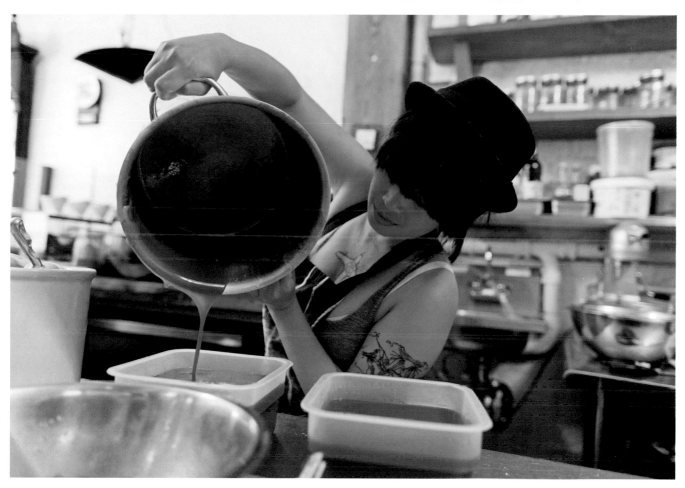

The pie is made with a combination of sweet and tart apples.

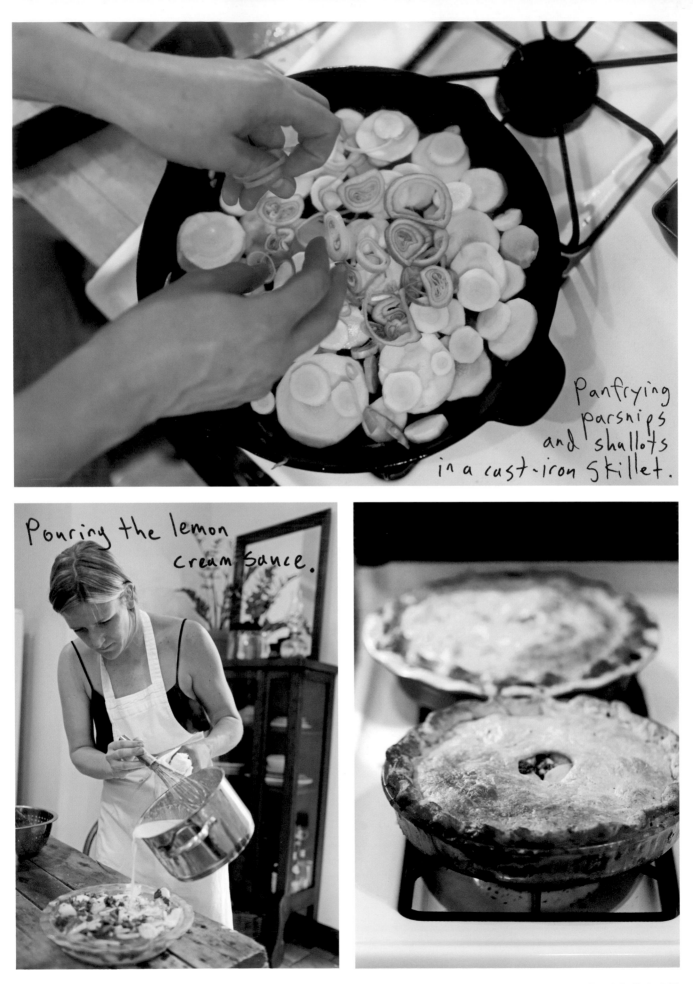

panfrying parsnips and shallots in a cast-iron skillet.

Pouring the lemon cream sauce.

FISH PIE AT HOME

Hi Emily + Melissa. Could I get the recipe for ~~buttermilk~~ chess pie?

fish

Pound and a half of good fresh whitefish, a li'l smoked salmon, some garlic, shallots, lot's of tarragon and blanched mustard greens, 3 parsnips sliced + sauteed salt + pepper to taste. Lemon Cream Sauce: Heavy cream, lemon juice (fresh), s+p — We use a cornmeal + butter crust — put it all together and bake!

what does "chess" mean?

Basically it's a Southern word for custard — it holds

up well in the "pie chest" and it's

JUST PIE! (chess pie)

could I get the recipe for salted caramel apple pie? your favorite all-butter pie crust

caramel: 8 tbsp butter, 1 c sugar, ¼ c H₂O → boil till deep golden brown + ½ c heavy cream → BUBBLY → whisk till smooth & cool

filling: 5-6 apples, peeled + thinly sliced & sprinkled w/ lemon juice spices — cinnamon, allspice, nutmeg, black pepper, angostura bitters, + flour. Whisk together & coat apples

assemble: starting w/ apples, layer apples, caramel & ½ tsp sea salt into a pastry lined pie pan. Top w/ lattice

could you draw a salted caramel apple pie

could you draw + label a map of your hometown Hecla from the 80s

grandparents ELSEN

grandma Liz

CALICO Kitchen

MAIN ST

SCHOOL

MOM'S CAFE

HOME COWS

Could you draw a slice of your grandma's coconut cream pie

salt salt salt
caramel caramel
APPLES APPLE salt
caramel caramel
APPLES APPLES APP

what are your 4 favorite parts of the Sing a song of sixpence nursery rhyme?

① when the queen is in her parlour eating bread + honey

② WHEN THE MAID HAS HER NOSE PECKED OFF

③ WHEN THE PIE IS OPENED + THE BIRDS BEGIN TO SING

④ A POCKET FULL OF RYE

LA TÊTE DANS LES OLIVES

Cédric Casanova left his job as a slack rope walker with Cirque du Soleil to start La Tête dans les Olives in 2008. La Tête is a tiny shop in the 10th arrondissement of Paris, where Cédric sells all sorts of products from Sicily. He does lunch and dinner for six people at La Tête, where they put out a folding table and make all sorts of Sicilian delicacies. Cédric works directly with growers to select the olive groves and oversee the extraction of the oils he sells in his shop. People often ask Cédric which of the varieties of olive oil is the best, to which he replies, "The greatest oil in the universe is the one you like!" I think those are some wise words.

Rose pepper.

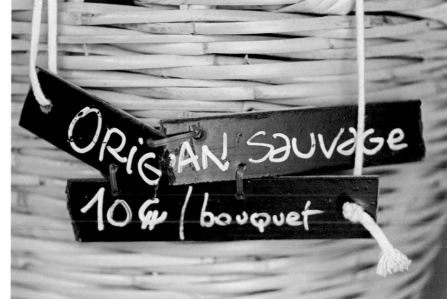

ORIGAN sauvage
10€/bouquet

Orange slices with fennel seeds,
shallots, black olives, and olive oil.

Cedro.

This piricuddara holds oils made from olives grown in Francesco's fields, →

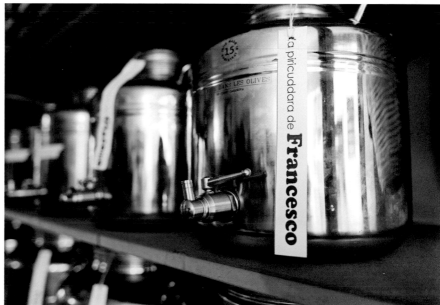

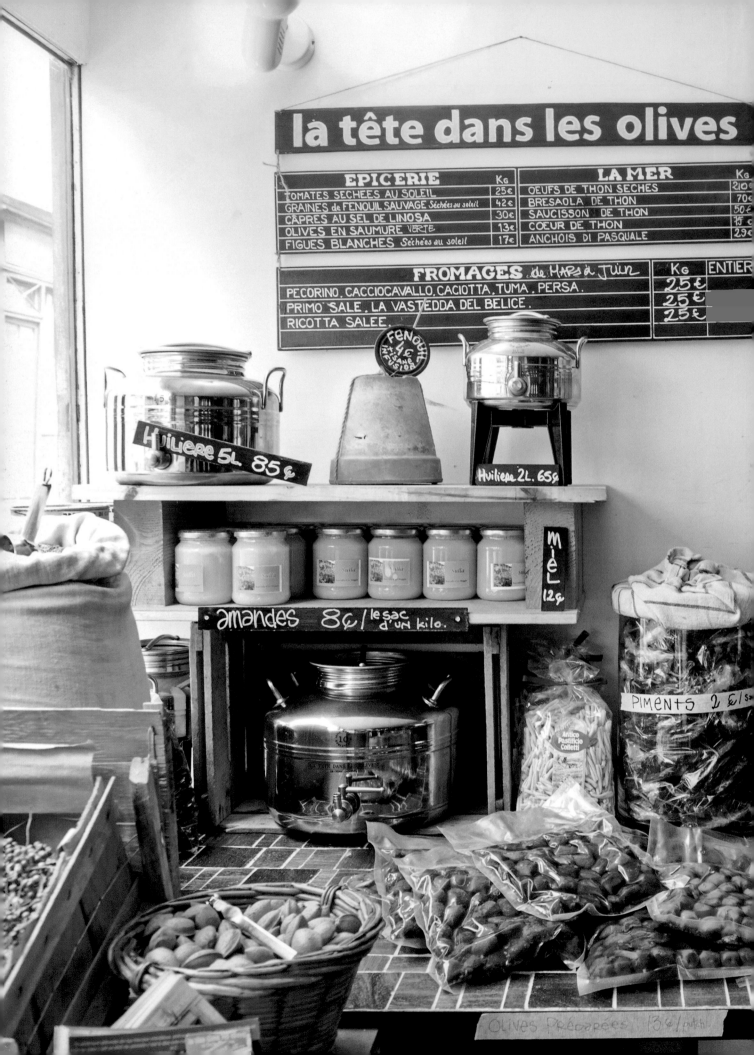

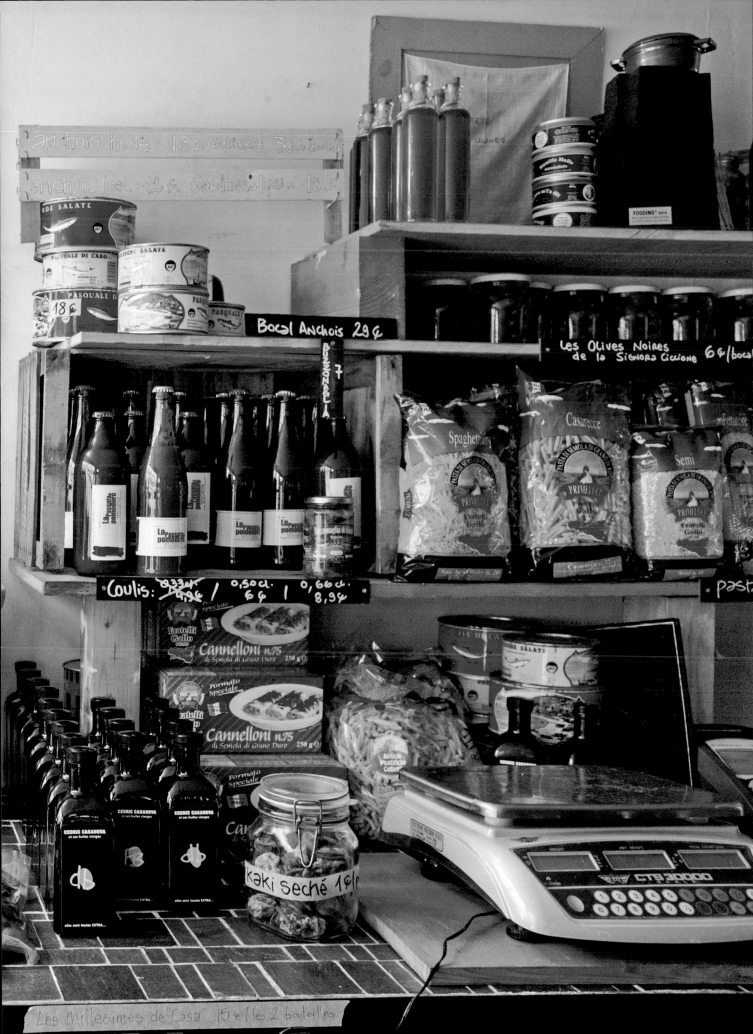

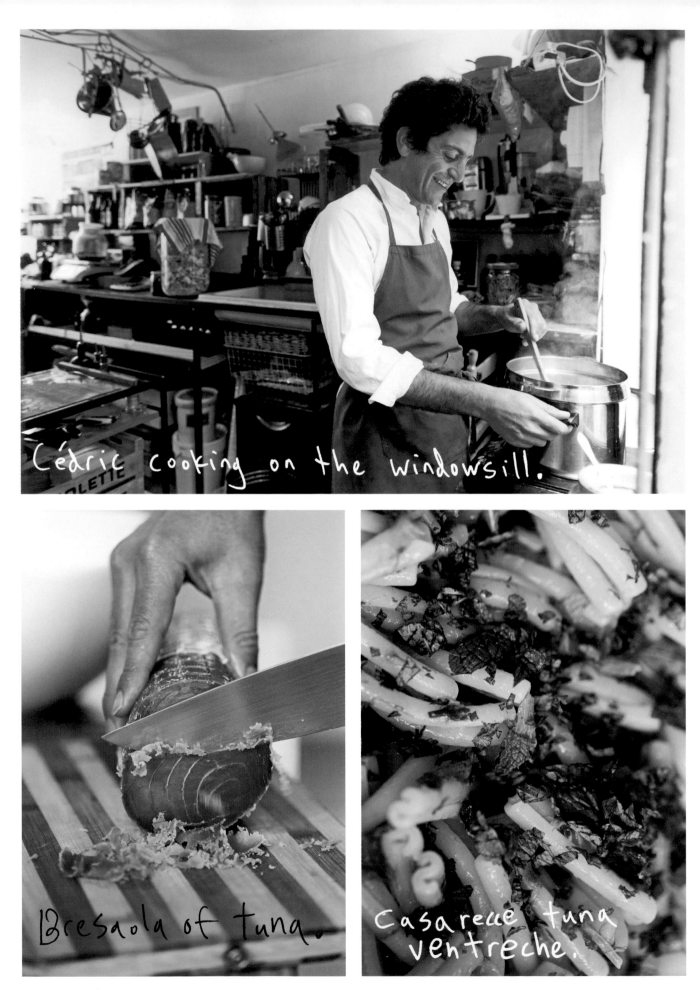

Cédric cooking on the windowsill.

Bresaola of tuna.

Casarecce tuna ventreche.

COOKING IN THE SHOP

Hello Cédric. Could I get your recipe for Quick Pasta?
① Put the water to boil ② take the can of tuna in a big bowl (without oil or water) ③ Add capers, lemon zest, garlic, raisin, and mix with a fourch. Add olive oil a strong tabacyone (like the Marco's one) - Pasta (caracelle or conchiglie rigate) when it is done put the pasta still wet in the big bowl ✱, that's it mix it well and serve.

- For 4 people ~
400g of pasta - 200g tuna, 50g capers, a half or all zest-lemon, half garlic, 30g raisin, 4 big spoon of oil -
Could you draw + label a map of your associates + what they grow in Vallée del Belice ↘

What can Sicily teach Paris? CHEARING IS HAPPINESS, BRINGING realities to be known by others realities to find a better way, a constructive way of living

Could I get your recipe for Orange Salad?
Orange (varieties: washington navel or tarocco or sanguinella) 2 oranges, 1 tea spoon of fenel, 8 anchous, schallot (1) black olives, extraV oil (PAOLA) -
slice the orange, add fenel seed, slice schallot and anchois and olives and add with oil -
Could you draw your olive oil huiliere s and how they relate to each other ↘

What can Paris teach Sicily?
CONVENIENCE !

FAR I HATTEN

Far i Hatten is located next to the petting zoo and mini-golf course inside Folkets Park in Malmö, Sweden. The restaurant first opened in 1892, under the name Parkrestaurangen, and has undergone many changes over time. Its current chef, Morgan Stockhaus, makes food with "traditional taste with a modern finesse." Morgan and his team bake all of the bread that they serve in their little kitchen in the park. Far i Hatten translates as "Father in his hat," a name Morgan believes is a reference to the restaurant's previous manager Per Anton Holmgren's habit of always wearing a hat while at work.

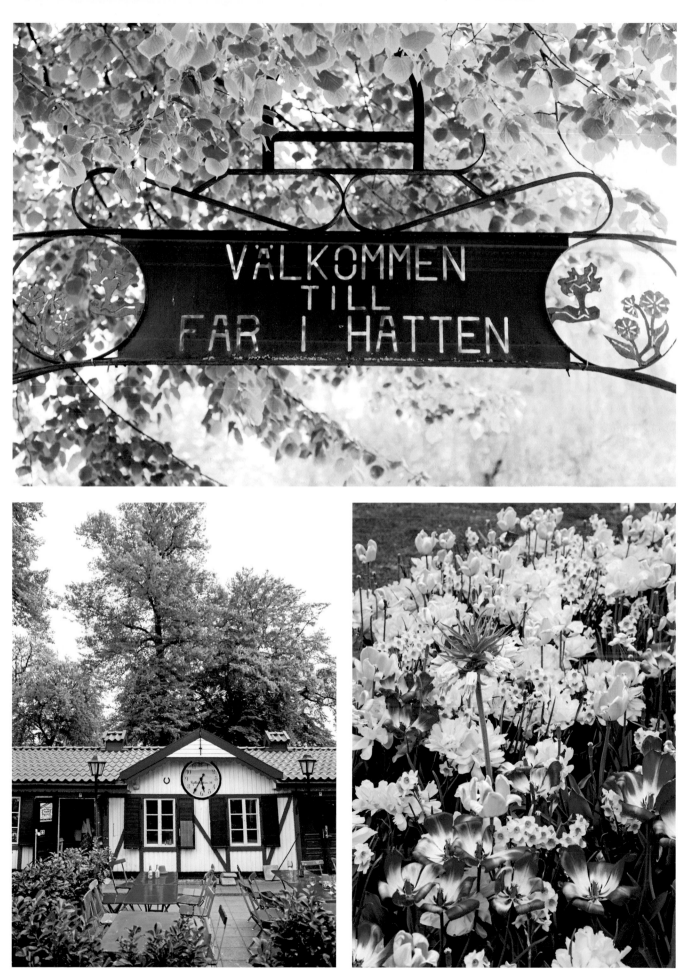

FOLKETS PARK

Could I get the recipe for fried pickled herring?
Herring is put together with herbs inbetween fried with wholegrain flour. Then pickled with 1 part 12% vinegar, 2 part sugar, 3 part water. Serve on dark bread, Don't forget the salt and pepper.

HERRING

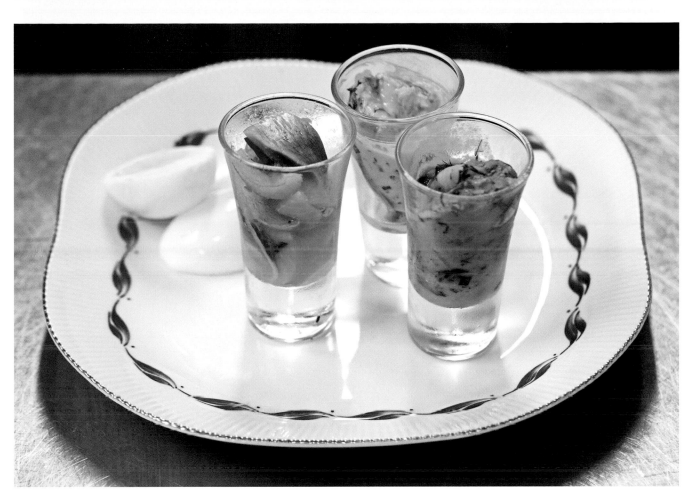

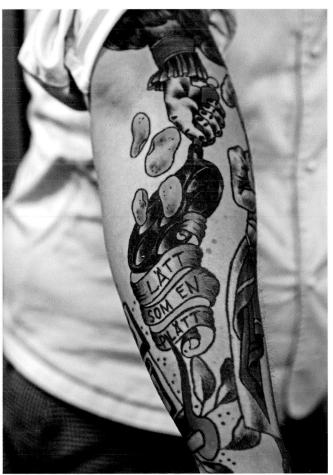

Three kinds of pickled herring, from left: apple-fennel, horseradish, and mustard-dill.

Morgan's tattoo says "Easy as a pancake." It makes more sense in Swedish.

THE PHOENIX COLLECTION

David Lee Hoffman started importing tea from China in 1990. He was particularly interested in pu-erh teas, which are totally different from any other type of tea. David describes the taste of pu-erh as "a handful of rich earth, porcini mushrooms, the wet forest floor, and a rustic wood-smoked mountain cabin." His house and business headquarters, which he runs with his wife, Bee Ratchanee Chaikamwung, were hand-built over many decades and include a concrete boat that doubles as a water pump (the *Titanic II*), a composting toilet in a tower surrounded by a moat (Le Grande Pissoir), and of course the self-explanatory Solar Power Shower Tower. All of the buildings and water features on the property are tied together as a continuous drainage and composting system. When you pour something down the drain in the kitchen it filters through the Worm Palace into the moat, through a secondary biological filter, down to the chickens, and then to the *Titanic II*'s pond.

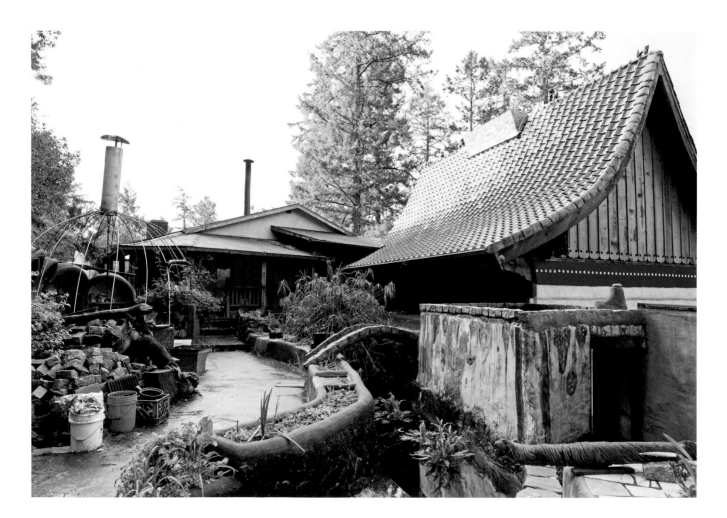

Rare pu-erh teas. ↓ A wooden hand-powered tea-cleaning machine. ↓

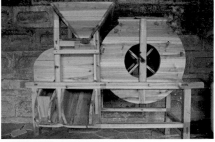

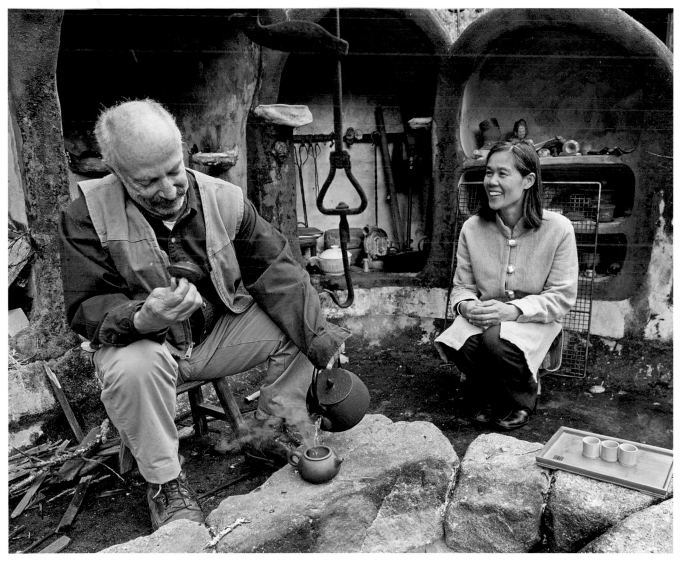

PU-ERH TEA

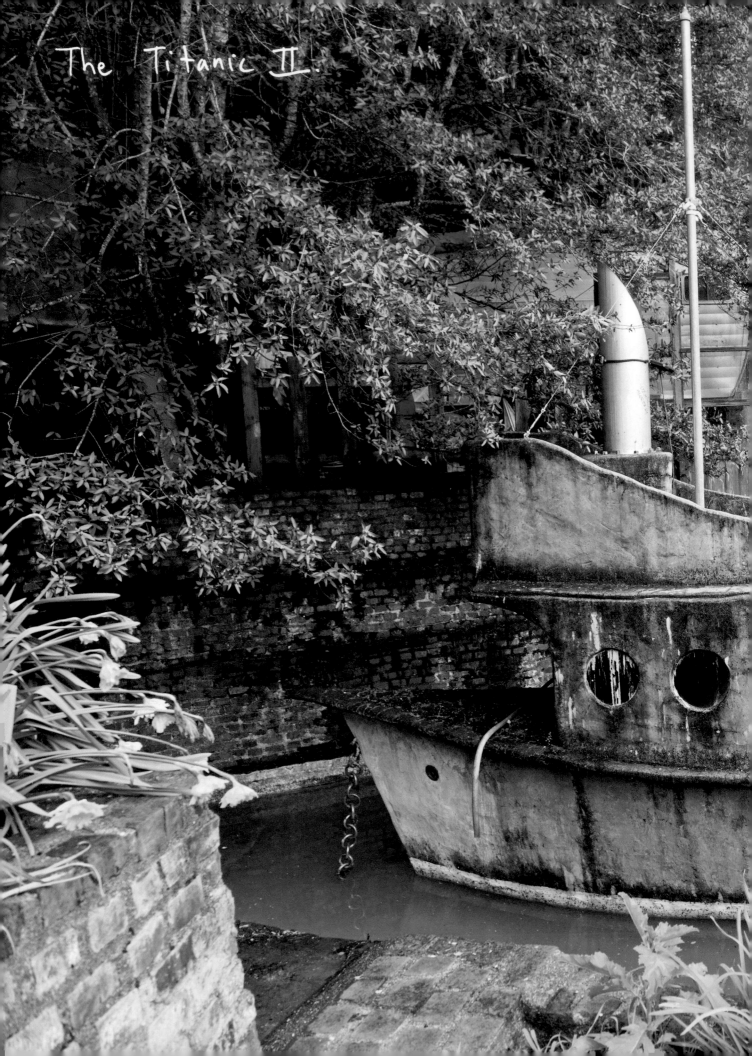

The Titanic II.

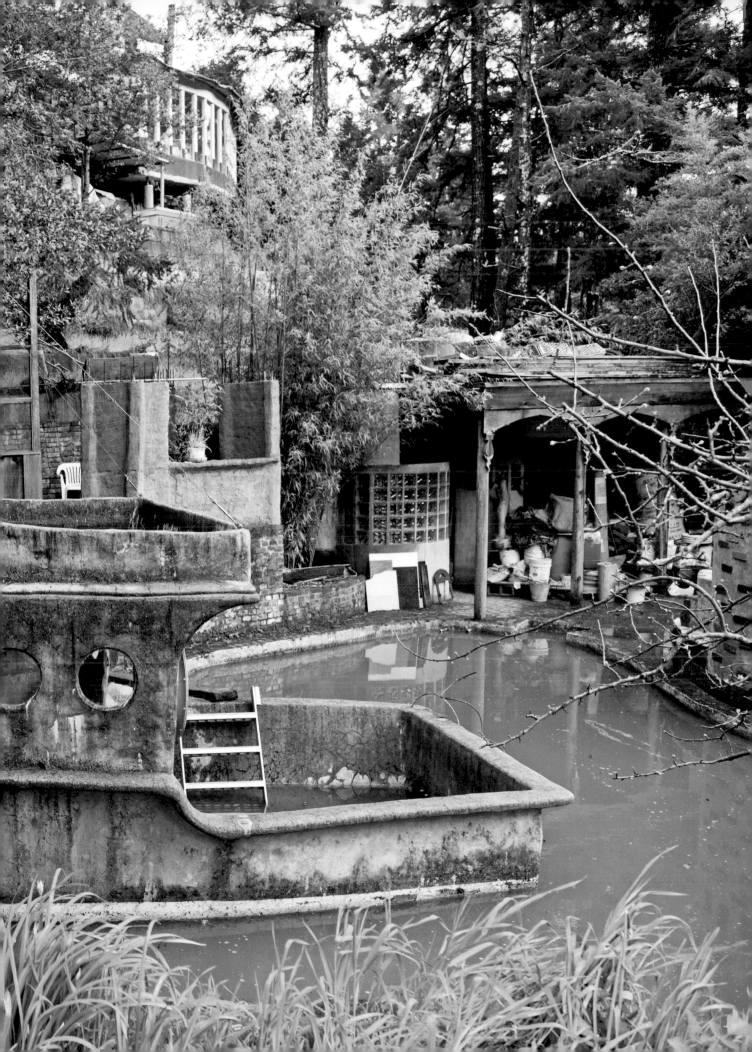

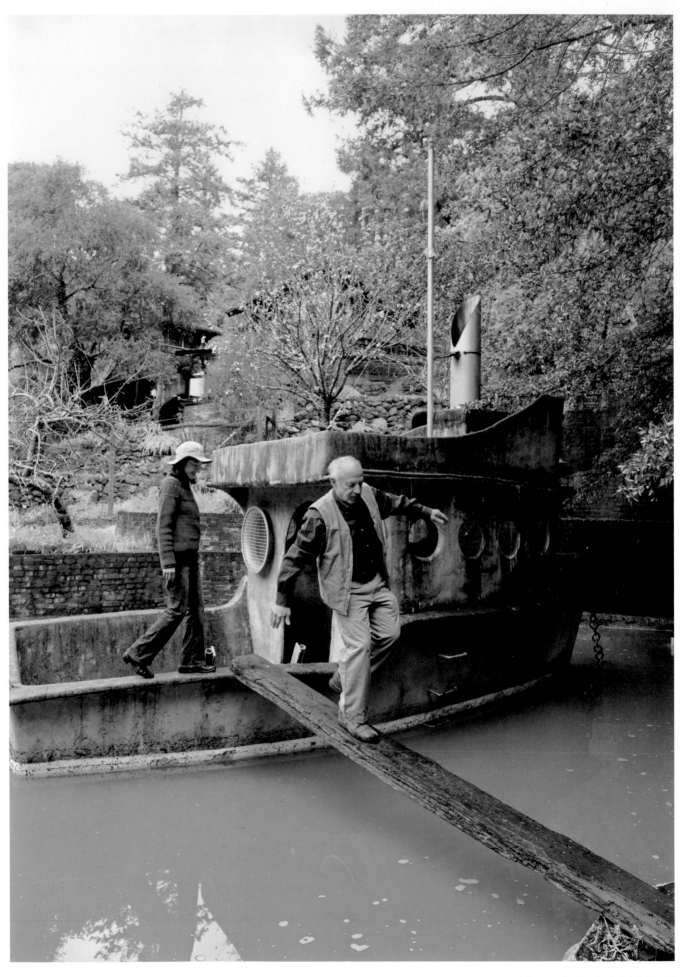

THE GROUNDS

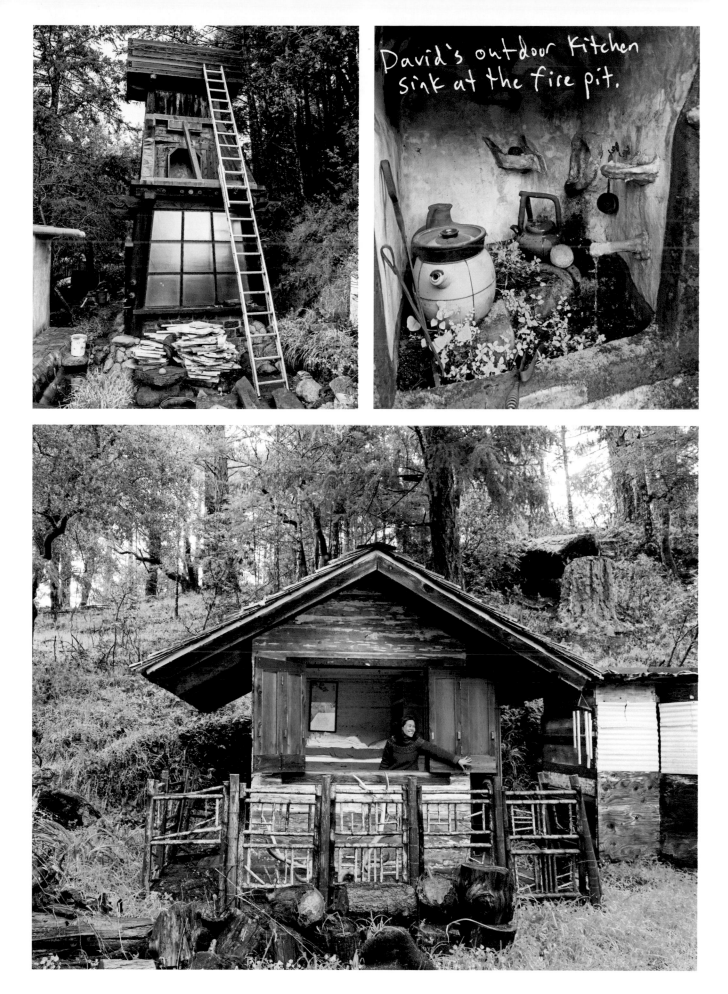

David's outdoor kitchen sink at the fire pit.

How is tea special?

It is simply the dried leaves off a tea plant, Camellia sinensis, but the tastes are so varied and flavorful

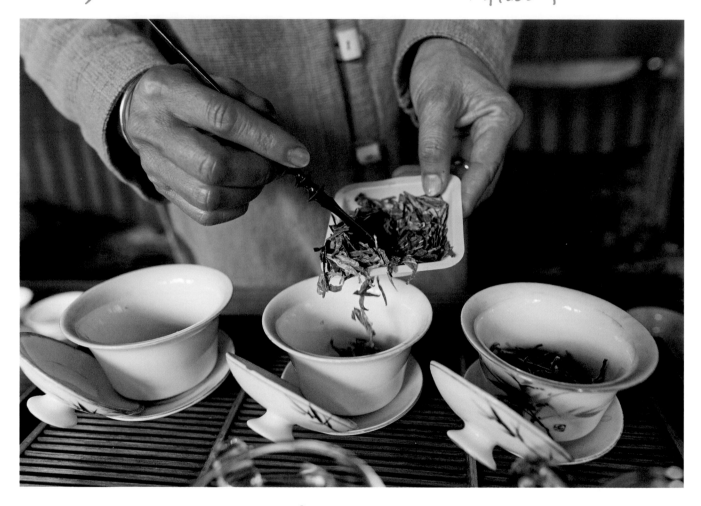

Could I get a recipe for Chai tea?

Boil whole black pepper corns and fresh ginger slices. Cool slightly and add black tea, cardamon, cinnamon. Pour off into hot milk, add sweeteners, Grate nutmeg on top. Serve. Enjoy!

THE TEA

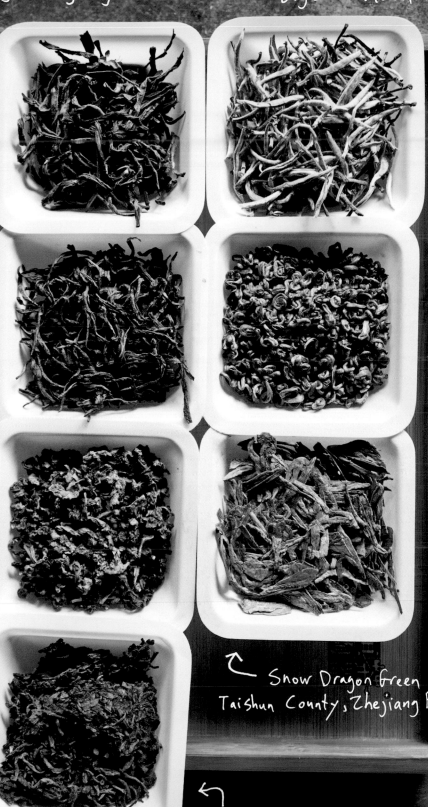

Phoenix Mountain Oolong, Mi Lan Xiang, Guangdong Province

Silver Bud White Pu-erh, Big snow mountain, Yunnan 2003

Honey Orchid Black Tea, Hunan Province

Golden Bi Luo Black Tea, Fenging Tea Factory, Yunnan

Tieguanyin "Monkey-picked" Oolong, Xiping Commune, Fujian

Snow Dragon Green Tea, Taishun County, Zhejiang Province

Linbao, Wuzhou Guangxi Province, 1995

ISA

Chef Ignacio Mattos and Taavo Somer's concept for ISA is to "play with things that are primal and elemental—fire, brick, timber, cosmic geometry, leaf, dirt, bitter, flesh, fat—through a modern, optimistic, futuristic lens." The food served at the restaurant is playful, foolish, fun, clean, and healthy, and Ignacio hopes that people who eat there experience "different sensations with beautifully sourced ingredients that speak on their own, presented in a primitive and natural way." Everything is handmade, all natural, sourced from great farms, or foraged and fished in wild areas outside of New York City.

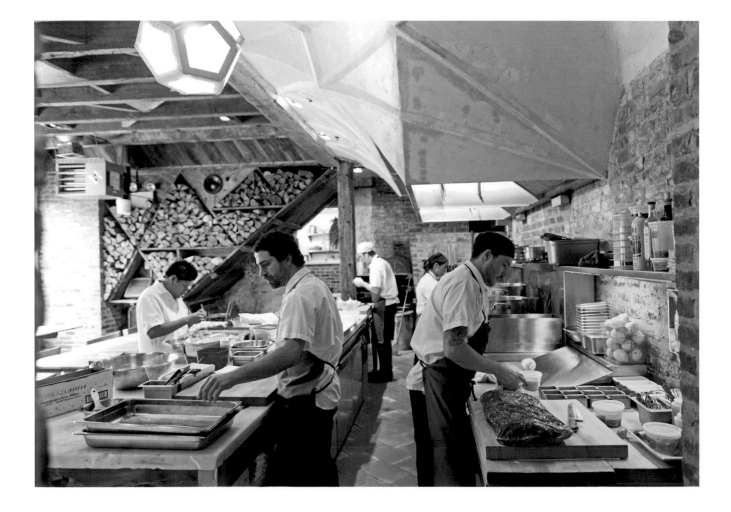

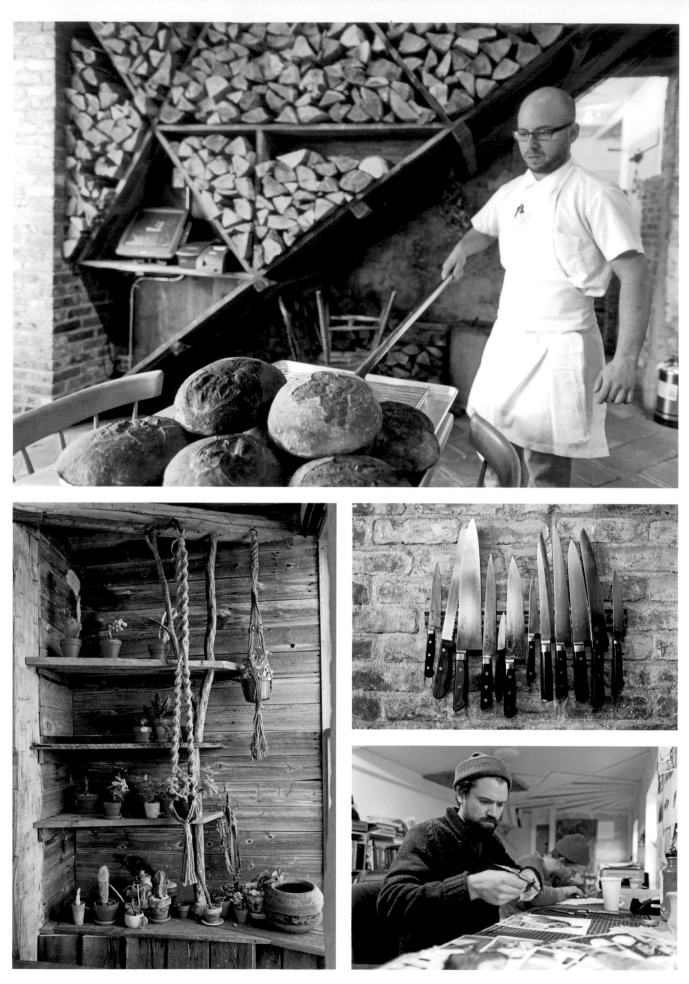

COLLAGING TODAY'S MENUS

Roasted hedgehog mushrooms, fried trumpet mushrooms, smoked egg yolk, and chestnuts.

A roasted onion petal is stuffed with concentrated onion soup and floated in a consommé.

A whole calamari, roasted in the wood oven with ink sauce, pil pil, and chickweed. →

THE FOOD

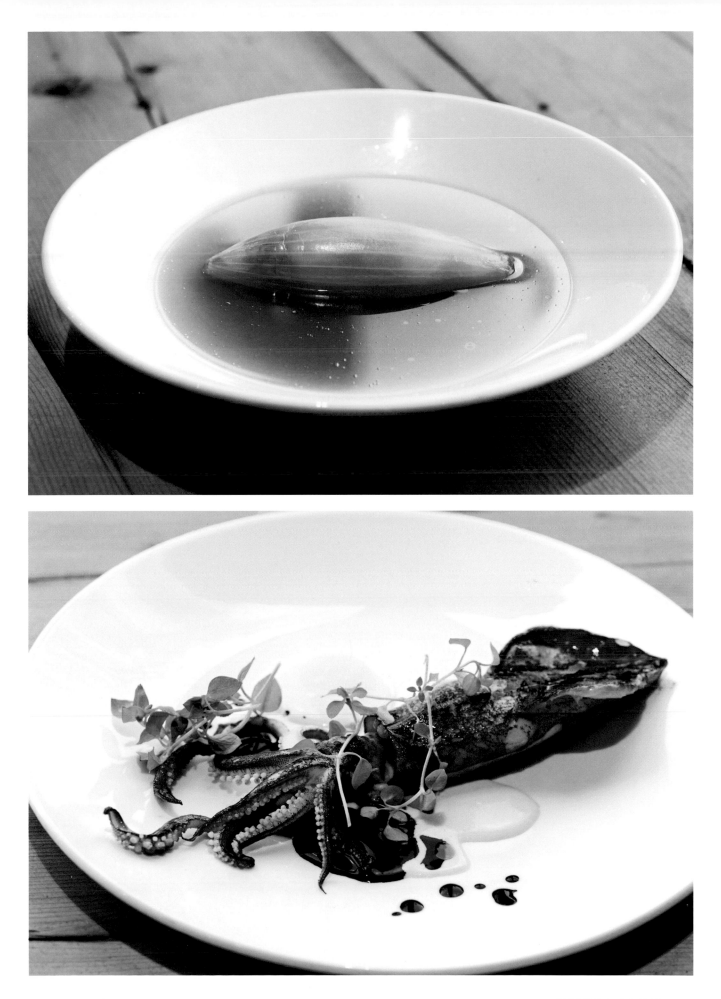

The Brain Hammock with a bee pollen rim.

The Enlighten up with juniper berries.

COCKTAILS

Hi Ignacio! Could I get the recipe for your tartare?

. hand chopped some good quality beef finely. SET aside.
. make a sunchoke puree: peel the sunchokes, roast in butter A low temp till they caramelized AND START DRYING OUT, blend in a powerfull blender with BROWN BUTTER AND SEASON WITH SALT FLAX and RYE CRUMBS: TOAST RYE BREAD IN BUTTER, GRIND IT IN A MORTAR AND PESTLE, mix with TOASTE FLAX SEEDS. JUNIPER BERRIES (fresh ones). GET SOME SMOKED OIL- OR SMOKE IT YOURSELF. PICKLED butter. SEASON THE MEAT WITH SALT chili AND AN EGG yolk. A DOT OF CREME FRAICHE "THE PLANETARY TARTARE" IN THE PLATE.

Taavo can you make a collage using some of my photos

Ignacio can I get the recipe for your Mackerel? A filet of MACKEREL, season it with salt and generous oil. Roast it AT 300 F till is done make sure stays juicy! little bit of yogurt on the plate. mixed of carrots, daikon RAdish all thinly slice on the Mandoline (season it with a nice white wine vinyar, lemon and salt. sprinkle cilantro spread Carrots And Radishes all over the place. sprinkle smoke dehydrated CApers AND A DOT OF EGG yolks. (cook at low temperature)

Ignacio what is modern food?
. HEALTY FUN And TASTY FOOD THAT'S understand it also AN ATTENTION TO THE CRAFT And my THERE ARE so MANY VARIABLES OF IT.... Techinces AND it VISUAL.

Taavo what is primitive food?
FOOD BEFORE FIRE! THINK LAZY CAVEMAN, THINK MICROWAVEABLE MEAL COOK ON BONFIRE, WITH KETCHUP ON THE BOX.

Pam how do I make the "dirt" you use in your desserts?
First, you want to make a dust from a dark dark cookie, made from black cocoa powder, butter, flour, sugar, salt. Bake it; grind it. Then, enrich it with previously foraged, dried, and powdered trumpet mushrooms; a smattering of coarsely crushed coffee beans + cocoa nibs; dried, candied, and ground black olives, and muscovado, and salt. At last, grate the finest quality fresh black truffle into your dirt, until it looks, smells, and tastes of the earth.

Ignacio could you draw + label the five best things you have ever eaten?

NOMA (CP.) DK
RAW Chestnut And Fish ROE

LA CUCHARA DE SAN TELMO
SAN SEBASTIAN Basque Pais
OREJAS DE PUERCO PIG EARS

DON CAFETOS, TULUM MX (RIP)
Chiles CURTIDOS.

MATHIAS DAHLGREN (SWEDEN)
BLUE CHEESE + MERINGUE

FRANNYS (BK) NY
LIMA BEANS

NORDIC FOOD LAB

The Nordic Food Lab was started by chef René Redzepi and Claus Meyer in 2009 as a place for research into "old and new techniques and raw materials" relating to Nordic cuisine. All of this research is shared with the public and available on the Lab's website. I think that this open-source research model is a new concept in the food world, and hopefully something we see more of. Lars Williams, Head of Research and Development, cooked at Noma for two years before René asked him to take over the Nordic Food Lab. One of Lars's first projects at the Lab is with seaweed, which is abundant in the Nordic region but not used in cooking. Lars has been experimenting with different types of seaweeds and wild foods and attempting to "meld them with Scandinavian gastronomic sensibilities" and flavor profiles.

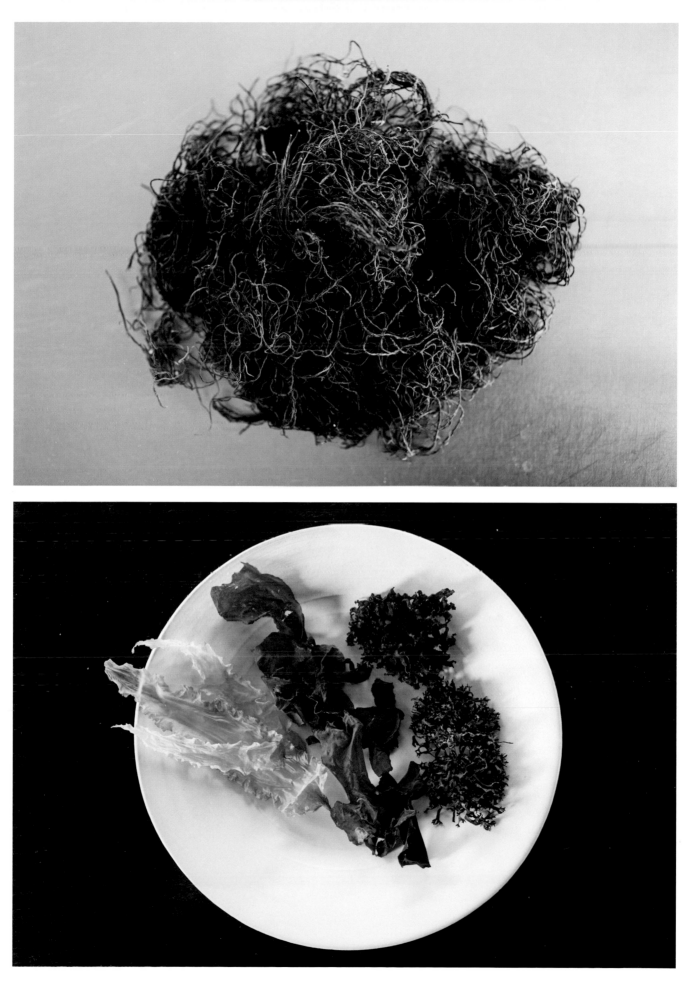

SEAWEED

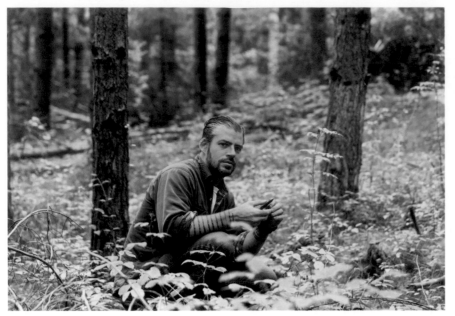

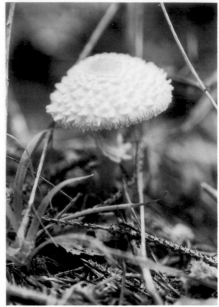

Shaggy
parasol mushroom,

Sea buckthorn
berries, →

A small cep
mushroom, ↘

FIELD RESEARCH

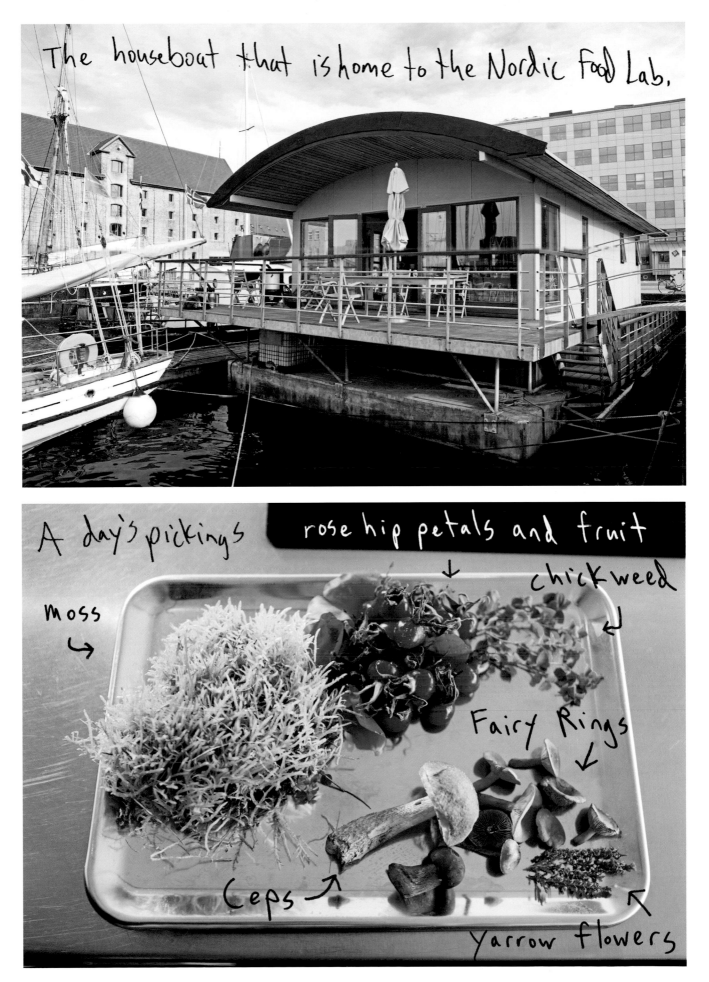

The houseboat that is home to the Nordic Food Lab.

A day's pickings

rose hip petals and fruit

chickweed

Moss

Fairy Rings

Ceps

Yarrow flowers

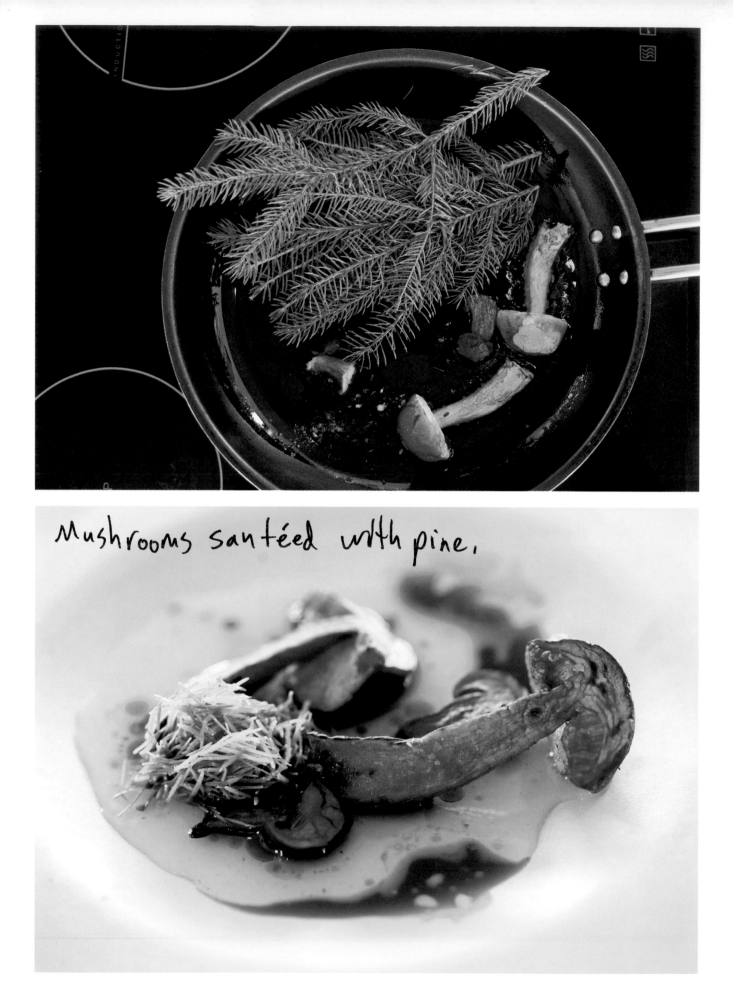

Mushrooms santéed with pine.

COOKING WITH PINE NEEDLES

Hi Lars! What is the goal of the Nordic Food Lab?
TO IMPROVE SCANDINAVIAN CUISINE, to explore old techniques w/ fresh eyes
& new techniques w/ ancient products.
ENCOURAGE EVERYONE to eat better, and where and why they eat

Could you draw some seaweeds that grow in Denmark + describe their characteristics?

Could I get a recipe for seaweed ice cream?
50g SØL (RED SEAWEED, DULCE IN ENGLISH)
600g MILK
100g CREAM
80g TRIMOLINE
24g SORBET STABILIZER

INFUSE SEAWEED IN MILK OVERNIGHT.
BLEND WELL.
HEAT TRIMOLINE & STABILIZE W/ ALL INGREDIANTS.
COOL
FREEZE IN PACOS - OR JUST PUT IN ICECREAM
 MACHINE

SØL (DULCE)
THE EASIEST
FOR NEOPHYTES
to accept
- floral
liquorish tones
AMAZING BROTHS
BLADDER RACK
MOST COMMONLY FOUND
SUGAR KELP CHANGES W/ AGE SWEET AMAZING TEXTURE

How do I make pine oil?
50g PINE NEEDLES, BLANCHED 4 MIN, COOLED & DRIED SOMEWHAT
50g PARSLEY LEAVES, PICKED & WASHED.
200g GRAPE SEED OIL
- BLEND ALL TOGETHER FOR 8 MINS, LET REST OVERNIGHT, STRAIN

Could you draw an outside view of the Nordic Food lab?

why would you like to encourage seaweed
in nordic cooking?
BECAUSE it is PROBABLY the MOST UNDERUTILIZED
NORDIC PRODUCT — $1 ONE the ENCOURAGES
PEOPLE to RE-EXAMINE the POSSIBILITIES
 IN THEIR LANDSCAPES

What have been your favorite discoveries at
the Nordic Food Lab?

BARLEY / YELLOW PEA FERMENT — AKA NORDIC MISO

PORK-SUSHI — & THEN CRUSHING REALIZATION THAT CHANG &CO HAS BEEN THERE, DONE THAT

MACKREL GARUM — AMAZING @ ONLY 2 MONTHS

SEAWEED ICE CREAM - A GREAT WAY to SHOW PEOPLE the POSSIBILITES

CARROT KOMBUCHA — You HAVE to TRY IT — SUPER EASY to MAKE

PEKO-PEKO

Sylvan Mishima Brackett started Peko-Peko catering in his backyard workshop as a first step toward opening a restaurant in the Bay Area. For now he is focusing on making flavorful, unpretentious, and beautiful Japanese food for events. Sylvan also makes perfectly packed and balanced bento boxes that highlight seasonal ingredients—a fall bento box "might highlight chestnuts, one in winter might include crab rice, and a spring bento might have pickled cherry blossoms."

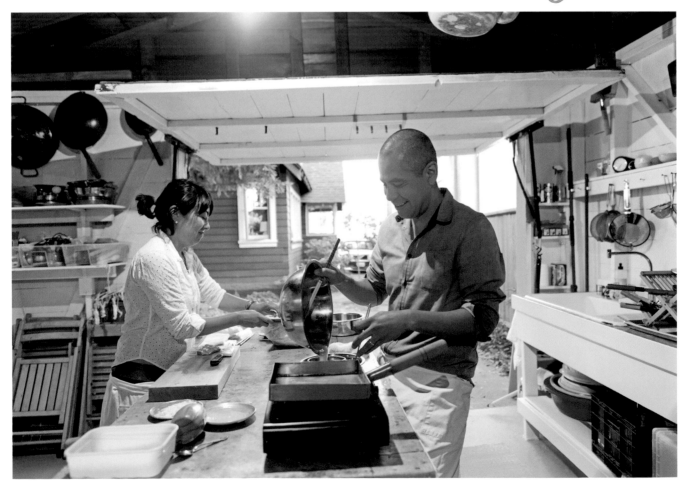

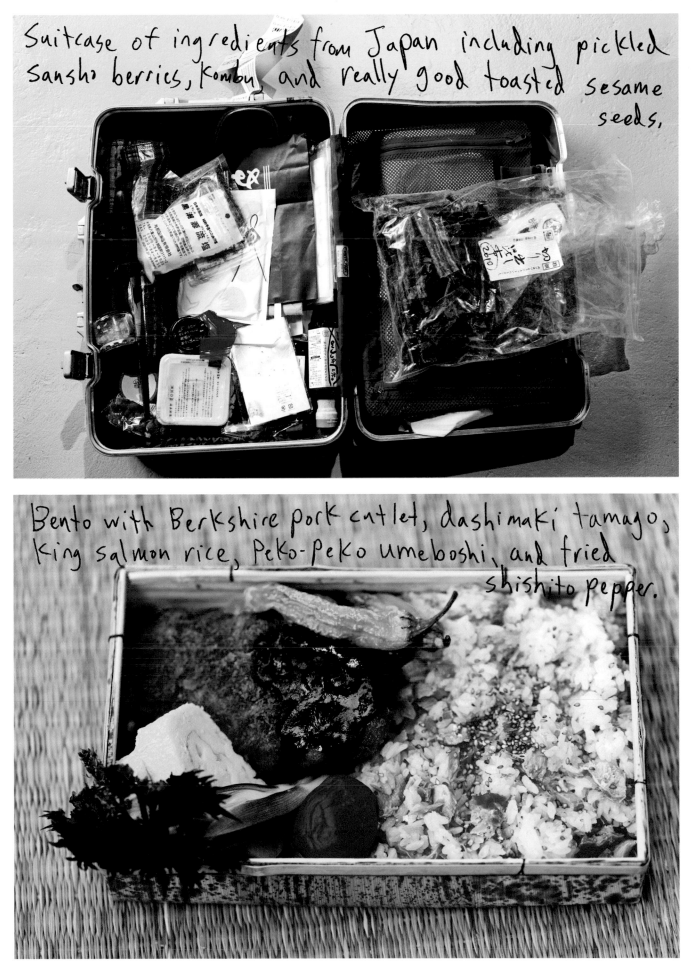

Suitcase of ingredients from Japan including pickled sansho berries, kombu, and really good toasted sesame seeds.

Bento with Berkshire pork cutlet, dashimaki tamago, king salmon rice, peko-peko umeboshi, and fried shishito pepper.

MAKING A BENTO BOX

The Peko-Peko test Kitchen.

Niboshi = sun-dried anchovies that Sylvan uses for dashi.

Five gallons of Umeshu — Japanese plum liquor made with ume, rock sugar, and vodka.

THE FOOD

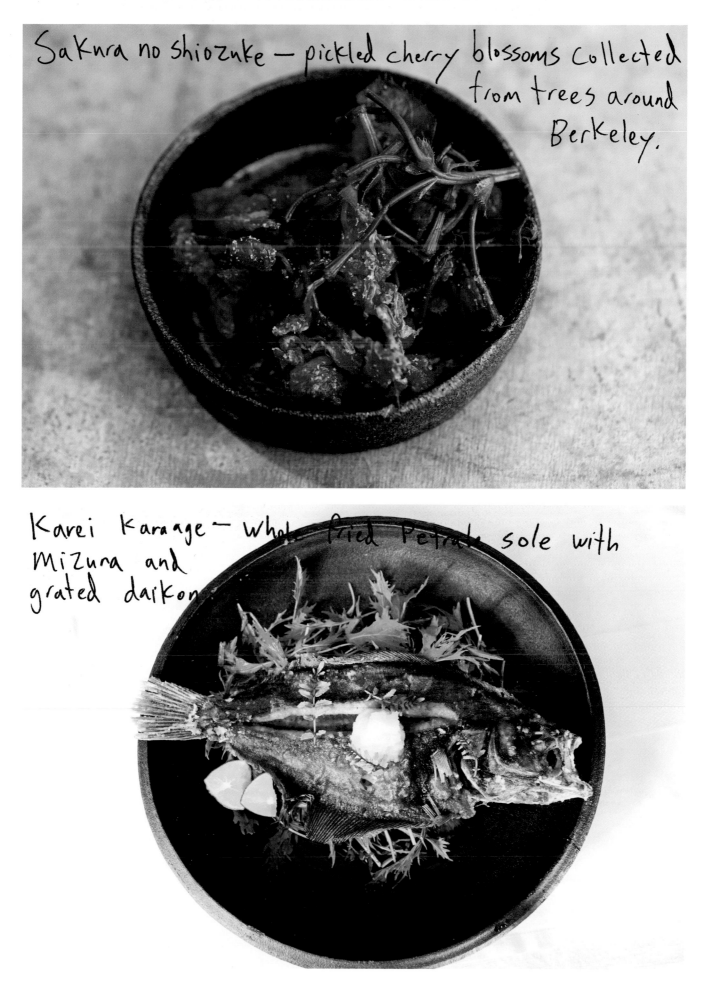

Sakura no shiozuke — pickled cherry blossoms collected from trees around Berkeley.

Karei karaage — whole fried Petrale sole with mizuna and grated daikon

Digging up myoga.

A basket with freshly picked myoga, sudachi, and Kinome.

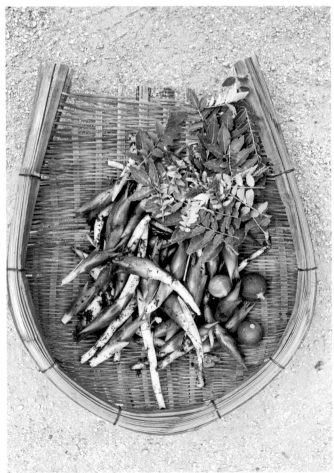

OAKLAND HILLS GARDEN

Hi Sylvan, What 6 things do you want people to bring you from Japan?

① whole katsuobushi (smoked, cured bonito)

② good kombu

③ iriko (little dried fishes for soup)

④ crazy japanese magazines

⑤ smuggled wasabi roots

⑥ heavy things (ceramic pots, dishes, rocks)

How do I make pickled cherry blossoms?
Find a cherry tree with puffy pink blossoms (yaezakura). Pick clusters of buds and some small new leaves. Wash a few times, drain and salt with handfulls of sea salt. Weight on them until they are submerged in their own liquid. Add ume vinegar (red or white) and let Put a sit another week. Dry for a couple days, spread out on a bamboo basket in the sun. Rinse them before eating.

Could you draw + label your ultimate bento box Here is one for spring. ↘

How do I make plum Wine?

Find nice green ume plums. Soak overnight. remove the stems with a skewer. Dry, layer with rock sugar in a big glass jar. cover with vodka. Let sit for one year. (or at least 3 months if you're impatient)

simmered bamboo shoots

our ume boshi (pickled plum)

rolled dashimaki tamago

Dungeness crab + rice + sansho leaves

wild cress

menchi katsu (minced pork + onion, fried with fresh panko)

plastic pigs filled w/ hatcho miso

How do I make Hatcho Miso?
I use a recipe from kitchen matsuya in Nagoya: boil 1 liter beef bone stock with 500 grams zarame sugar. add 375 grams black black hatcho miso. Heat it up and dip tonkatsu in it. strain, reheat, store → it lasts forever if you boil it occasionally.

could you draw + label your 4 favorite locals ingredients

bamboo shoots

spot prawns

wild cress

pacific halibut

PEKOPEKO

BETHELLS BEACH CAFÉ

The café caravan known as the Bethells Beach Café has been in the black dunes of Bethells Beach since the 1950s, and has been run by Jim Wheeler and Anna Saunders for the past 10 years. Jim is actually a fifth-generation descendent of John Neale Bethell, the first European settler of Bethells Beach. They have worked hard to make a friendly environment that has "become a local hub to meet and socialize" for both locals and day trippers. All of the food is prepared in a mobile catering kitchen that is located directly behind the café, next to the dunes. There are shared tables and live music, and the kids have a blast running around in the dunes. As Anna puts it best, "Cafés are more than great coffee; they're an environment that feels welcoming and familiar."

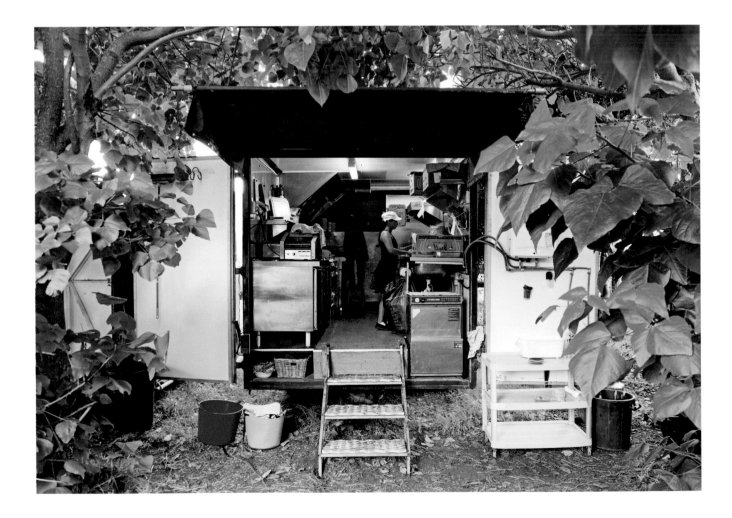

Anna could I get
the recipe for Apricot Slice?
with
love Mix butter (melted)
+ some water into
rolled oats, wholemeal
flour, brown sugar +
Baking soda to a nice
just moist consistancy.
Layer ½ in a tin,
cover with stewed apricots,
(thickened with cornflour)
and layer over the other
half of mix. Cook med oven
till nicely browned.

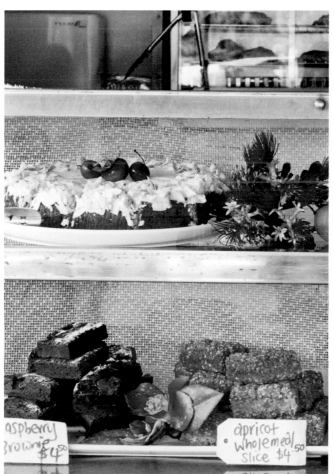

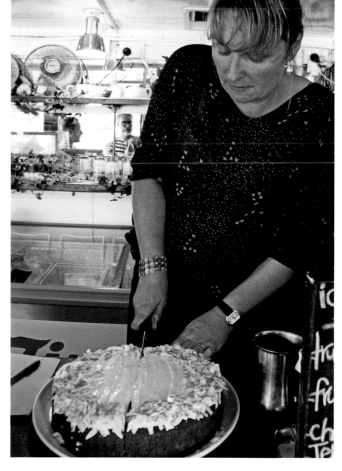

SWEET THINGS

Menu ◦

- West Coast Burger $9.80
- garden party Vege Burger $9.80
- hot chips $5.50
- Kumara fries $7.50
- foccacia toastie $7.50
- Vege samosas $5.50
- pies $4.50

THE BETHELLS

DU PAIN ET DES IDÉES

Christophe Vasseur left the fashion business to pursue his childhood dream of learning to bake. He spent four years on his own, reading historical texts and trying out different recipes. His idea was to take traditional know-how and recipes that had been lost over time and bring them back in a fresh way. The space where his bakery is located and many of the recipes he uses are more than a century old. The front space is largely untouched from when it was built in the 1880s. A key element to what Christophe does is the way he develops a nutty taste and a thick crust in his bread. I still think about his chocolate pistachio rolls almost every day at teatime.

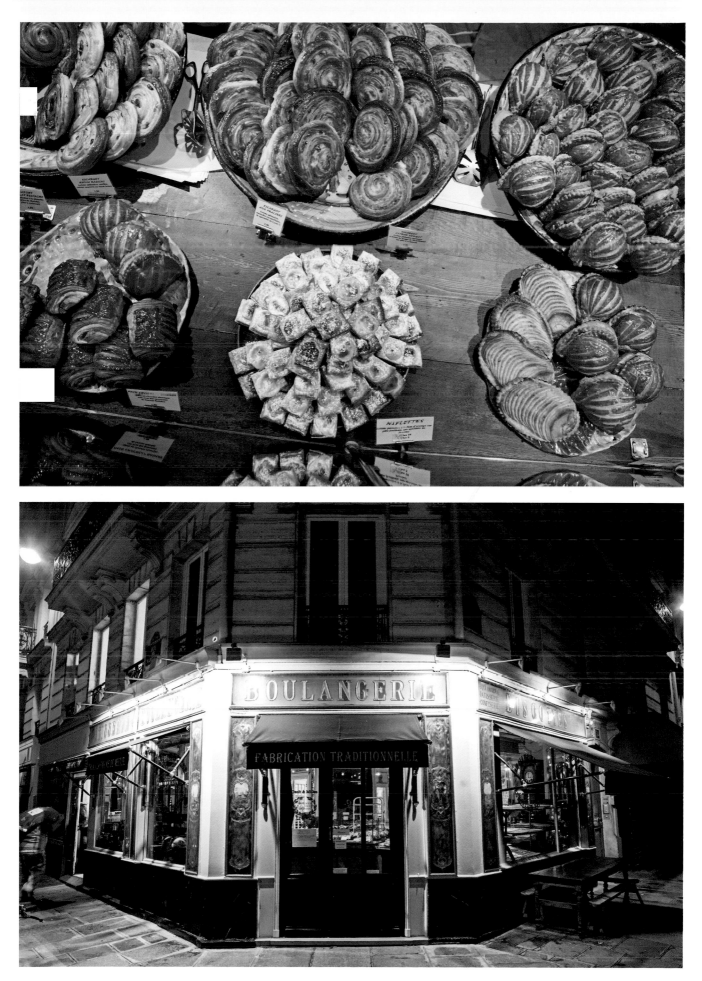

THE SHOP

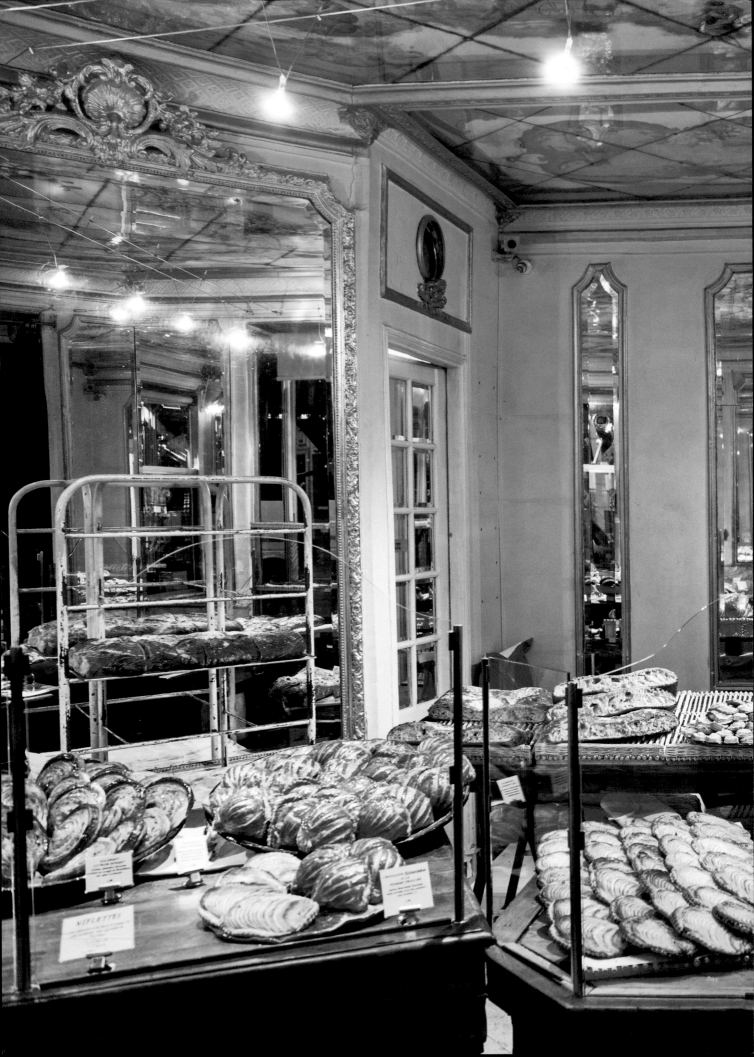

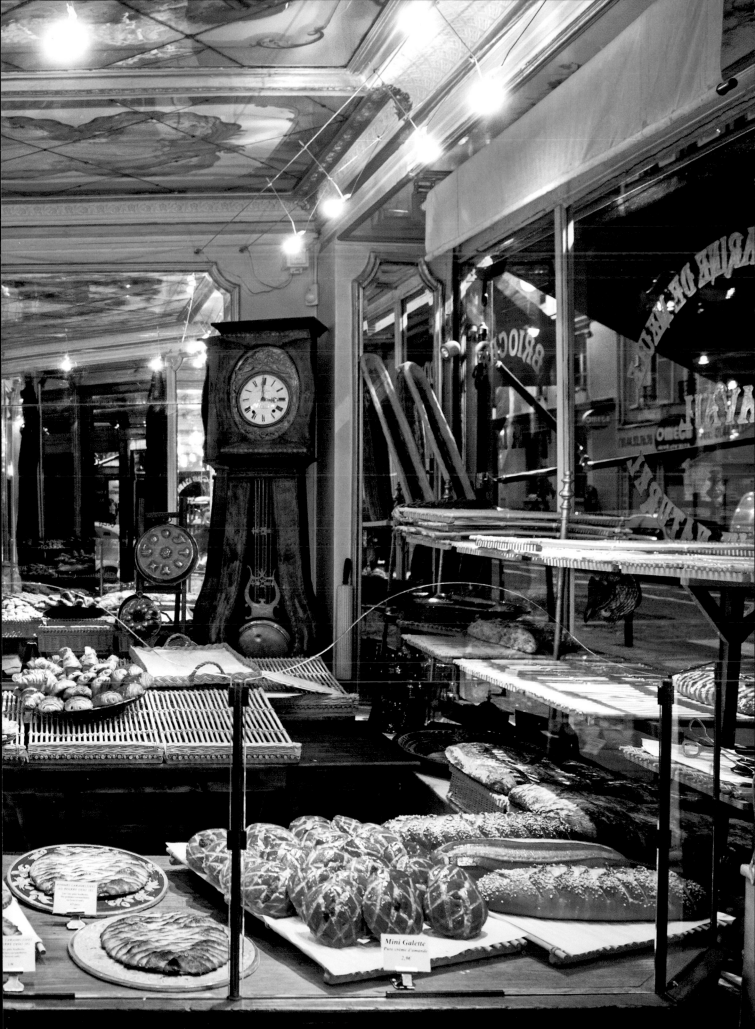

Mini Galette
Pure crème d'amande
2,9€

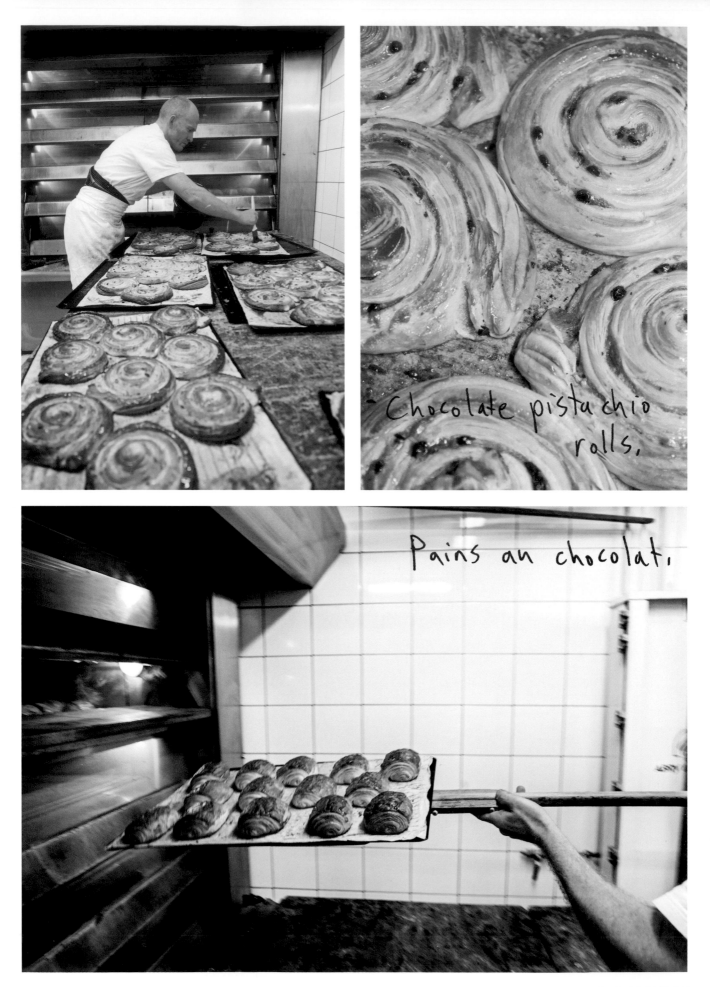

Chocolate pistachio rolls,

Pains au chocolat,

THE BAKERY

Mouna brioche with orange blossom.

Niflettes are a specialty from Provins—orange-blossom custard on puff pastry.

MAST BROTHERS CHOCOLATE

Rick and Michael Mast started experimenting with making chocolate in their apartment in 2004. They taught themselves how to do this through trial and error, getting support from online forums, and not giving up. They got so good at making chocolate at home that they left their jobs and in 2007 started Mast Brothers Chocolate in Brooklyn. At the time they were New York City's only bean-to-bar chocolate maker, and one of the few in the world. All of the processes were developed in line with the Mast brothers' do-it-yourself beginnings—from their unique packaging, which they design in-house and print locally, to their winnowing machine, which was made out of handblown glass to the brothers' specifications. Working to connect their consumers with the whole process of making the chocolate is an important part of everything they do at Mast Brothers. In 2011 they hired a cargo schooner to sail 20 tons of beans up from the Dominican Republic, which was a great way to highlight where the beans come from, as well as reduce their carbon footprint.

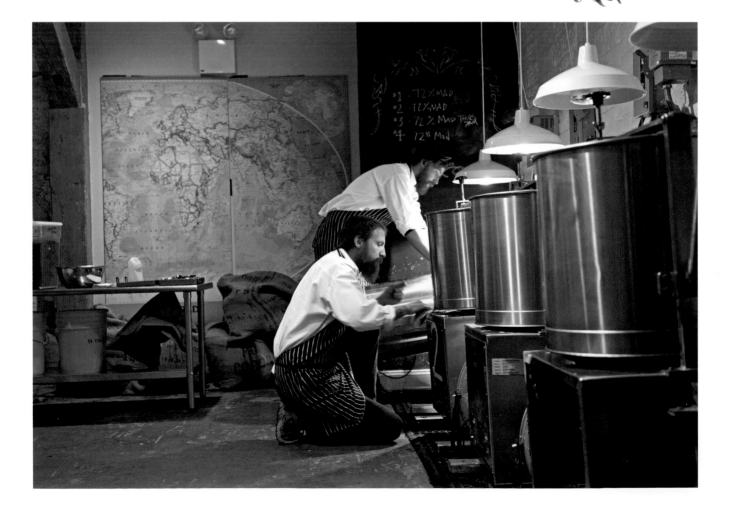

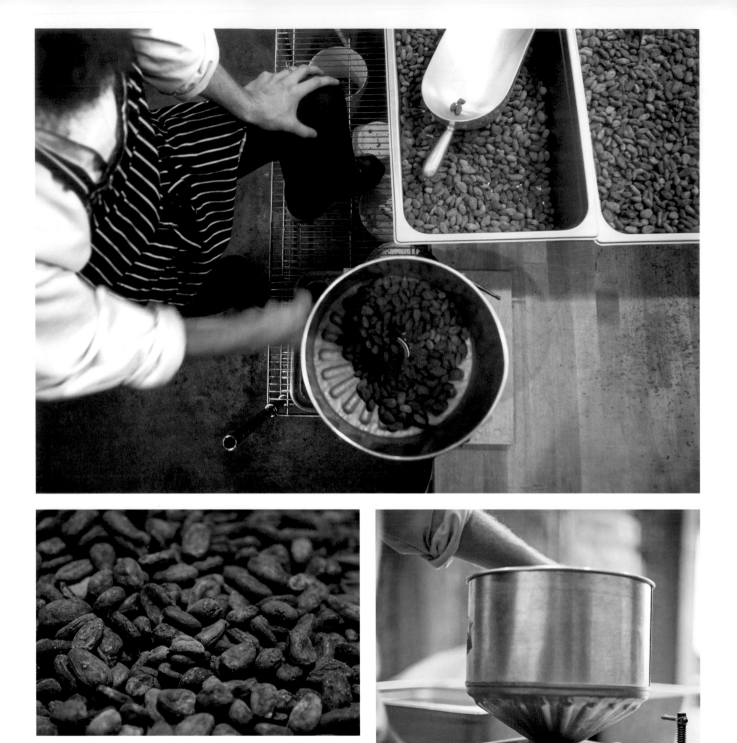

Cracked beans awaiting the winnower.

Hand-grinding cacao.

GRINDING AND AGING CACAO BEANS

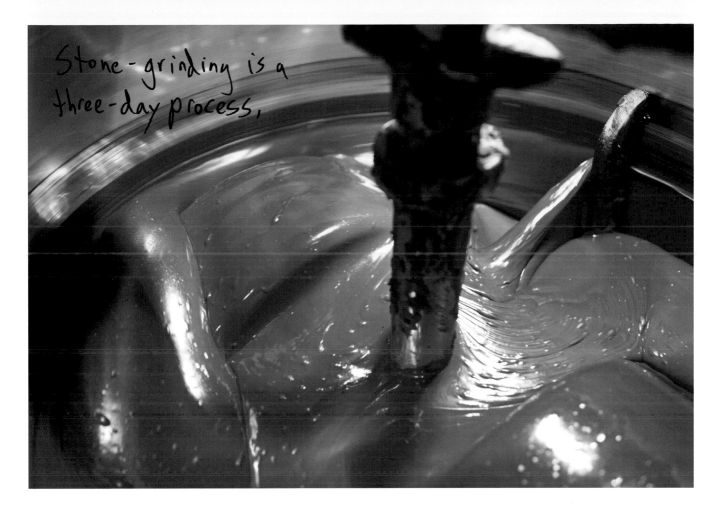

Stone-grinding is a three-day process.

Hey Rick and Michael! What are 4 things people should know about chocolate?

① Cocoa Trees grow near the equator

② chocolate is made from the seeds of a cocoa pod

③ Cocoa pods grow on the trunks of cocoa trees.

④ Cocoa beans are usually fermented.

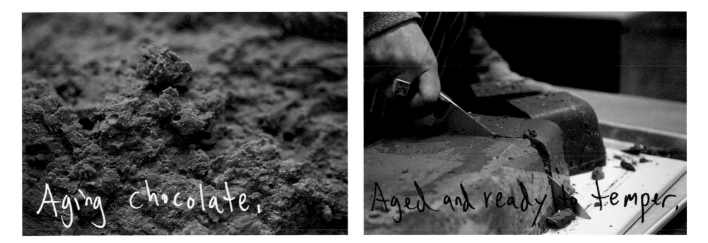

Aging chocolate.

Aged and ready to temper.

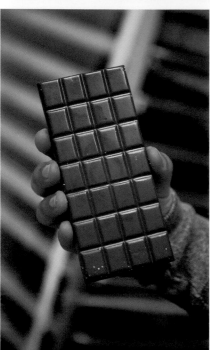

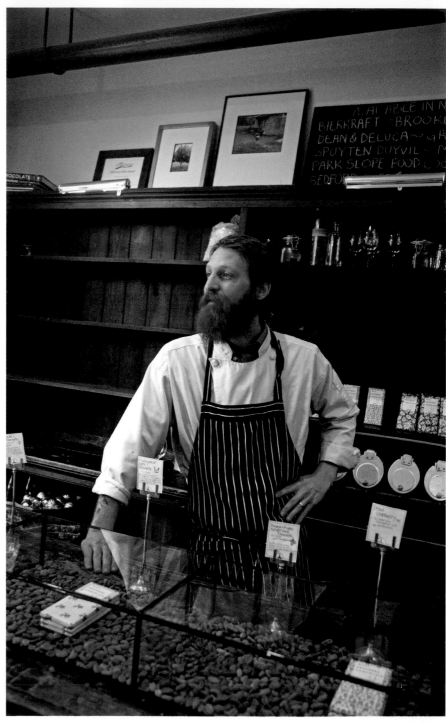

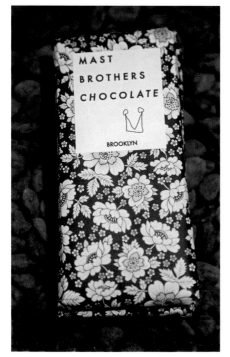

MAST
BROTHERS
CHOCOLATE

BROOKLYN

THE CHOCOLATE BAR

How to make chocolate
☆ at home ☆

STEP # 1 plant cocoa trees, harvest pods, ferment the beans, dry the beans under the sun, sail them to your town. Or just buy some.

STEP # 2 Roast the beans

preheat oven to 300°F. Remove any bark, shells, stones, etc. from beans. Place on sheet tray & roast for 9 minutes. Rotate tray. Roast for add'l 9 minutes. Cool.

STEP # 3 Crack + Winnow the beans

Run freshly roasted beans through a 3-roll-mill (or just crack them under a pot). Place in bowl & blow a hairdryer over the cracked shells & nibs. Shells are light and will blow away!

STEP # 4 Stone Grind

Find a stone grinder or perhaps even a matate. Add desired amount of sugar (try Maple Sugar). Grind until you have achieved desired texture. You've made chocolate!

STEP # 5 Temper Chocolate

To achieve that beautiful, glossy sheen & crisp snap - melt chocolate to 115°F, cool to 84°F and then bring up to 87°F. Pour into desired shape & cool.

SA FORADADA

Sa Foradada is a paella restaurant in Mallorca that is only accessible by boat or by climbing a fence and hiking down a very long path through ancient olive groves. Sa Foradada was originally built as one of the private homes of Archduke Luis Salvador of Austria. In 1972 it was leased by Emilio Fernández, who transformed it into a restaurant. Emilio's daughter Lidia works the front of the house, while Emilio makes the paellas over the fire in the back. It is by far the most beautiful natural setting for a restaurant that I have ever been to, and if you get a chance, I highly recommend you hike on down or anchor your boat in the harbor and have a beautiful paella.

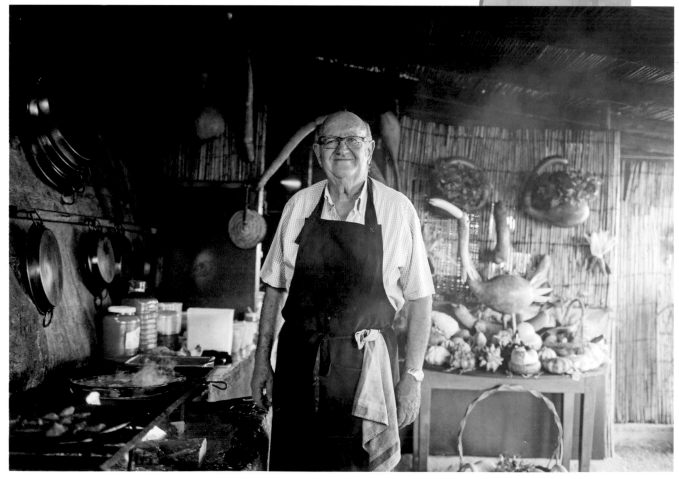

Sa Foradada on top of the cliff. Park your boat in this lagoon. If you don't have a boat, jump the fence.

GETTING THERE

The walk down to the restaurant.

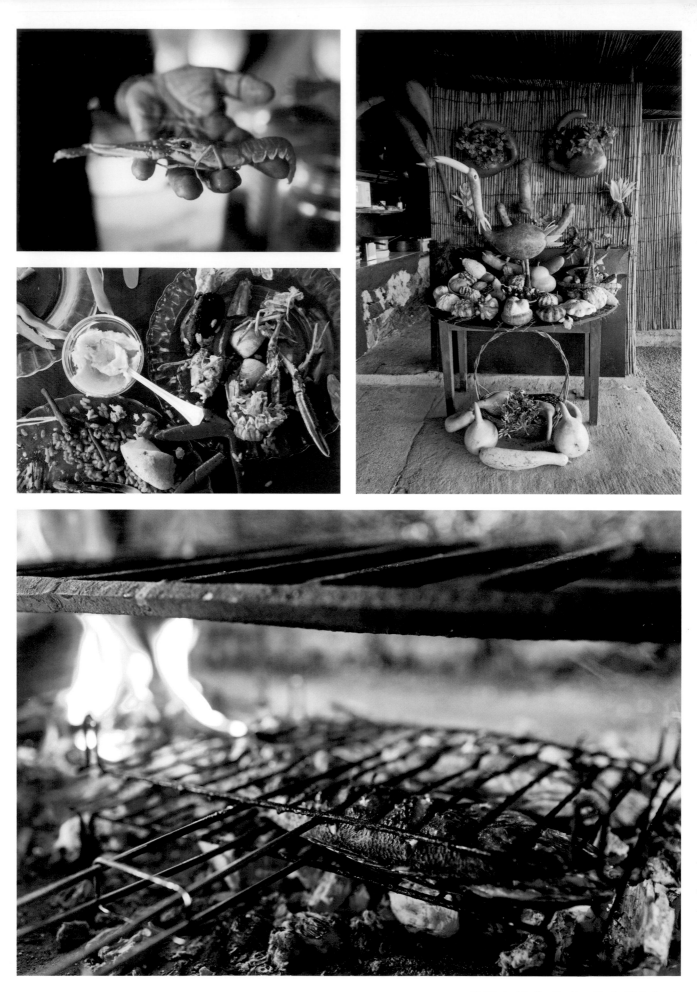

SEAFOOD PAELLA

Seafood paella . Ingredients:

Calamar, Sepia, Tomate, Aceite, Cebollas, Arroz y Caldo de Pescado. Gambas, Mejillones, Almejas, patas de Cangrejo y Verduras.

Edible Selby's Home-style Recipes

Selby's Salad Pasta

Do you like arugula? Do you like pasta? Make spaghetti, I like to make whole wheat. Right before the spaghetti is almost done fry up some chopped-up fresh tomatoes in a pan with a bit of olive oil.

throw into the tomatoes a giant handful of arugala for every person who is eating and let it wilt. As soon as its wilted mix it in with the al dente pasta and serve with grated parmesan.

Olga's Orange Taco Salsa

Boil 4 large tomatos in water, They should be covered in boiling water. Boil for 20 minutes.

Add 3 tablespoons of water and a pinch of salt to a blender plus the four boiled tomatoes. Throw in a big tablespoon of chopped white onion, half a chopped up jalapeño (without seeds) and juice from half an orange. Crumble half a tablespoon of dried oregano into blender. Blend it up to desired consistency. I like some chunky bits.

Pour salsa over hard shell tacos filled with refried beans, cheddar cheese, fresh tomatos, lettuce for a vegetarian feast. I'm hungry.

Olga's Shell Soup

4 oz of small shell pasta
one 8oz can of Tomato Paste
2 cubes of vegetable bullion
1 tablespoon of olive oil
Garlic salt, sour cream for garnish

Brown shells in olive oil in a soup pot. This should take about 2 minutes over medium heat. Once they turn brown add four cups of water, tomato paste, bullion, a little garlic salt or fresh garlic and a pinch of ground pepper. Simmer until pasta is soft. Plop a large spoonful of sour cream on top of soup when serving.

Selby's Mountain Man Miso Soup

Half a container of fresh red miso

32 ounces roughly chopped mushrooms
which could include shitake, enoki, portabello,
crimini, button or chanterelle, etc.

2 green onions sliced thin

1 clove garlic finely chopped

2 tbs olive oil

1 large white onion roughly chopped

Soy sauce

1 container of extra firm tofu cubed into
1-2 inch pieces and fully drained of water

In a nonstick pan heat 1 tbs olive oil on high
until it gets hot but before it smokes. Carefully
drop in drained tofu, splash in a tablespoon of
soy sauce and fry over medium heat until
browned on all sides. Take tofu out of pan and put aside.

In a large metal soup pot simmer white onion in
1 tbs olive oil over medium low heat. When onion
becomes almost clear throw in garlic and green onion
and mushrooms. Stir and cook over medium heat
until everything is cooked. Add 4 cups of water
and bring to a boil. After reaching a boil turn down
heat to low. Remove some of the broth in a
large bowl and add 4 tbs. of miso paste. Mix
around until miso is dissolved into broth and
throw it back into soup. If your soup needs more
liquid add water, if the broth needs flavor add miso.
Add tofu and serve!

Hi Nojiri-san! Could you draw + label the different parts of a tuna?

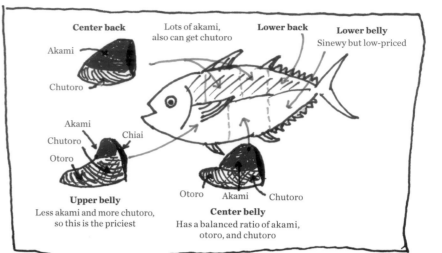

Center back
Akami
Chutoro

Lots of akami, also can get chutoro

Lower back

Lower belly
Sinewy but low-priced

Akami
Chutoro
Otoro
Chiai

Upper belly
Less akami and more chutoro, so this is the priciest

Otoro Akami Chutoro

Center belly
Has a balanced ratio of akami, otoro, and chutoro

What are the reasons that tuna is king of all fish?

I'm not sure if it's really the king or not, but I do agree that it is most people's favorite. When you think of sushi, you think of tuna, of course!!

Where are the best tuna in the world found?

Everyone has their own opinion, but we prefer tuna from Japanese waters. They migrate throughout the seas around Japan in all four seasons.

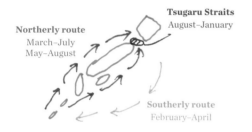

Tsugaru Straits
August–January

Northerly route
March–July
May–August

Southerly route
February–April

Could you draw + label the different knives that are used to cut tuna?

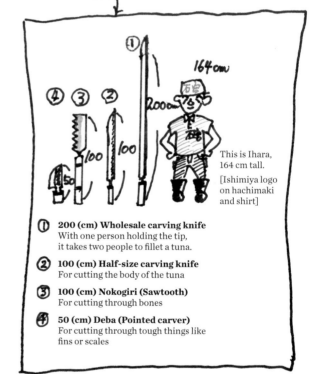

164 cm

This is Ihara, 164 cm tall.
[Ishimiya logo on hachimaki and shirt]

① **200 (cm) Wholesale carving knife**
With one person holding the tip, it takes two people to fillet a tuna.

② **100 (cm) Half-size carving knife**
For cutting the body of the tuna

③ **100 (cm) Nokogiri (Sawtooth)**
For cutting through bones

④ **50 (cm) Deba (Pointed carver)**
For cutting through tough things like fins or scales

Could I get a recipe for something I can make with tuna?

Shimofuri-zuke
(Marinated blanched tuna)
Place a block of tuna in boiling water for about 30 seconds. When the surface turns white, remove and chill [by submerging in ice water]. Marinate the block in a sauce reduction of soy sauce, sake, and mirin for up to 30 minutes. Serve with wasabi—enjoy!

Kimi (egg yolk) sauce
Mix egg yolk with soy sauce or soba sauce—makes a delicious dipping sauce!

How has Tsukiji changed?

Wild tuna catches are decreasing sharply. For that matter, farmed tuna is on the increase, and the days when farmed tuna exceeds wild tuna are now more common. We, however, will remain committed to wild tuna.

What are the best signs that a tuna is of the highest quality?

This is based on experience, of course, but surprisingly, it's about inspiration (at a glance). Nowadays it's important to have background information (fishing grounds, sea conditions, fishermen, fishing practices, etc.). Anything more is . . . a company secret.

ISHIMIYA

Hi Yoshida-san! Could you draw + label the 8 cheeses you make? ↘

How do I make mozzarella tempura?

Ingredients
Drained mozzarella
Calamari
Tomato
Basil

Directions
Dice all ingredients into 1-cm cubes, dip into flour mixed with water, then deep-fry.

Serving Suggestion
Delicious when served with gomashio [sesame] salt!!

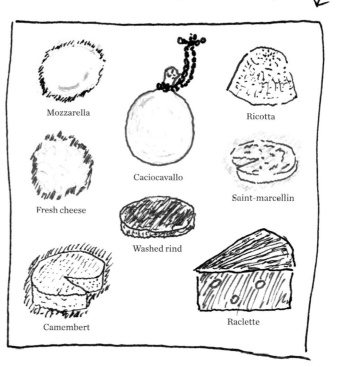

Mozzarella

Caciocavallo

Ricotta

Fresh cheese

Saint-marcellin

Washed rind

Camembert

Raclette

How do I make ricotta sashimi?

Add wasabi to ricotta, drizzle with soy sauce, and enjoy. Simple.

Why did you quit your office job to start your fermier?

1. I'm a gourmand.
2. I like making things.
3. I hate being used by people.
4. Tokyo doesn't suit me.
5. I was in the adventure club when I was in college, where I did whatever I liked.

What are your 6 favorite cheeses that you don't make?

① Roquefort ③ Parmigiano (Parmesan) ⑤ Bitto

② Cheddar ④ Pecorino ⑥ Mimolette

Could I get the recipe for mozzarella zuke?

Douse small pieces of mozzarella liberally with soy sauce, mirin, and sake.

What has cheese taught you?

Whatever you're creating, the most important thing is the quality of the raw materials (in my case, the milk).

What have the cows taught you?

I really understand how every living thing has individual characteristics and a precious existence.

YOSHIDA FARM

To all of the people featured in this book for letting me into your world; Deborah Aaronson, for being an amazing editor and for all of your tireless support; Danielle Sherman, for your inspiration, creative help, photo editing, and great taste; Sally Singer, for being such a great partner with me on the "Edible Selby" column and for writing the introduction to the book; Chad Robertson, for writing the foreword and for all your help along the way; Michael Ian Kaye and the design team at Mother New York. You guys rock. I love the design of the book; Andy McNicol, for being such a great agent; Jonathan Shia, for all of your research, writing help, fact checking, and general book assistance; and Ignacio Mattos, for inspiring me to do this.

Thank You Abby Aguirre, Abigail Smiley Smith, Akihiro Furuya-san, Al Keating, Alexandre de Betak, Alfred Steiner, Alice Waters, Allison Hopelain, Allison Powell, Amanda Urban, Amory Wooden, Amy Yvonne Yu, Anders Selmer, Angela Crane, Ankur Ghosh, Anna Kent, Anthony Elia, Anthony Myint, Arto Barragan, Aya Kanai, Bagge Algreen-Ussing, Barry Friedman, Beau Bryant, Bernstein & Andriulli, Bill Gentle, Boyz IV Men, Brad Meyer, Brandon Harman, Camilla Ferenczi, Candice Hawthorne, Carlos Quirarte, Carol Alda, Carole Sabas, Caroline Burnett, Casa Brutus, Chelsea Zalopany, Christine Muhlke, Christopher Simmonds, Christopher Vargas, Cocos Cantina Auckland, colette, Coqui Coqui, Damien Poinsard, Dana Cowin, Danika Underhill, Danny Gabai, Darryl Ward, David Blatty, David Gooding, David Imber, David Prior, David Selig, Derrick Miller, Ehrin Feeley, Elke Hofmann, Elle Sullivan Wilson, Emi Kameoka-chan, Emilie Papatheodorou, Eric Ripert, Ewen Robertson, Fanny Gentle, Fanny Singer, Francesca Bonato, Gabi Platter, George Gustines, Great Lake in Chicago, Guillaume Salmon, Hacienda Montecristo, Harry Wigler, Howard Bernstein, Humphry Slocombe San Francisco, Ilana Darsky, Jackie Chachoua, Jacopo Janniello Ravagnan, Jamie Perlman, Jane Herman, Jane Pickett, Janet Dreyer, Jeffries Blackerby, Jennifer A. Murphy, Jennifer Brunn, Jennifer Vaughn Miller, Jenny Golden, Jenny Park, Jeremy Sirota, Jessica Boncutter, John Jay, Johnny Iuzzini, Jules Thomson, Julien David, Junsuke Yamasaki-san, Justin Ongert, Karen Walker, Katie Lockhart, Katrina Weidknecht, Kazumi Yamamoto-san, Kim Hastreiter, Kimi Suzuki-san, Lauren Sherman Winnick, Le Fooding, Lee White, Leslie Simitch, Liam Flanagan, Lidia Fernandez, Lisa Kajita, Lucy Marr, Mariko Munro, Mark Hunter The Cobrasnake, Martin Berg, Martin Sten Bentzen, Martino Gallon, Mary Wowk, Mathias Dahlgren, Matt Kliegman, Maura Egan, Michael Jacobs, Michelle Ishay, Mika Yoshida-san, Mikhail Gherman, Mitch Goldstone, Murray Bevan, Nick Kokonas, Nicolas Malleville, Yuri Nomura-san, Olga Vargas, Olivia Gideon Thomson, Paco Mattos, Paulina Reyes, Pellegrini's Espresso Bar Melbourne, Philip Andelman, Philip Smiley, Phillip Baltz, Rhonda Sherman-Friedman, Richard Selby, Rikki Selby, Rory Walsh, Saltie Brooklyn, Salumi De Stefani, Sarah Andelman, Sawako Akune-san, Saxelby Cheese New York City, Scott Hall, Scott Selby, Seiichi Kamei-san, Showroom 22, Sofia Sanchez Barrenechea, Simon Doonan, Stephen Marr, Steve Heyman, Steve Tager, Stevie Parle, Susan Winget, Sylvia Farago, Sylvia Rupani-Smith, T: The New York Times Style Magazine, Taavo Somer, Takaaki Sato-san, Tallulah Ford Miller, The Department Store Auckland, The Leather King Mitch Alfus, Theresa Kang, Thomas Keller, Trunk Archive, Valery Gherman, Victoria Lagne, We Folk, William Eadon, William Morris Endeavor, Willy Hops, Yoko Hiramatsu-san, Yumiko Sakuma-san, and Yuri Chong.

Thank You

Hi! There are lots of recipes in this book. I haven't actually tested any of them, so I can't promise you that they are complete, accurate, will work, or, even if they do work, will taste good. It's up to you if you want to try following one and eating the results. And, if you do try making one of the dishes and it's a disaster don't blame me. Or my publisher. Blame yourself. Just kidding. But not really. Tweet me a photo of the finished product @theselby. I'd love to see it.

♡ Selby

Editor: Deborah Aaronson
Designer: Mother New York
Production Manager: Ankur Ghosh

Library of Congress Cataloging-in-Publication Data:

Selby, Todd.
 Edible selby / Todd Selby.
 p. cm
 ISBN 978-0-8109-9804-9 (hardback)
1. Portrait photography. 2. Celebrity chefs—Portraits. 3. Photography of food. I. Title.
 TR681.C66S45 2012
 779'.96413—dc23
 2012007961

Printed and bound in China
10 9 8 7 6 5 4 3 2 1

Abrams books are available at special discounts when purchased in quantity for premiums and promotions as well as fundraising or educational use. Special editions can also be created to specification. For details, contact specialsales@abramsbooks.com or the address below.

THE ART OF BOOKS SINCE 1949

115 West 18th Street
New York, NY 10011
www.abramsbooks.com